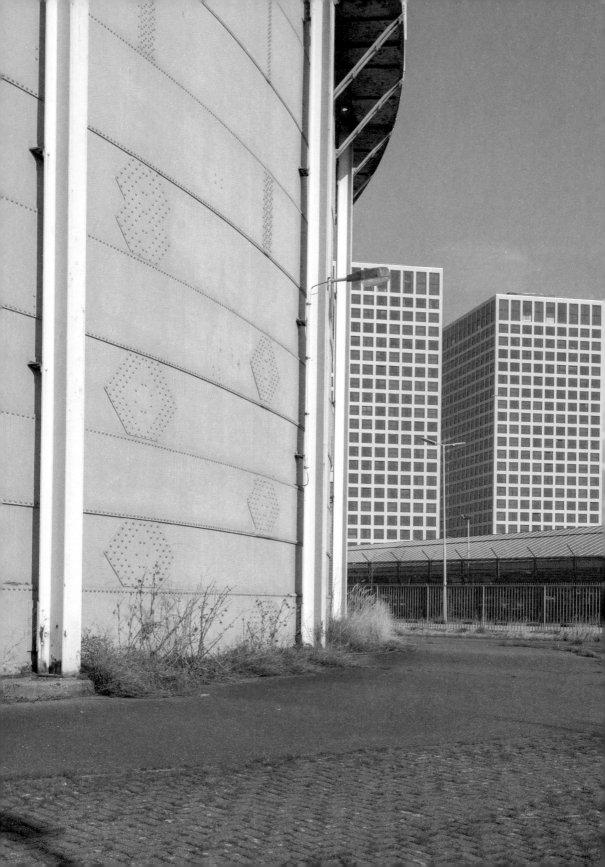

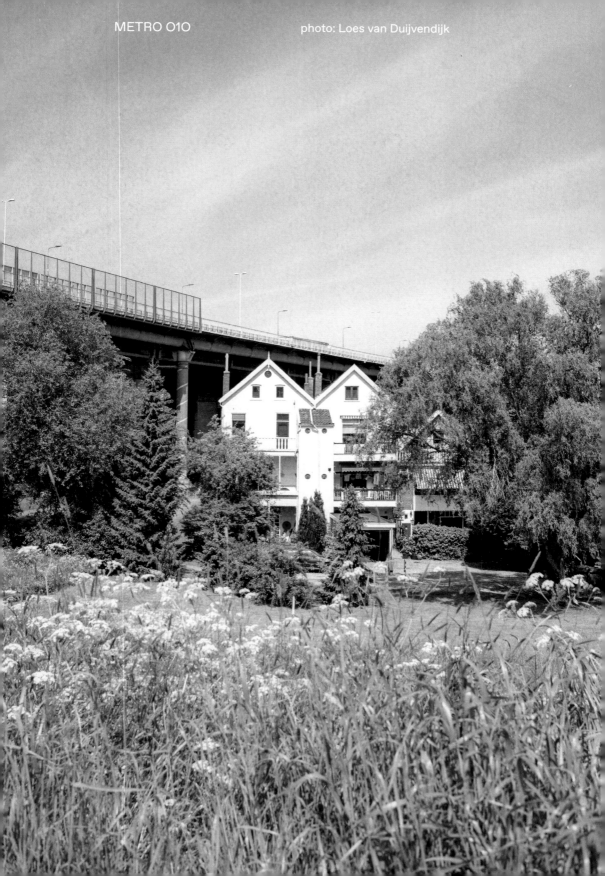

photo: Loes van Duijvendijk

for Siebe and Fedde

METRO 010

Initiator, concept & art director
Ellen Schindler

Story
Abdelkader Benali

TODAY
1270
1340
1488
1653
1653
1760
1872
1940
1945
1970
2050

Contents

Reader's guide

In front of you is *METRO O1O*. A book full of stories about Rotterdam, in words and images. It includes poetry, photos and lots of historical material from Rotterdam's archives and museums. A book to sink your teeth into or just pick up to read a chapter. This reader's guide helps you on your way and shows you where to find everything, making the book easy to read. Enjoy your voyage of discovery through the history and future of Rotterdam.

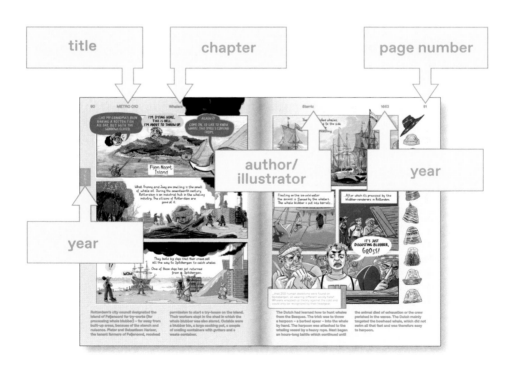

historical background
extra info on chapter

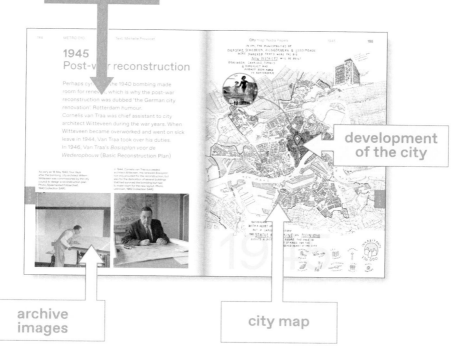

development of the city

archive images

city map

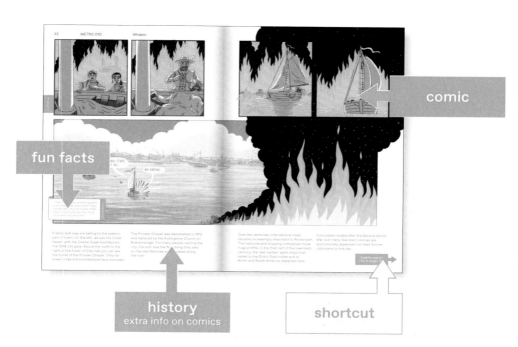

comic

fun facts

history
extra info on comics

shortcut

photo: Loes van Duijvendijk

METRO 010

Whoever you are and wherever you're from: if you love stories about Rotterdam, this book is for you. *METRO 010* is about loving the city and knowing the city. About history, architecture and culture. About important events in the past that made the city what it is today. About you and me, the city's residents. How can we learn to understand Rotterdam – our city – and make it better?

But *METRO 010* is not just a book about Rotterdam, it is also a book *by* Rotterdam. All of the cartoonists, illustrators, photographers, poets, designers, historians and writers who contributed to the book come from 'Roffa'. Born and bred or newcomer, established or upcoming artist – they've all paid tribute to the city in this book in their own unique and personal way.

The story starts far in the past, when Rotterdam was no more than a fishing village, and it ends with five future scenarios in 2050. But read it in your own way – start with the cartoons or immerse yourself in the texts; devour the book in one go or read a chapter from time to time; read it from front to back, or vice versa. Do as you like, the book is yours!

Just remember one thing: a city isn't created in a single moment, by a single person, but is made over many centuries. By all of its residents, together. And as it was in the past, so it will be in the future. You have a voice, use it!

Ellen Schindler
Stichting Ken Je Stad, Maak Je Stad
(Know Your City, Make Your City Foundation)

Everything changes, all the time

When we think about the near and far future of the city, there's one thing we know for certain: everything changes. It always will. That's why it's important to always focus on the horizon. Not just on today's horizon, but also and especially on that of tomorrow.
If we look around us, right now, we see many challenges coming our way: climate change and energy transition, shortages of available and suitable housing, the fact that the way agriculture is practised affects the city and its environs, and so on.
To make matters worse, there is always a war going on somewhere; bombs and shells destroy everything in cities and their environments, bricks as well as life. Many people lose loved ones. This is heart-breaking, but it can also inspire the people that are left behind to find the strength to rebuild their country. We already see this happening in Ukraine.

The Netherlands also experienced such impactful incidents. Of course, we immediately think of Rotterdam. The city began drawing up reconstruction plans immediately after it was bombed in 1940. A group of international experts tackled the question of how to go about the reconstruction. This group was headed by Cornelis van Traa, the director of Rotterdam's Urban Development Department at the time.
He organized meetings to find the best way to plan the reconstruction. One question Van Traa asked was extremely important: Do we want to rebuild the old city as we knew it, as it was? Or do we want to design a new city, interesting, full of meaning, leaving the horrors behind? A fresh start, a new beginning, trusting that Rotterdam will never be hit that hard again?

Van Traa and his colleagues decided on a new concept for the entire city centre – think for example about the iconic Lijnbaan. This meant urban designers, architects and members of many other disciplines were to play an important part. The population was soon involved as well. The reconstruction was not just physical. After the new city council had taken the necessary first steps, citizens also got to work. A sense of pride in their city grew among the residents. Together, they put their shoulders to the wheel.

Gradually, social developments also began to take place. This was essential, because there was a lot of suffering and pain to be overcome. Residents felt they were all in the same boat – a powerful emotion, one that helped them regain their courage and keep going.

People that live in a city must make that city themselves and help it make headway. And professionals must serve these people: this is the way to make a city that belongs to everyone.

Personally, I had the great pleasure of working on the development of the south of Rotterdam, including the plan for *Kop van Zuid*, for many years. I learned that you have to do something like that with love and attention: *with* the people and *for* the people. Together, we've proven that this can be done and that it results in something very special: a city for everyone.

Writing an introduction is no easy feat, but for this very special book I wrote one with pleasure. *METRO 010* shows how we can make a city and who we need to make it. The beautiful and convincing illustrations not only tempt you to read, but also make you want to get to work right away.

Riek Bakker
Former Director of Urban Development, Urban Planning & Housing in Rotterdam

Unlikely, but true
Somewhere in the streets of Rotterdam

'Bizarre.'

'What's bizarre?'

'This story is.'

'So what're you reading?'

'METRO 010. A journey through time.
The unlikely, but true story of the city of Rotterdam.'

'That does sound bizarre.
Tell me!'

'Do you want the long or the short story?'

'The short one, of course.
If I want the long one,
I'll read the book.'

'Boy and girl meet for a blind date.'

'Oh. Romance!'

'Sort of. Pretty bizarre.'

'What's bizarre?'

'So, listen. They enter a café, drink something,
have a chat.'

'I'm telling you: romance!'

'No, there's no click. Or a small one. Anyway: they
walk towards the metro. And that's when the story
begins. The metro to Zuidplein turns out to be a kind
of time machine.'

'The metro a time machine?
Impossible! I'm in luck if the
metro leaves on time.'

'You have to read the book to get it. There's this
physical phenomenon that makes time and space collide.
It creates a hole in the universe, by which the two are
catapulted into the distant past.'

 '. . .'

'What're you doing?'

 'Let me just get the book.
 Oh wow, it's a graphic novel.
 Why didn't you say so.'

'That's my book!.'

 'I can borrow it, right?'

'I haven't even finished it myself, yet. It's full of
information about Rotterdam.'

 'About the war and stuff?'

'Yes, that too. But about more, much more. For once,
history doesn't start with the 1940 bombing, but with
the city's early beginnings in 1270.'

 '1270? What happened in 1270?'

'The first dam in the Rotte River happened. There's this
girl who manages to prevent a flood by cleverly using
'het puntertje van Rotterdam': a small wooden craft
that has been preserved and is now actually on show in
the city.'

 'Interesting. Is there anything
 in it about Feijenoord?'

'You mean the district?'

 'No, the football club of course.'

'The club is mentioned a couple of times, but it's
mainly about the district the club was named after.
In the seventeenth century, Feijenoord was an island.
On it was a factory in which whales caught off Greenland
and Svalbard were cut into pieces and boiled. The oil
was used for fuel.'

'. . .'
'Hey you. Are you still listening?'

> 'Sorry, I was just leafing
> through the book. This is all
> so cool!'

'By the way, it's not only about history. It's also about the future of Rotterdam. About our future. What will the city look like in 2050? How will we live? And what will we do in the city?'

> 'Science fiction.
> Electrical cars everywhere.'

'As long as a war doesn't break out.'

> 'I'll never leave Rotterdam.'

'Me, neither. That's what the book is about as well. About all those people who came to Rotterdam for a better future.'

> 'Maybe there's something in it
> about my ancestors. They once
> came from afar.'

'Who knows. I'm sure you're gonna love this book. Hey, where are you going?'

> 'I'm gonna sit down on that
> bench right there and read
> some more. Your story makes
> me curious.'

'But that's my book.'

> 'I'll get it back to you when
> I'm finished. Promise!'

Today
Franny & Joey

The city is never complete. Every generation, every century changes the city. Districts are added, buildings demolished. Railway tracks, canals and roads are built; dwellings, churches, shops constructed. Sometimes this happens because the economy or society requires it, sometimes simply because the wishes or tastes of a city's residents change. But the city of yesterday remains visible in the city of today at all times.

This is also true of Rotterdam. The city has existed for more than 750 years, but no building in the city is that old. Yet its first traces, the very first places in which Rotterdam began, can still be found in the city of today. The choices made by Rotterdammers over the centuries are still visible. Whether they constructed a dam, laid out a railway line or a port, made a dwelling for themselves or built the tallest building in the country: all of these traces of history together make up Rotterdam as we know it today.

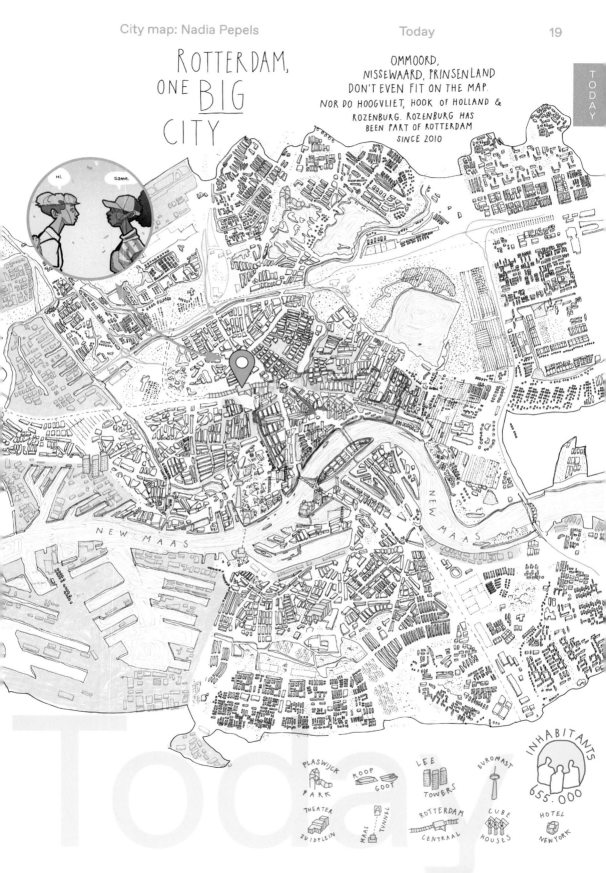

TODAY

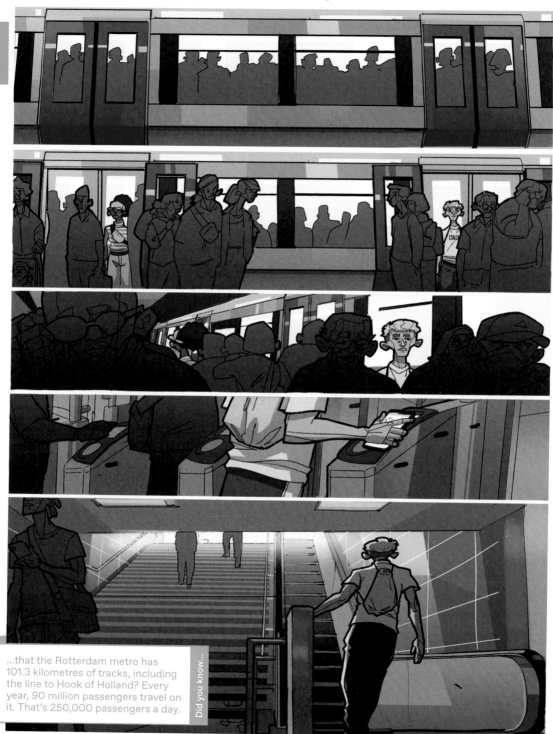

Did you know...

...that the Rotterdam metro has 101.3 kilometres of tracks, including the line to Hook of Holland? Every year, 90 million passengers travel on it. That's 250,000 passengers a day.

Beurs is Rotterdam's most important metro stop, because it is where the lines cross. On 9 February 1968, the platforms on the North-South Line opened. Those for the East-West Line had already been prepared. On 6 May 1982, that line was opened as well. About 130,000 passengers board or change metros at Beurs every day.

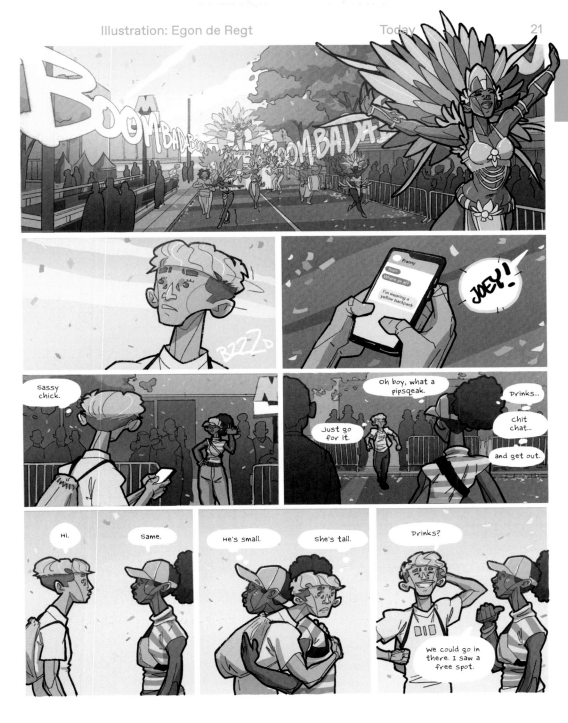

The Summer Carnival in Rotterdam has been an annual spectacle since 1984. From a small cultural, artistic group consisting of Curaçao and Aruban carnival revellers, it grew into a multicultural melting pot. The tropical event became so popular that not only Antilleans, but also people from Brazil, Cape Verde, Suriname, Bolivia, Colombia, Peru, the Dominican Republic, Mexico, the Windward Islands, Spain, England, Trinidad, Jamaica, Angola, France, Germany, Belgium and the Netherlands decided to participate.

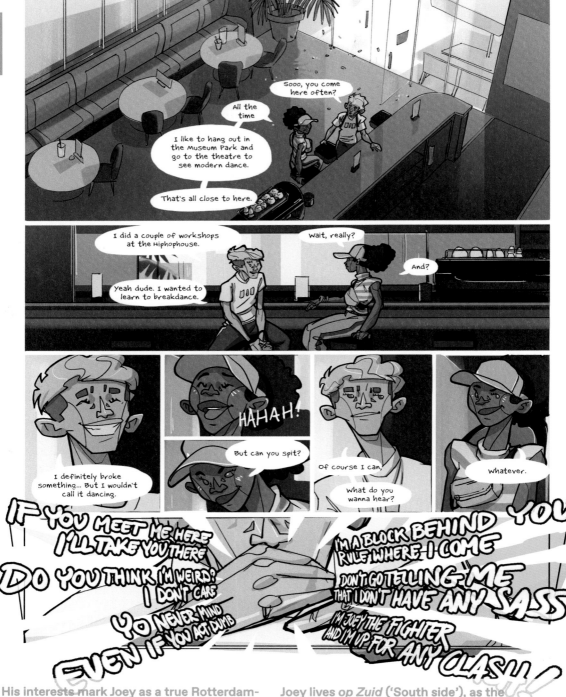

His interests mark Joey as a true Rotterdammer. As a boy from the *Boerenzij* (Peasant Side), he's taken Feyenoord to his heart. *Boerenzij* is the old nickname for Rotterdam-Zuid, because of the migrants from rural Holland, southern Europe, Morocco, Turkey and other countries living there.

Joey lives *op Zuid* ('South side'), as the Rotterdammers say, and loves technology and spitting rhymes. Rotterdam-Zuid has a heritage of machine and shipbuilding, of logistics and 'making'. Joey may well become the new Leen van der Vlugt, the designer of the De Kuip Stadium in the 1930s.

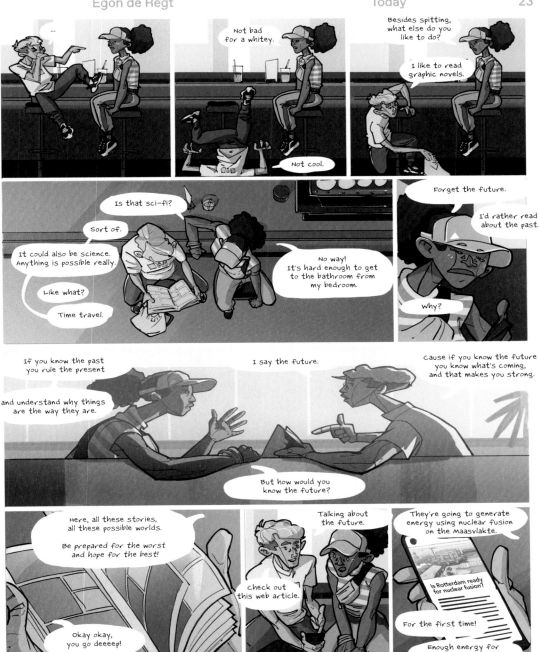

Without the Rotterdammers, there would be no Franny, either. Not only because she and her parents were born here, but also because her family has a Surinamese background. Without the slave trade, in which Rotterdam entrepreneurs played an important part, her family would never have ended up here.

The diversity of today's Rotterdam has everything to do with the many migrants who, over many centuries, have come to Rotterdam from all corners of the world in search of a better life. This is how 'Rotown' has been able to grow into a global city.

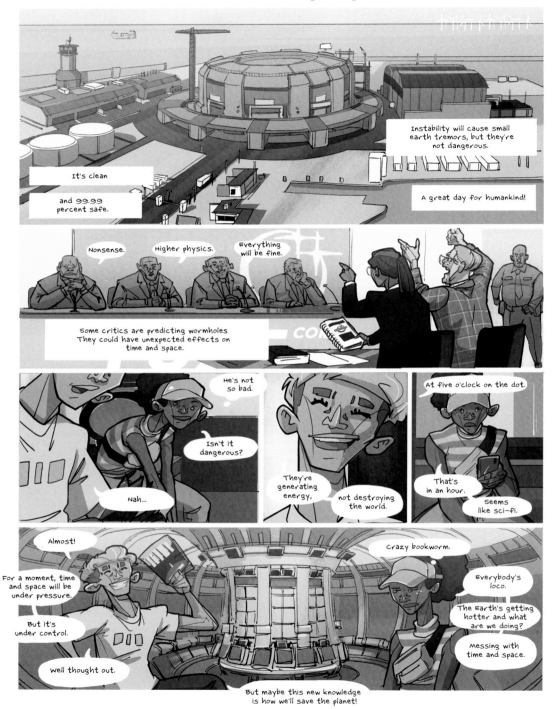

This type of nuclear fusion power plant is science fiction for now. In January 2022, scholars in England managed to sustain a controlled nuclear fusion process for five seconds. Nothing new has happened since.

The first commercial nuclear fusion power plant is not expected to be operational until after 2050.

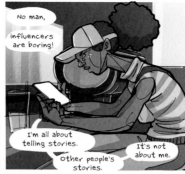

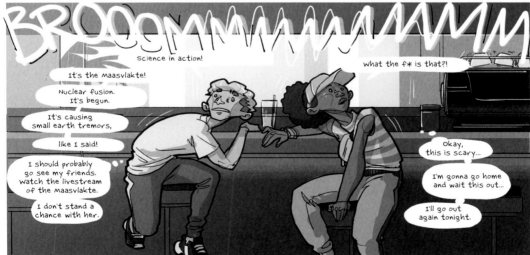

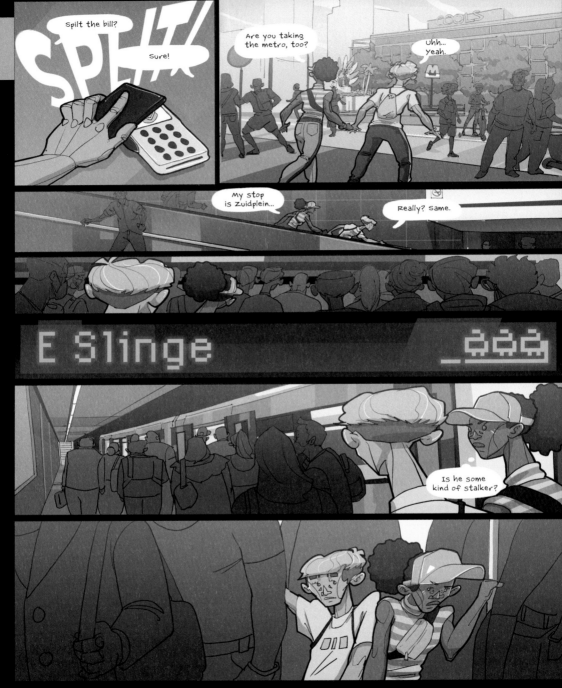

The metro connection from Rotterdam Central Station to Zuidplein opened in 1968 and was the first in the Netherlands. There used to be emergency housing for bombing victims known as Het Brabantse Dorp in this area. After Zuidplein comes Slinge, where you can get off to experience the atmosphere of the 1950s. The area includes Zuidwijk, designed by the famous architects Willem van Tijen and Gerrit Rietveld. Nearby is Lotte Stam-Beese's brainchild Pendrecht. At the time, nothing was more important than building social housing: practical flats with large windows and ringed by greenery.

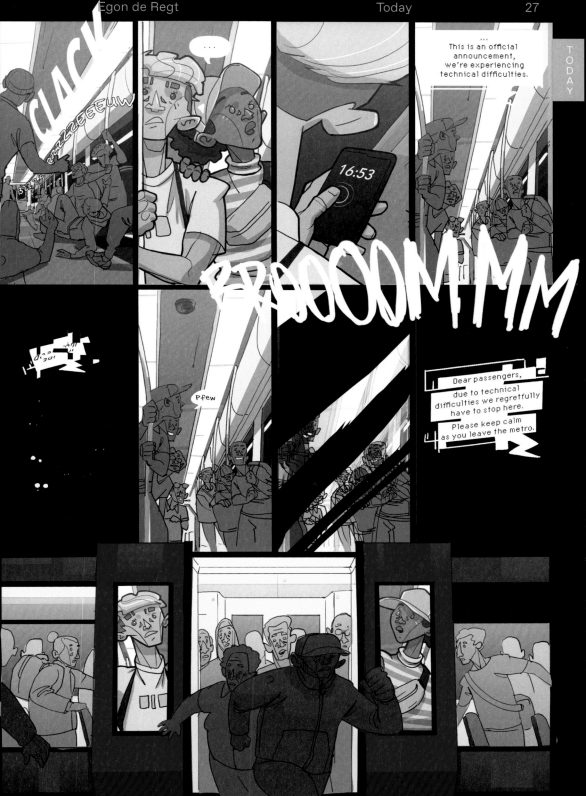

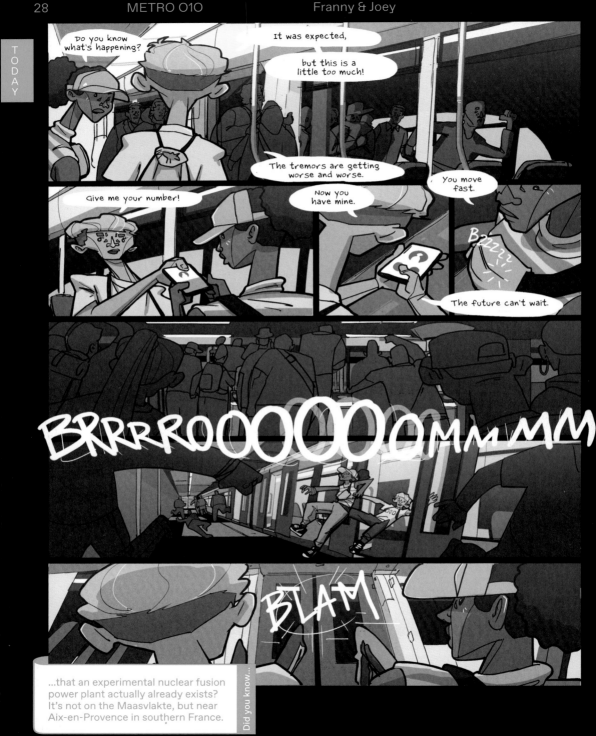

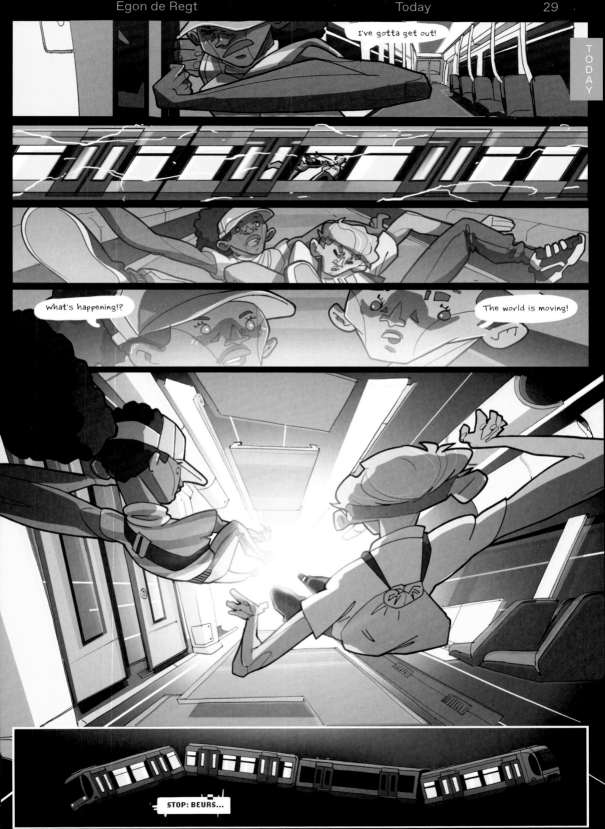

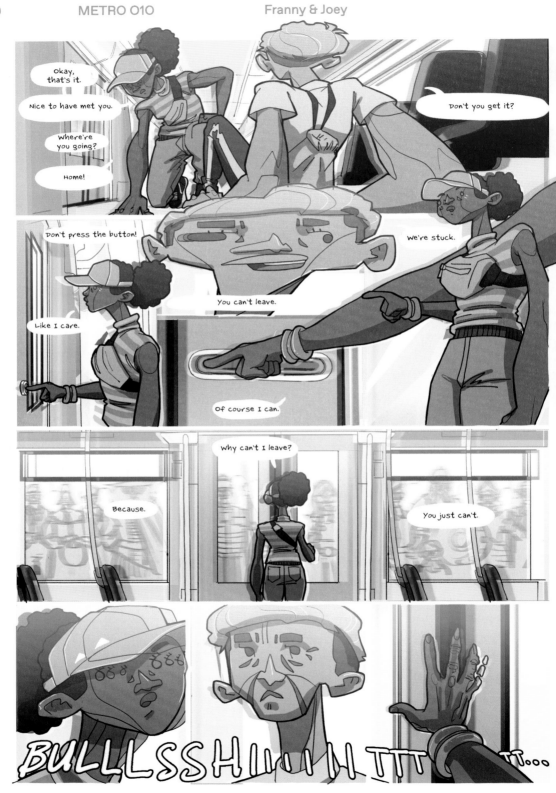

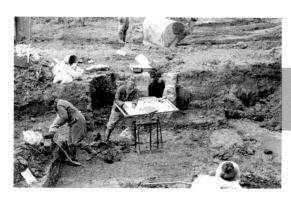

→ Archaeologists at work at the one-time location of the dam in the Rotte during the construction of the Willems railway tunnel. Photo, A. de Herder, 1990 (SAR collection).

↓ This is how the punt looked when the archaeologists found it.
1991 (BOOR Archaeology collection).

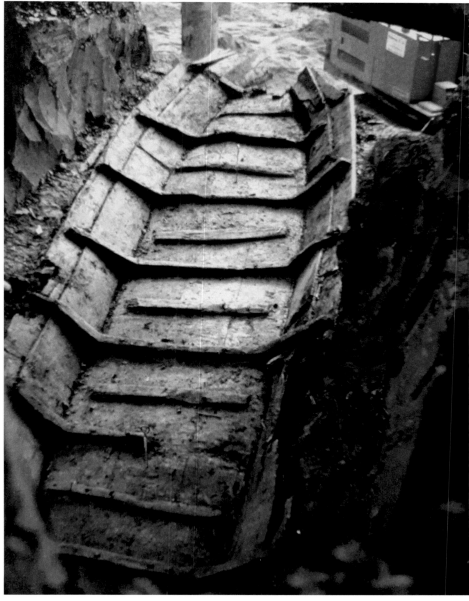

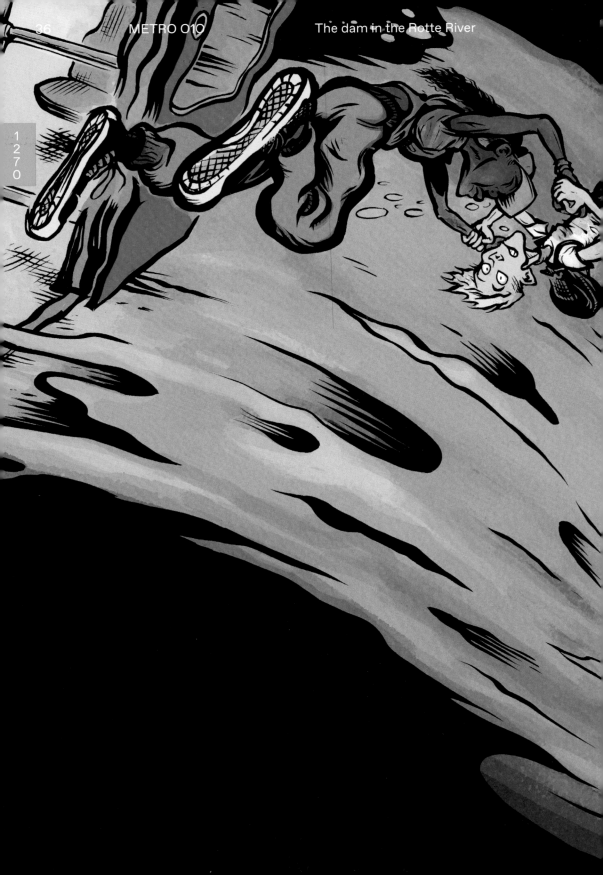

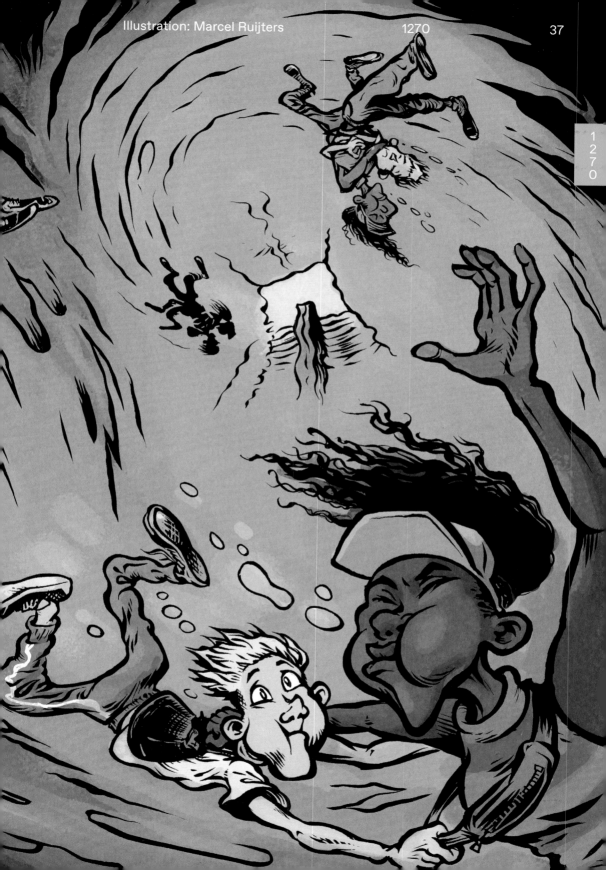

1270

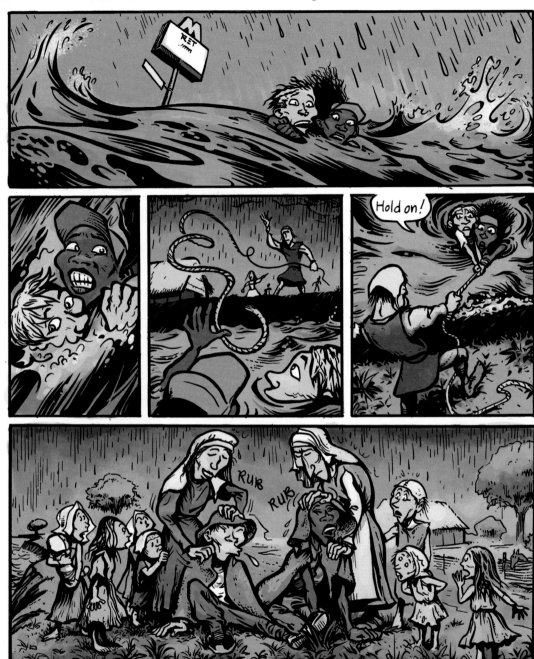

The dam in the Rotte River where Franny and Joey are pulled onto dry land was built by order of Lord Ghisebrecht Bokel, a nobleman. His family owned the Hof van Wena and Slot Bulgersteyn. An avenue is named after him in Hillegersberg and he is also the name giver of the Bokels Dijk, now Beukelsdijk, in the Nieuwe Westen district. Beukelsdijk is part of an old sea dike that was built in the twelfth century.

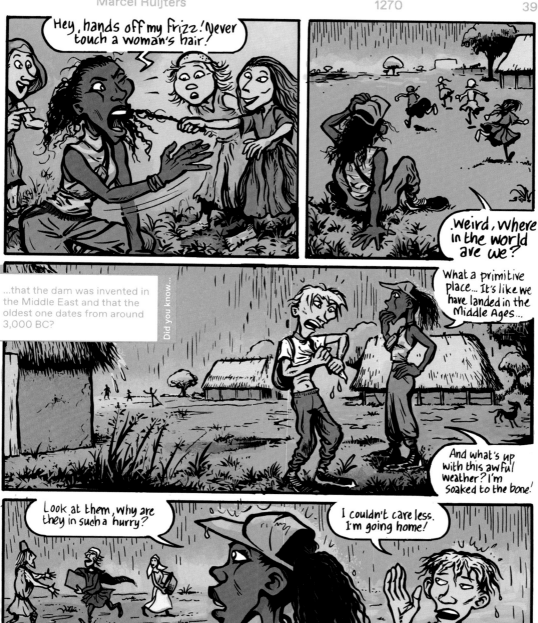

1
2
7
0

Franny is lucky that, as a 'newcomer of colour', she is immediately accepted by the residents of the Rotte settlement. They can use her help, because there's work to be done. In the Middle Ages, hardly anyone in the Netherlands had ever seen a person with a dark skin or frizzy hair.

Only a pilgrim or crusader might have come across a knight converted to Christianity from Nubia (now northern Sudan) in Palestine, or an African Muslim in transit to Mecca.

1270

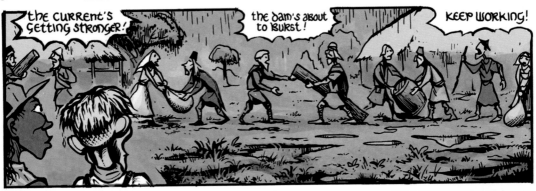

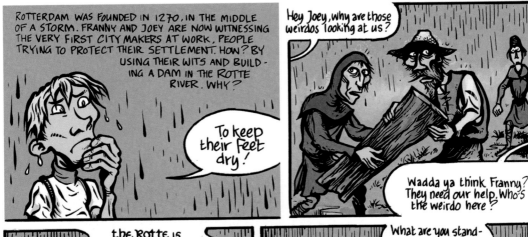

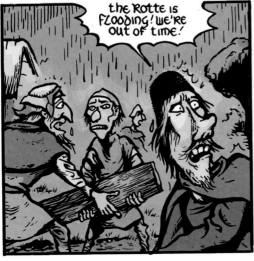

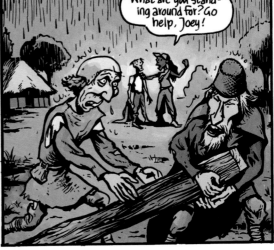

In the Middle Ages, when a flood loomed, everyone – man, woman, child – had to help protect the dikes and dams. Initially, every local resident was obliged to maintain an individual section of dike. This didn't always work out well. Count Floris V of Holland therefore decided that people would have to do all of the work together. During storms and spring tides, it would be a matter of all hands to the pump. Count Floris V was also the founder of the Hoogheemraadschap van Schieland (District Water Board of Schieland). This dates from 1273 and exists to this day.

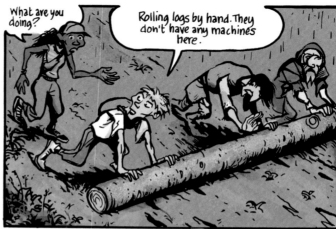

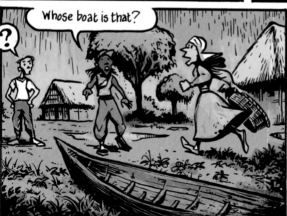

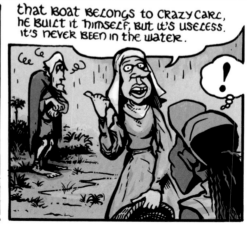

Gekke Karel ('Crazy Carl') simply lived among the population, which was not exceptional in the Middle Ages. People with mental disabilities were considered 'creatures of God'. They were teased, but also protected by the community. The first 'madhouse' in the Netherlands was built in 1442 in 's-Hertogenbosch. In 1596, Rotterdam also built a 'madhouse' in which the mentally ill were locked up. As if it were a zoo, people could come over and look at the 'mad people' for a fee.

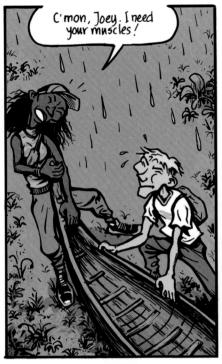

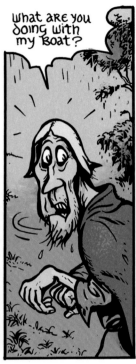

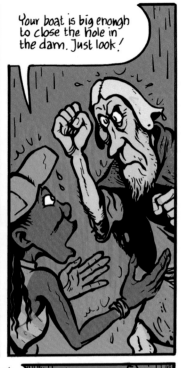

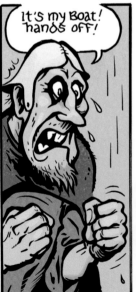

Good thinking by Franny! Who knows, she may have learned in history class that Rotterdam was spared from an all-consuming flood during the North Sea Flood Disaster of 1 February 1953 in a similar way. On that night, boatman Arie Evegroen, by order of mayor Vogelaar, placed the bow of his 18-metre-long ship *De Twee Gebroeders* in the dike near Nieuwerkerk aan den IJssel. By doing so, he saved millions of people in the Randstad from drowning.

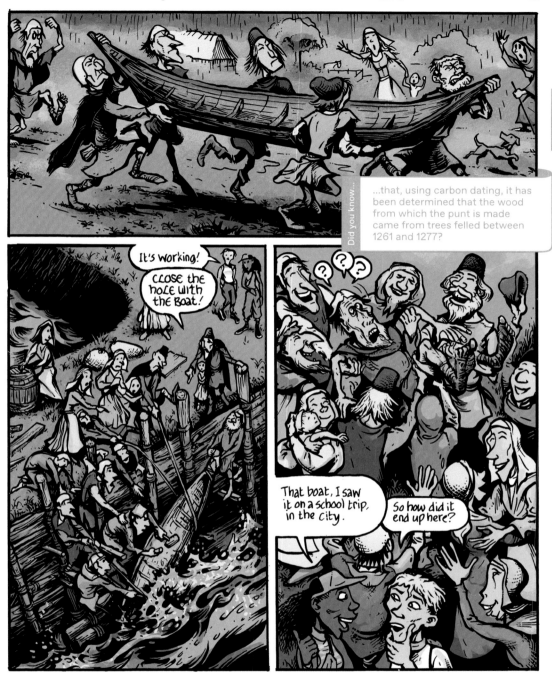

Around 1270, the Rotte River was dammed up to prevent the Maas River from flooding. This dam still exists: it's 400 metres long and 45 metres wide and is hidden underneath the Hoogstraat in Rotterdam, between the Koopgoot and the Rotterdam Public Library. During the construction of the Willems railway tunnel, a startling find was made at this location. Ten metres below the Binnenrotte River, archaeologists found a small wooden craft, a so-called punt. The theory is that people sank this small craft at the time to fill the last hole in the dam.

1270

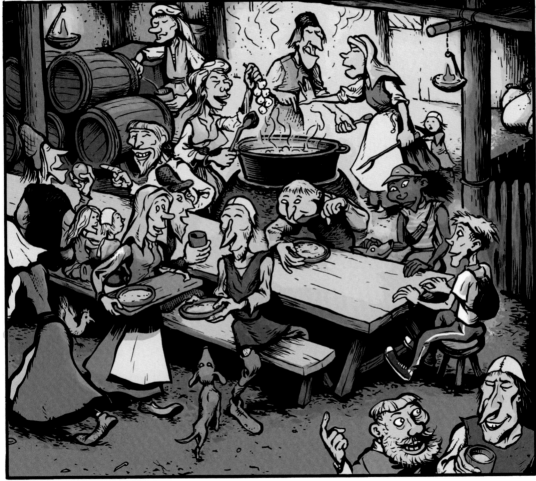

Is that pea soup simmering in that black pot? Peas and beans were the staple food for ordinary people in the Middle Ages, alongside cabbage, leeks, turnips and onions. Rotterdammers caught a lot of fish in the nearby rivers. They liked to make stews and ate with their hands. For cutting meat and poultry – a great luxury – they used their own knives. Rich people would also eat swan or heron. Potatoes were unknown back then: these originate in South America and only became popular food in the Netherlands after 1750.

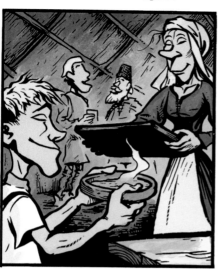

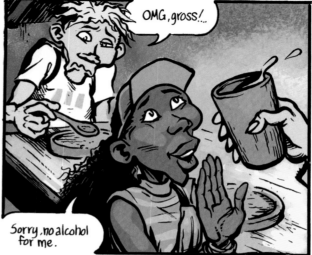

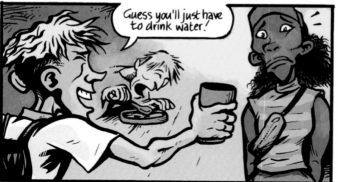

In the Middle Ages, people brewed their own beer from hops, adding spice mixtures for preservation purposes. The alcohol content was low. From the fourteenth century, breweries began to settle in Rotterdam. The modern yellow, frothy beer was not invented until much later, in 1842 in Pilsen in the Czech Republic.

Did you know... ...that it was quite common for children to drink beer in the Middle Ages, because the water was often polluted?

1270

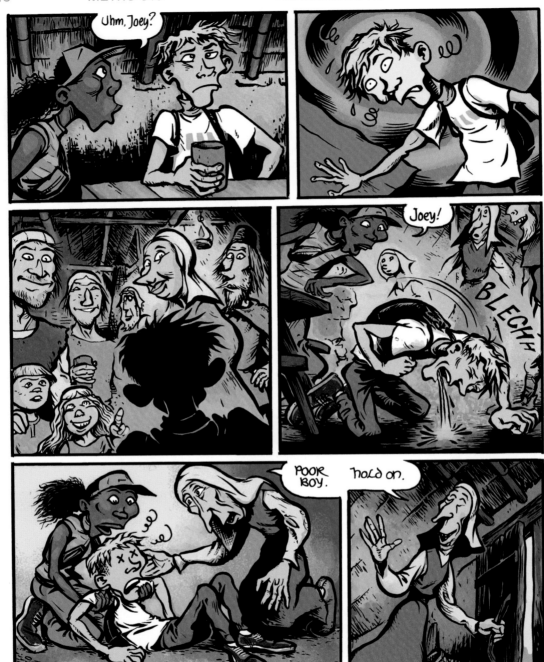

People in the Middle Ages knew a lot about medicinal herbs. In the twelfth century, the nun Hildegard von Bingen wrote a book on the subject called *Causae et Curae* (Causes and Cures) that is still in use today. Hildegard had many talents: she not only wrote about herbs, but also about religion, science, philosophy and music. She's the first female composer in history we know by name.

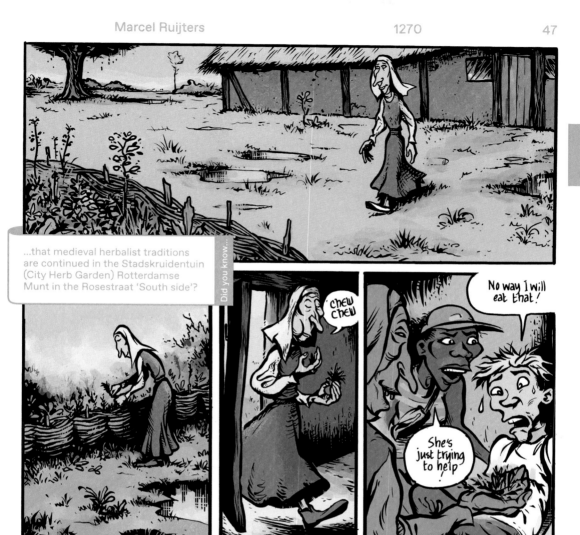

...that medieval herbalist traditions are continued in the Stadskruidentuin (City Herb Garden) Rotterdamse Munt in the Rosestraat 'South side'?

Did you know...

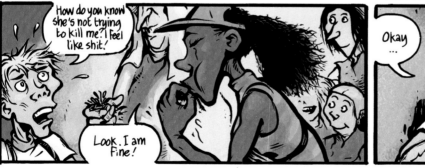

The herbalist must have given Joey chamomile, or mug wort. This crop still abundantly grows in the wild. To this day, there are herbalists who treat and sometimes even cure minor and major discomforts using herbs that in many cases just grow in the environment: nettles, dandelions, daisies.

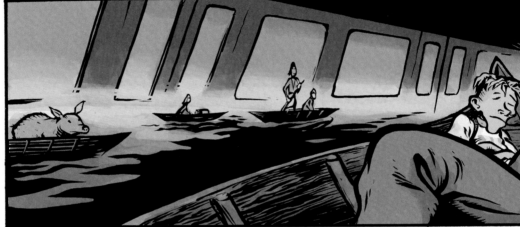

In the thirteenth century, the Rotte River ran through what is currently the centre of Rotterdam. The original name was probably Rotta, derived from *rot*, meaning muddy or turbid, and *a*, meaning water. In 1871, part of the Rotte River, the Binnenrotte, was filled in for the construction of a railway viaduct. Outside the city, the Rotte flows like a real river to this day; its source is 22 kilometres north of Rotterdam.

In the thirteenth century, the dam in the Rotte was located where the Hoogstraat is now, in or near the location of the Markthal. Only the area up to Oppert had buildings in it at the time, nothing more. So Franny and Joey must have boarded at metro stop Blaak, on their way to metro stop Stadhuis.

Fast forward?
Go to page 54

1340
City rights

Once the dam had been closed, Rotterdam grew rapidly. It was not yet a city: it didn't have official city privileges like Schiedam, Delft and Dordrecht. In 1299, the town was first granted city privileges by nobleman Wolfert van Borselen, but Wolfert was murdered and the city privileges were subsequently withdrawn.

In 1340 the time had come. William IV, count of Holland and Henegouwen, definitively granted city privileges to Rotterdam, which had about 2,000 residents at that time.
Rotterdam was now allowed to start building city walls and to dig canals. The entrance to its port was protected by two towers on either side. The city was also allowed to dig the Rotterdam Schie, a canal connecting Overschie and the spot in which Hofplein is now located.

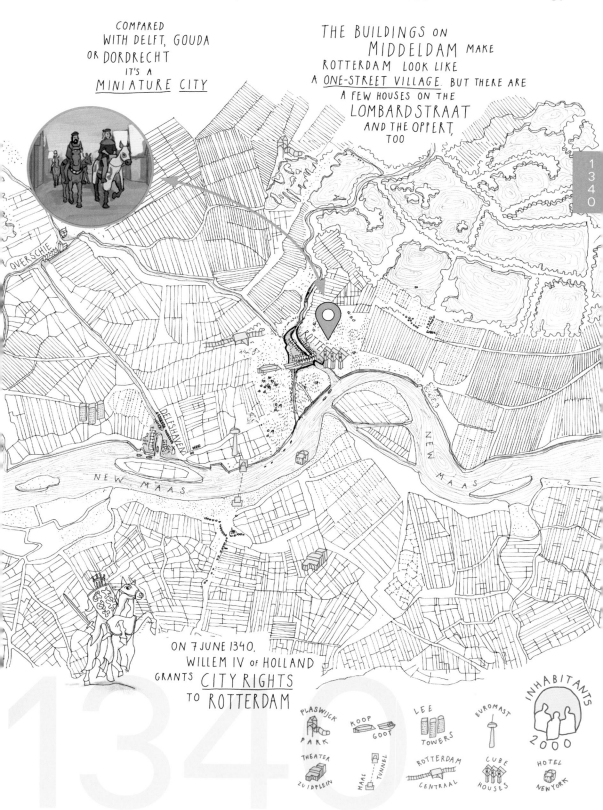

COMPARED WITH DELFT, GOUDA OR DORDRECHT IT'S A MINIATURE CITY

THE BUILDINGS ON MIDDELDAM MAKE ROTTERDAM LOOK LIKE A ONE-STREET VILLAGE. BUT THERE ARE A FEW HOUSES ON THE LOMBARDSTRAAT AND THE OPPERT, TOO

1340

OVERSCHIE

DELFSHAVEN

NEW MAAS

NEW MAAS

ON 7 JUNE 1340, WILLEM IV OF HOLLAND GRANTS CITY RIGHTS TO ROTTERDAM

1340

PLASWIJCK PARK

KOOP GOOT

LEE TOWERS

EUROMAST

INHABITANTS 2000

THEATER ZUIDPLEIN

MAAS TUNNEL

ROTTERDAM CENTRAAL

CUBE HOUSES

HOTEL NEWYORK

1
3
4
0

This meant vessels could reach the main water connections that intersected the county of Holland. Rotterdam grew into a notable trade and fishing city. Delft received permission to dig a similar canal, the Delfshavense Schie. Where the Schie canal flows into the Maas River, Delft founded a port called Delfshaven. For centuries, this was a distant suburb of Delft. Much of historical Delfshaven has been preserved.

Map of Rotterdam in 1340, based on research and excavations. You can see two streets on either side of the Rotte, leading to the Hoogstraat, with the river dam in the middle. D. Weynand and C. Hoek, 1990 (collection SAR).

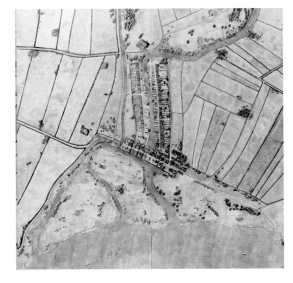

This bunch of keys was found during excavations; they may well be the oldest keys in the city. Circa 1400 (collection MBVB).

Commemorative coin De Porter, issued for Rotterdam's 650th anniversary (1340-1990). 1990 (collection MR).

On 7 June 1340, Rotterdam definitively received city privileges, as recorded in this deed. 1340 (collection SAR).

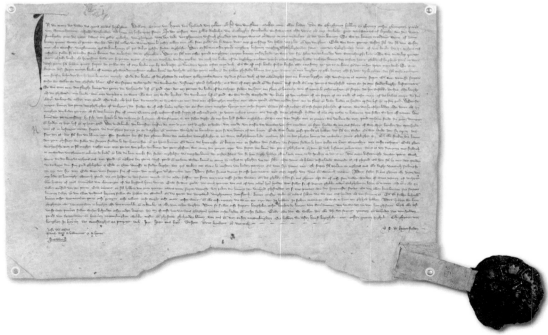

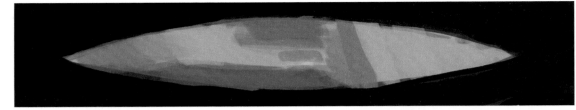

1340

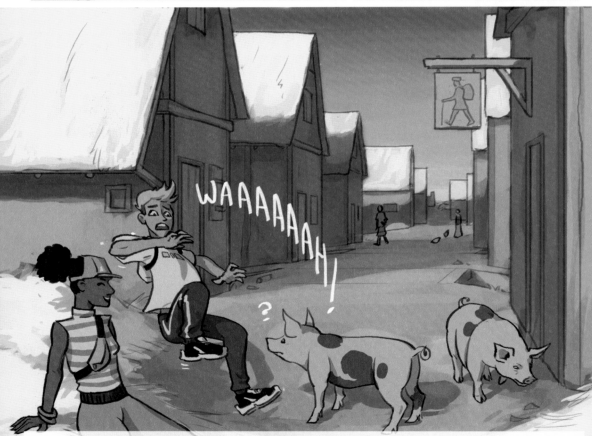

People kept their livestock at the back of the house. Pigs roamed the streets; you were allowed to have a maximum of two running around. Chimneys didn't yet exist, but smoke holes did. There were also pubs back then. This sign may refer to Calais, the oldest pub in Rotterdam's history, where itinerant merchants and fishermen came to drink and play dice. Famous inns in later times include Het Zwijnshoofd, De Spiegel and De Dubbelde Witte Sleutels.

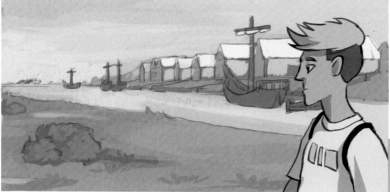

1340

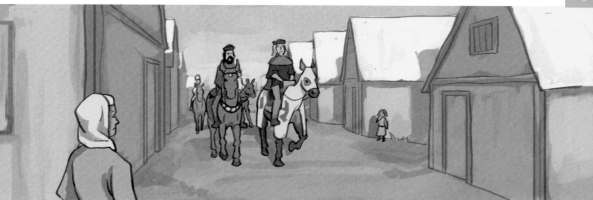

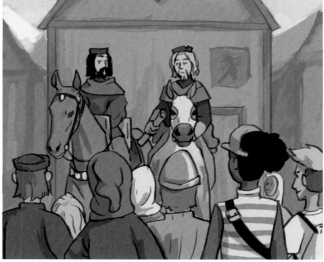

On 7 June 1340, Count William IV granted city privileges to Rotterdam. The original deed is still kept in the Rotterdam City Archives. The Rotterdammers received the right to make their own laws and build canals and ramparts. They no longer had to pay tolls, were exempt from taxes and allowed to hold annual fairs. In return, there were obligations: the city had to provide Count William with free lodgings and supply soldiers at his request and, in case of a naval war, even a cog with 26 men.

1340

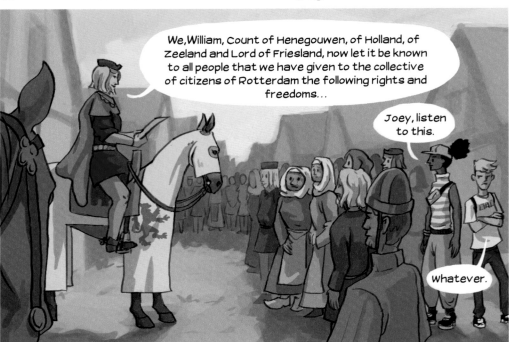

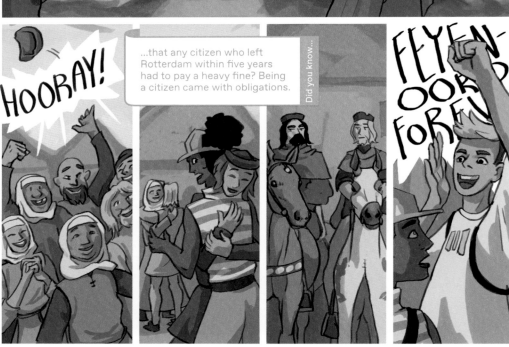

Count William IV sold city privileges left and right on a large scale. He was known as William the Bold and appears to have been quite the bloodthirsty fanatic. He needed a lot of money for his passion, which was going on crusades. As a young man, he travelled to Jerusalem as a pilgrim and fought the Muslims in Spain. Later, he went to war against the pagan Lithuanians and Prussians. In 1345, William IV fell near Warns, a village in south-west Friesland, in battle against the Frisians. His sculpture now sits in front of the Schieland House.

Hey!

Quiet, you loudmouth.

Let go of me!

Just look!

1340

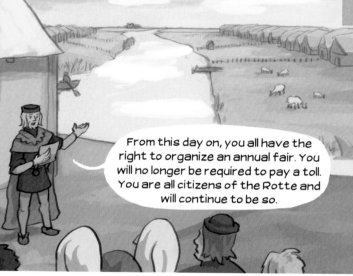

From this day on, you all have the right to organize an annual fair. You will no longer be required to pay a toll. You are all citizens of the Rotte and will continue to be so.

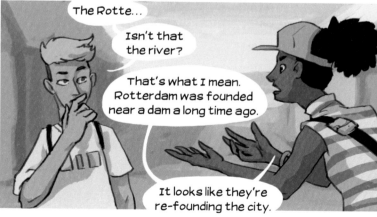

The Rotte...

Isn't that the river?

That's what I mean. Rotterdam was founded near a dam a long time ago.

It looks like they're re-founding the city.

Seems like a boring re-enactment! There are better ones on Youtube.

You could become a *poorter* (citizen) of Rotterdam by paying ten sixpence or by providing 3,000 bricks for the construction of the Saint Laurens Church. In 1350, Rotterdam already had a parish church without a tower, dedicated to Saint Laurentius and Magdalena, on the site of the current choir of the Laurens Church. Construction of the tower began in 1449. At the end of the fifteenth century, the church was completed. In the Middle Ages, people were in much less of a hurry than we are today.

1340

Many people contracted serious diseases from fleas and other pests. Fleas transmitted the plague bacillus from rats to humans. It is estimated that between 1346 and 1352, a third of all Europeans died during a major plague pandemic – several tens of millions of people. Today, plague can be quickly cured with antibiotics. The first antibiotic, penicillin, was developed in 1928.

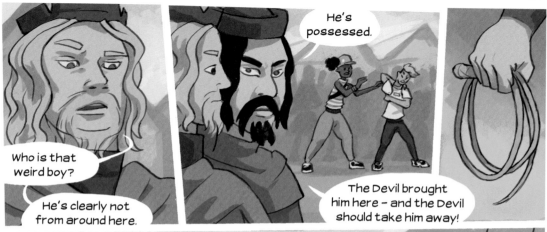

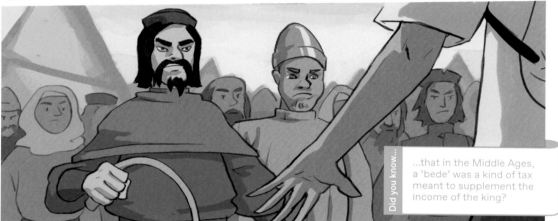

Did you know...

...that in the Middle Ages, a 'bede' was a kind of tax meant to supplement the income of the king?

In the Middle Ages, people believed that the devil was always up and about trying to undo God's work. The church constantly warned about the devil and his works. People really believed they could be possessed by the devil. If this happened, the latter had to be cast out by a priest. Things could get hairy if people thought you were in the devil's service. Witches and heretics were burned at the stake. Luckily, Franny and Joey managed to keep their attackers at bay: club songs like that can work wonders!

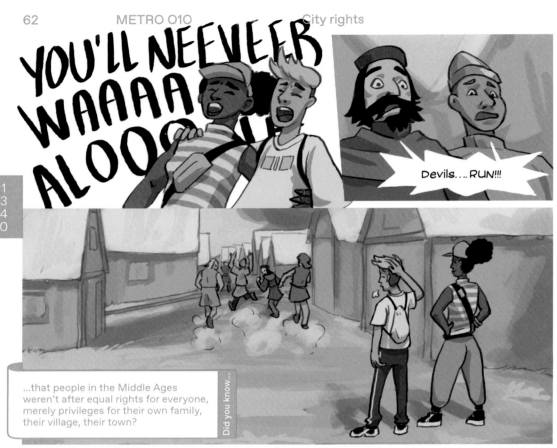

In the Middle Ages, many people thought that diseases were a punishment from God, spread by evil vapours. They tried to stop epidemics through lockdowns and isolation, just like in times of Covid-19, but in those days medical science was also inextricably linked to faith. Patients had to be quarantined for exactly forty days: that's how long the Lent lasts that precedes the feast of Easter, marked by the death and resurrection of Jesus Christ.

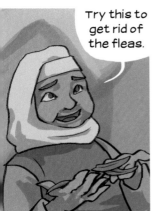

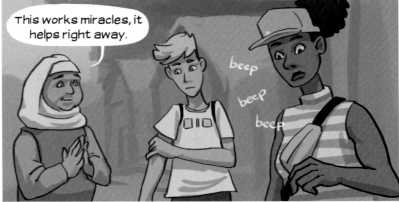

The citizens of Rotterdam were not allowed to loiter on the streets at night without purpose. The daredevils of the day snuck out to cemeteries to play ball games, drink wine and beer or meet their lovers. Those who were caught brawling in the pub, young or old, were fined heavily. There were so-called 'stoven' in which men and women could socialize together sitting in hot water during the day, but these had to close after dark. So back then there was a kind of curfew.

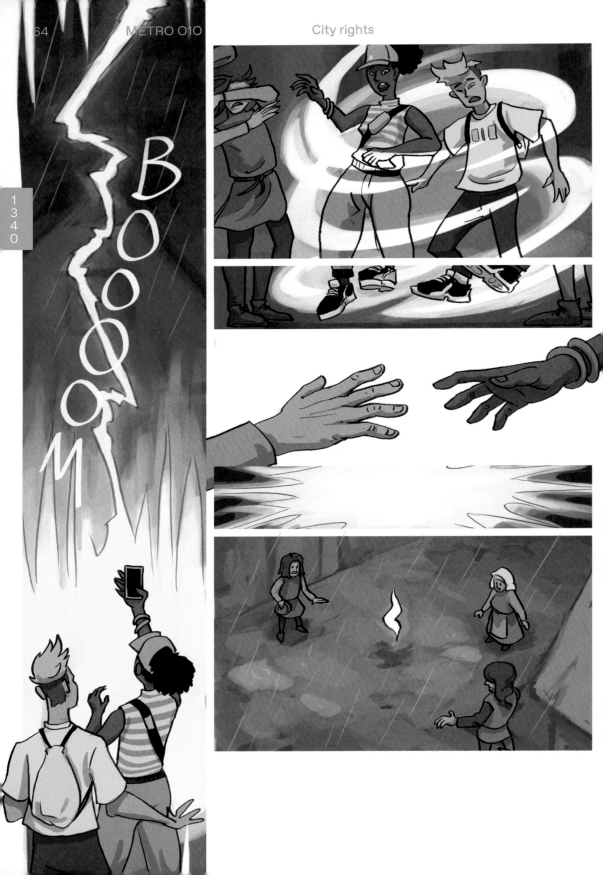

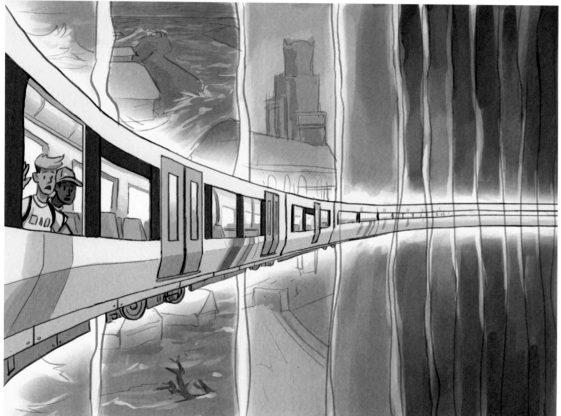

In the Middle Ages, most people thought that violent natural phenomena were a warning from God. When lightning struck or a comet was seen, they feared the Last Judgement. Epidemics, major fires and floods were also considered signs from above.

God also warned sinful people with all kinds of freaks of nature. If a calf or lamb with two heads or five legs was born somewhere, monks would write it down meticulously in their monastery chronicles.

Fast forward? Go to page 70

1488
Jonker Frans's reign of terror

Sometimes something unexpected happens with devastating effects. One example is the 1940 bombing; another the campaign of Jonker Frans van Brederode in 1488 (*jonker* is the Dutch name for a squire). This nobleman was only 22 years old when he dropped out of law school and took on the then-overlord of the Netherlands, Maximilian of Austria, with a pirate fleet and 850 soldiers. It was a mad thing to do, because he faced one of Europe's most powerful rulers.

Jonker Frans's campaign was one result of the Hook and Cod wars, which had been going on for almost a century and a half. Jonker Frans was with the Hooks. The dispute was about the right to govern the counties of Holland and Zeeland. Most of the city council members were Cods, while the Hooks had more supporters among the nobility. The Cods had named themselves after the predatory fish of the same name; the Hooks after the hooks used to catch cod. Both parties had their own songs and slogans.

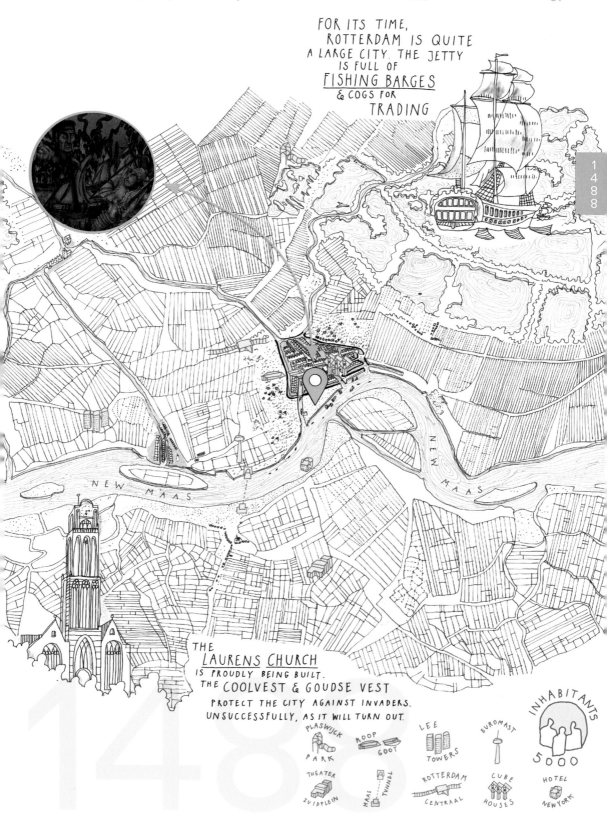

FOR ITS TIME,
ROTTERDAM IS QUITE
A LARGE CITY. THE JETTY
IS FULL OF
FISHING BARGES
& COGS FOR
TRADING

1488

NEW MAAS

NEW MAAS

THE
LAURENS CHURCH
IS PROUDLY BEING BUILT.
THE **COOLVEST & GOUDSE VEST**
PROTECT THE CITY AGAINST INVADERS.
UNSUCCESSFULLY, AS IT WILL TURN OUT.

PLASWIJCK PARK

KOOP GOOT

LEE TOWERS

EUROMAST

INHABITANTS
5000

THEATER ZUIDPLEIN

MAAS TUNNEL

ROTTERDAM CENTRAAL

CUBE HOUSES

HOTEL NEWYORK

There was a sharp frost in the air on the day Jonker Frans appeared before the city with his gang of Hooks on 18 November 1488. This allowed him to march into Rotterdam over the ice of the Coolvest (now Coolsingel). The Cods were robbed of their possessions and chased out of town.
All remaining residents, women and children included, had to build fortifications in the freezing cold. Delfshaven was burned to the ground.

Maximilian of Austria ordered Stadholder Jan van Egmond (his deputy in Holland) to make short

This engraving has gone down in history as a true image of Jonker Frans, but it was made more than two centuries after he died. Engraving, François van Bleyswijck, 1724. (collection MR).

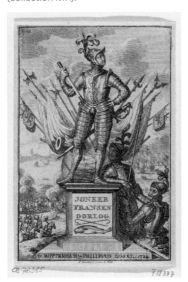

Map of the three Schies (water-courses). Top left Rotterdam, top right Delfshaven and in the foreground Overschie. 1512 (collection NA).

work of Jonker Frans and his gang. They stopped food shipments to Rotterdam, causing famine. Next, they laid siege to the city. On 22 June 1489, negotiations took place in City Hall, while the Rotterdammers were at the door begging Jonker Frans to give up. He demanded a free retreat for himself and his men. One year later, Jonker Frans was wounded and captured. He died in 1490, locked up in a Dordrecht dungeon, at the age of 24. Delfshaven was rebuilt in the sixteenth century. Thanks to herring fishing and whaling, it grew into a prosperous town with about 1,000 residents.

Portrait of Maximilian I. It was quite absurd of Jonker Frans to go up against such an important ruler: Maximilian of Austria, the father of Charles V. Painting, Albrecht Dürer, 1519 (collection Kunsthistorisches Museum, Vienna).

A super-canon from the time of Jonker Frans. Very few such canons survived, as they had a tendency to break after a couple of shots. This one is preserved in Middelburg.

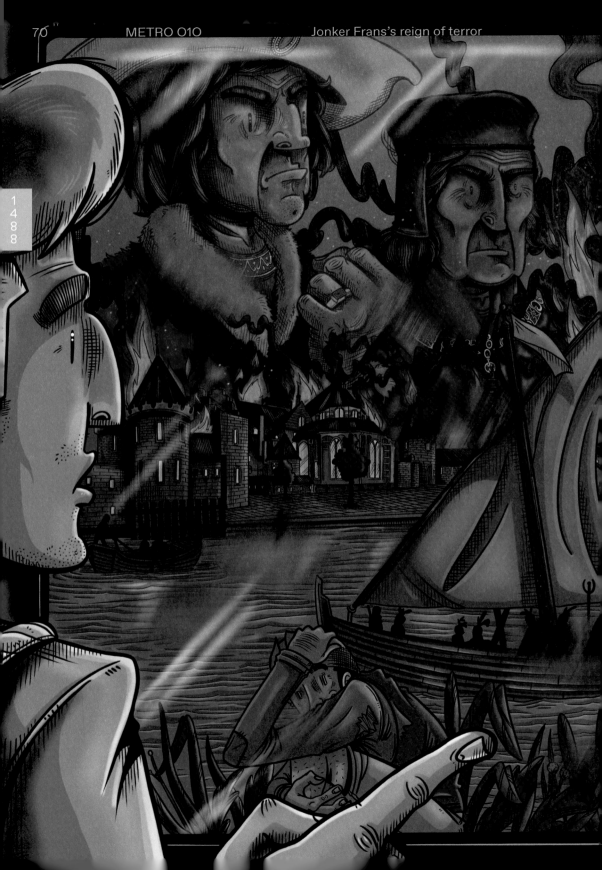

1488

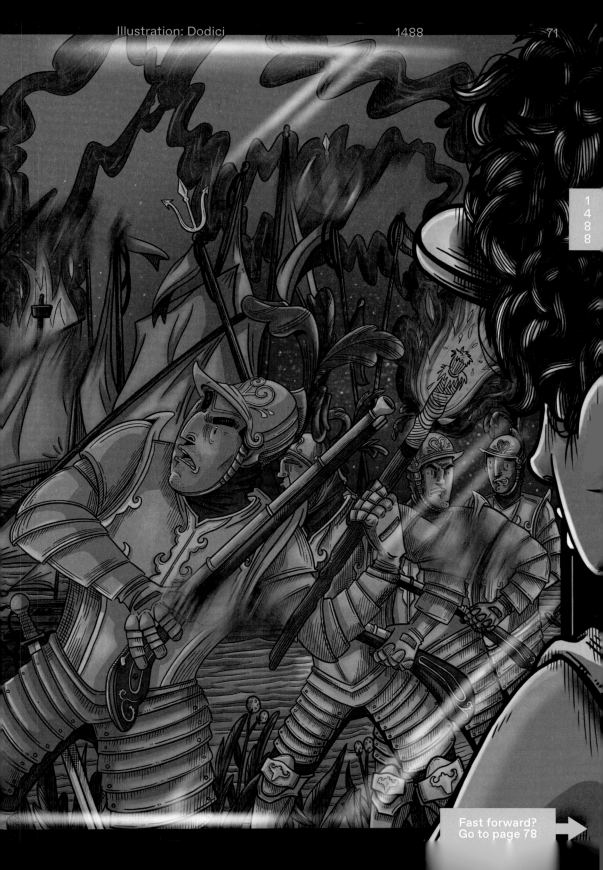

1488

Fast forward?
Go to page 78 →

1653
Whalers

By 1653, Rotterdam was no longer a provincial city. The Eighty Years' War (1568-1648) had dealt heavy blows to rival Antwerp, and Rotterdam was the better for it. The city grew and its expansion was planned for the first time. This was a job for the 'city carpenter', as urban designers were called at the time. Urban design was no longer the competence of farmers and fishermen building their own dwellings, but of professionals who used ideas from abroad, from Italy and France, about what an ideal city should look like. They wanted the city to grow in accordance with rational, scientific principles. The result had to be logically ordered and to this end, all kinds of new techniques were introduced, such as that of land surveying.

The port needed much more space. In 1590 and 1591, the Haringvliet and the Boerengat were created, especially for fishermen. During the Twelve Year Truce (1609-1621), Waterstad was constructed, a huge urban extension that allowed merchant ships to access the Oude Haven and

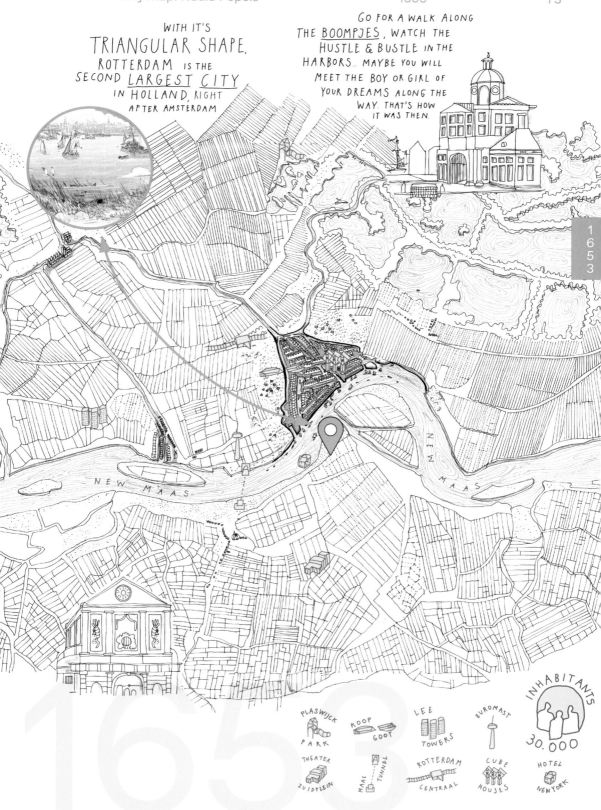

WITH IT'S
TRIANGULAR SHAPE,
ROTTERDAM IS THE
SECOND LARGEST CITY
IN HOLLAND, RIGHT
AFTER AMSTERDAM

GO FOR A WALK ALONG
THE BOOMPJES, WATCH THE
HUSTLE & BUSTLE IN THE
HARBORS. MAYBE YOU WILL
MEET THE BOY OR GIRL OF
YOUR DREAMS ALONG THE
WAY. THAT'S HOW
IT WAS THEN.

1653

NEW MAAS

NEW MAAS

PLASWIJCK PARK
KOOP GOOT
LEE TOWERS
EUROMAST
INHABITANTS
30.000

THEATER ZUIDPLEIN
MAAS TUNNEL
ROTTERDAM CENTRAAL
CUBE HOUSES
HOTEL NEW YORK

1653

Blaak. The 'Rotterdam Ring of Canals' was dug
south of the Hoogstraat, in an area previously
occupied by nothing but sandbanks and
waterways – the current centre of Rotterdam.
By 1615, Waterstad was completed. The medieval
city had doubled in size in a short time.

1
6
5
3

Waterstad had harbours for large vessels,
which had long since stopped sailing only in
Europe. Twice a year, a VOC ship (the Dutch
United East India trade company) made the
long voyage to the Dutch East Indies, now called
Indonesia. The journey took eight months at least
and on average, one in ten of those on board did
not survive.

Historical map of the Stadsdriehoek
('city triangle' – named after the
triangular shape of the inner city) in
Rotterdam. Coloured map, Johannes
de Vou, 1694 (collection MM).

Eighteenth-century depiction of Dutch
whalers hunting for bowhead whales.
Engraving, unknown. From: *Monsters
of the Sea*. R. Ellis, 1994.

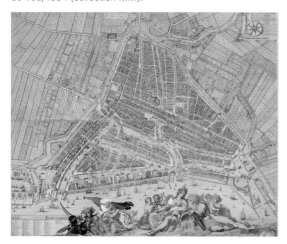

The shipyard at which these impressive vessels were built was on the Boompjes. The ships of the VOC chamber Delft, which built them in its own shipyard, sailed from Delfshaven. The VOC's Zeemagazijn (sea warehouse) is still there, on Achterhaven. Also departing from Rotterdam where the ships of the slave traders who bought people in Africa to transport them as slaves to the colonies in Central and South America.

Profits from that overseas trade, mostly 'blood money', were used to beautify the city.
The quaysides of the new harbours were adorned with the posh mansions of shipowners, colonial merchants and other wealthy citizens.

Having returned from their life-threatening whale hunts, whalers had some exciting stories to tell. This woodcut is based on one such story and comes from the book *Historiae animalium* (Animal Histories). Conrad Gessner, 1558.

Those buildings showed that the city was important and ruled over the surrounding countryside. Large markets were held. Water management was regulated in the new Schieland House, built in 1665 by the Schieland Water Board.

1653

Even in the seventeenth century, whales occasionally stranded. Many people thought this was how God made his anger visible about the misbehaviour of humans.
Jan Saenredam, engraver and cartographer, 1602 (collection RM).

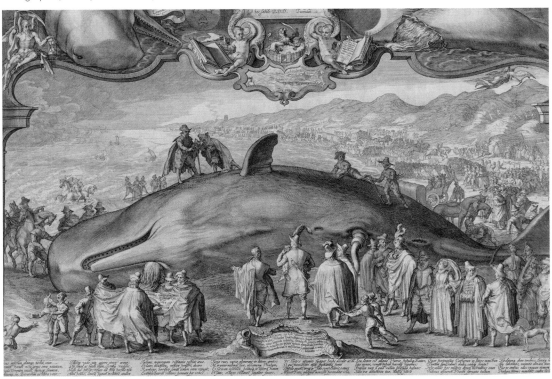

In 1980, archaeologists on Spitsbergen found graves of Dutch whalers and try-workers. The skeletons still had their caps on. Whalers identified people by the striped patterns of the caps; because of the cold, the men were wrapped so thickly that you could only see their eyes. Hats from the seventeenth century (collection RM).

Whalers at work. On the right, a man being attacked by a polar bear. Drawing, Adriaen van Salm, circa 1690-1720 (collection MR).

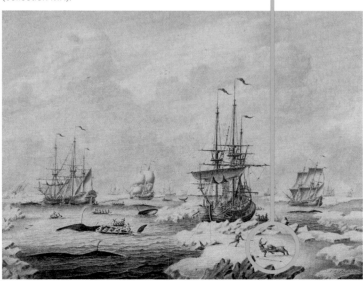

1653

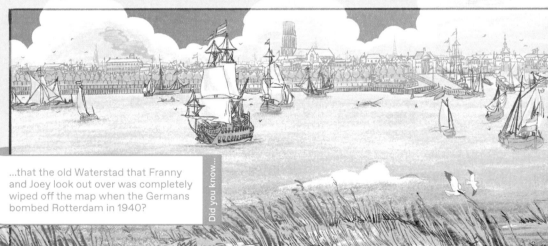

...that the old Waterstad that Franny and Joey look out over was completely wiped off the map when the Germans bombed Rotterdam in 1940?

Did you know...

From 1621 onward, the tower of the Saint Laurens Church briefly sported a wooden spire. This caused the tower to slant and in 1645, the spire was demolished due to wood rot. In 1650, on a stormy Sunday morning, the tower even threatened to topple over. During a church service, at that!

The minister called for calm, but everyone fled outside. Fortunately, there were no casualties. In 1665, the tower was adjusted once again. Since then, no-one has tried to change it, and it has kept its truncated shape.

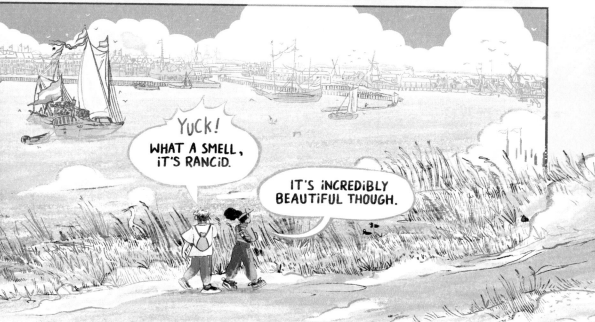

It's busy on the river. Around the year 1650, Rotterdam had a fleet of dozens of herring busses and fluyts (a Dutch type of cargo ship, more on this later) and many trade vessels arrived from abroad as well. Now and then, VOC ships returned from the Dutch East Indies, after a nine-month voyage. Their crews were often weak and sick; at least ten per cent would have died en route. But the holds of such ships were full of precious cargo and the profits went to VOC shareholders in their fine mansions.

1
6
5
3

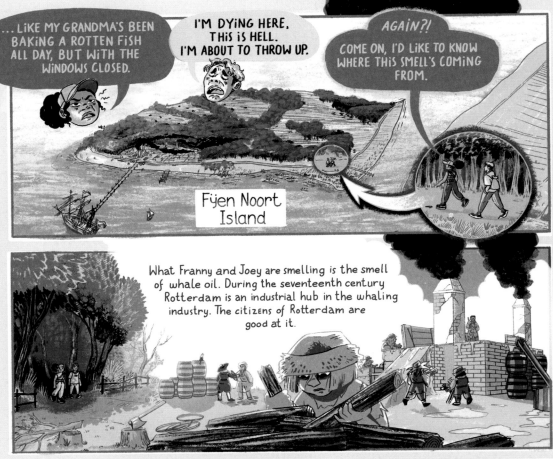

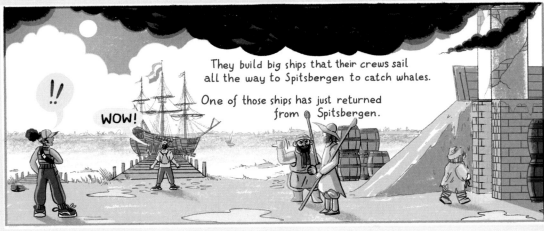

Rotterdam's city council designated the island of Feijenoord for try-works (for processing whale blubber) – far away from built-up areas, because of the stench and nuisance. Pieter and Sebastiaen Harlaer, the tenant farmers of Feijenoord, received permission to start a try-house on the island. Their workers slept in the shed in which the whale blubber was also stored. Outside were a blubber bin, a large cooking pot, a couple of cooling containers with gutters and a waste container.

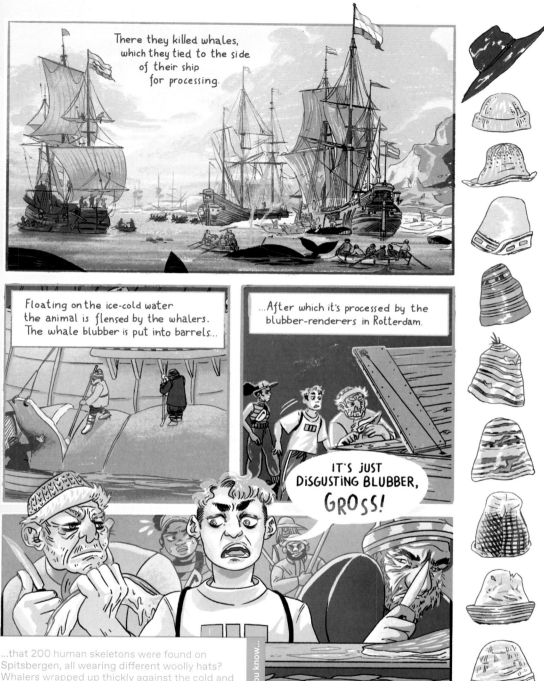

There they killed whales, which they tied to the side of their ship for processing.

Floating on the ice-cold water the animal is flensed by the whalers. The whale blubber is put into barrels...

...After which it's processed by the blubber-renderers in Rotterdam.

IT'S JUST DISGUSTING BLUBBER, GROSS!

Did you know...

...that 200 human skeletons were found on Spitsbergen, all wearing different woolly hats? Whalers wrapped up thickly against the cold and could only be recognized by their headgear.

1
6
5
3

The Dutch had learned how to hunt whales from the Basques. The trick was to throw a harpoon – a barbed spear – into the whale by hand. The harpoon was attached to the whaling vessel by a heavy rope. Next began an hours-long battle which continued until the animal died of exhaustion or the crew perished in the waves. The Dutch mainly targeted the bowhead whale, which did not swim all that fast and was therefore easy to harpoon.

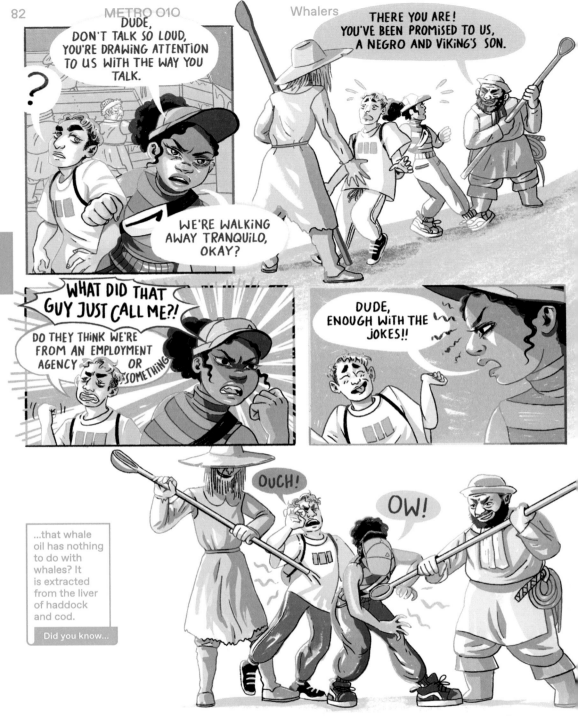

In the sixteenth century, people started calling Africans 'negroes'. 'Black' is *niger* in Latin and *negro* in Spanish and Portuguese. At the time, Amsterdam was home to a small community of free black people, of whom Rembrandt painted beautiful portraits.

Most Rotterdam-mers knew about the transatlantic slave trade, in which Dutch ships systematically participated from about 1630, but meeting someone with dark skin was still something quite extraordinary.

Feijenoord is where the blubber is rendered into fuel and other products.

Yeah, in the same place that the stadium is now located.

1653

Whale blubber is cooked on the periphery of Rotterdam.

The city is literally built on the death of thousands of whales, captured at the edge of the North Pole.

Whale bones have been found on the Coolsingel.

The city grows due to the busy trade in whale oil. A lot of money is made and then used to build the city.

The Basques of northern Spain had started whaling on a large scale as early as the Middle Ages. They used whale oil as lubricating oil, lamp oil and raw material for making soap and tallow candles. You would cut the blubber from the whale's huge body and boil it down over a big fire – a skill the Dutch had to learn from the Basques, just like harpooning. Then you scooped the released boiling hot oil into gutters that led to cooling containers. It was horribly hard work, and the workers risked severe burns.

1653

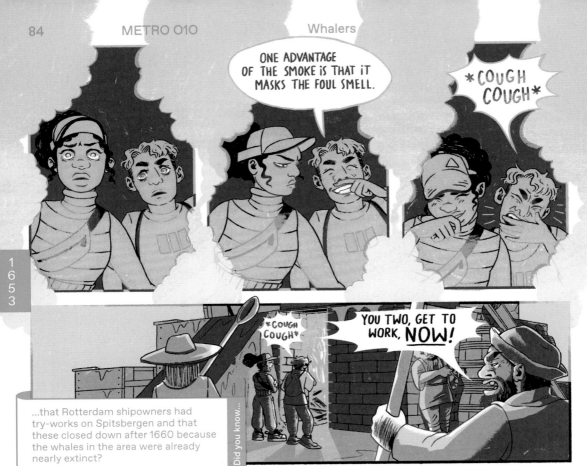

...that Rotterdam shipowners had try-works on Spitsbergen and that these closed down after 1660 because the whales in the area were already nearly extinct?

For most seventeenth-century children, going to school was out of the question. Child labour was common throughout most of the world's history. You could only escape this if you were of rich or noble descent. Children often had to work hard for a living from the age of seven. It was only in 1871 that the Netherlands passed a law setting the minimum age for this at twelve, and even then it did not apply to children who worked in their parents' businesses.

Children who were allowed to learn an actual trade from a master were privileged. In most trades, after a seven-year apprenticeship they had to pass specific master tests (exams) to win the right to work in the trade. This was all regulated by guilds, of which they were required to be members.

Masters could be very heavy-handed. Usually, as an apprentice, you had to be satisfied with food, drink and a place to sleep. If you were also given a couple of dimes you would consider yourself very lucky.

1
6
5
3

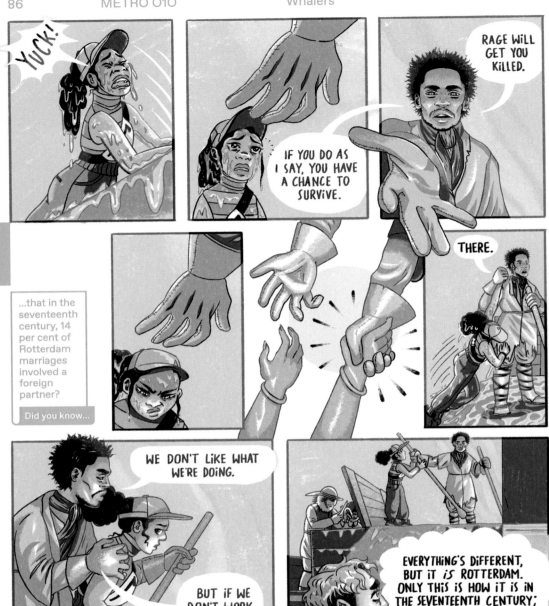

...that in the seventeenth century, 14 per cent of Rotterdam marriages involved a foreign partner?

Did you know...

Ships of the Dutch West India Company occasionally carried Africans as crew members. On a much larger scale, migrants from Europe came to the Netherlands in search of a better life. Jews from Spain, Portugal and Eastern Europe fled persecution; Germans fled the Thirty Years' War that devastated their country. Many Protestant refugees called Huguenots came from France. In Rotterdam, Protestant refugees from Flanders also played a part in the development of the city. All of these immigrants were indispensable for the growth of trade and business.

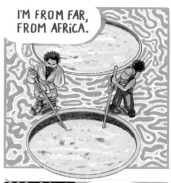

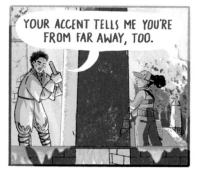

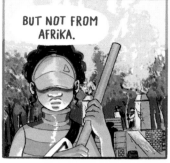

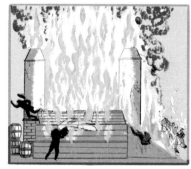

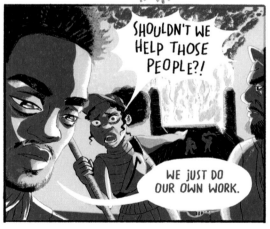

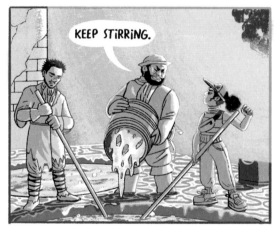

Around 1650, the Dutch began installing large brick ovens with copper pots on them on their whalers – that's what the whaling vessels were called. This meant they could start rendering the whale blubber aboard the vessels. The last Dutch whaling vessel was sold to Japan in 1964.

This vessel was called the *Willem Barentsz* and the Japanese used it to hunt in the Southern Ocean.

1653

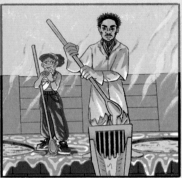

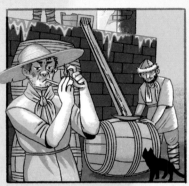

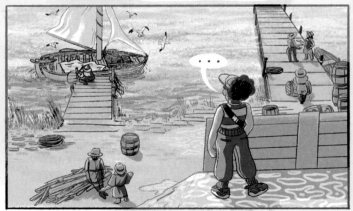

Joey will have earned a maximum of twenty stivers a day at the try-works; Franny, being a woman, much less. People worked at the try-works from sunrise to sunset. This means they earned less in winter than in summer, due to the latter's longer days.

By European standards, these were fairly good wages. The Dutch workers and artisans usually managed to survive without growing hungry, which was quite a success in those days.

...that around 1650, Rotterdam had about 50 whaling vessels?

Did you know...

1
6
5
3

In the seventeenth century, ordinary people ate much more bread than they do today. A loaf of rye bread cost six stivers, a jug of beer half a stiver. Addiction to tobacco – smoked in earthenware pipes – was already widespread. Many people went to the pub to smoke their pipe. A revolt broke out in Haarlem in 1690 when the city council tried to ban smoking in the streets.

1653

Herring was the people's staple food in seventeenth-century Rotterdam. Fishing for herring was an important industry. Around 1620, Holland already had 600 herring busses, three-masted sea-going vessels of circa 14 metres long and 3.5 metres wide.

There were 80 of these vessels in the port of Rotterdam. From the port, smaller craft took the herring to the customers.

1
6
5
3

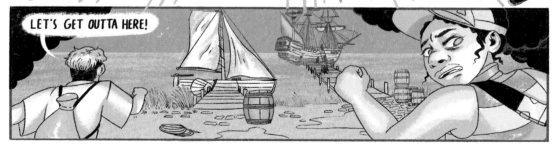

It was not so much the stench, but rather the permanent fire hazard that was the foremost reason why the Rotterdam city council preferred to locate the try-works outside of the city. The fire hose, invented by artist Jan van der Heyden, represented a huge step forward in the seventeenth century.

Van der Heyden was also the inventor of a street lamp that burned on vegetable rapeseed oil. Such street lanterns appeared all over Rotterdam, in a fixed pattern: if you stopped at one lantern, you had to be able to see the next one.

1
6
5
3

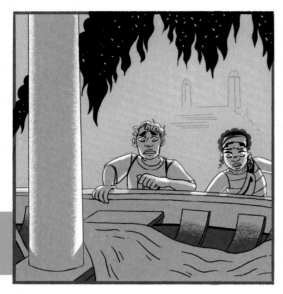

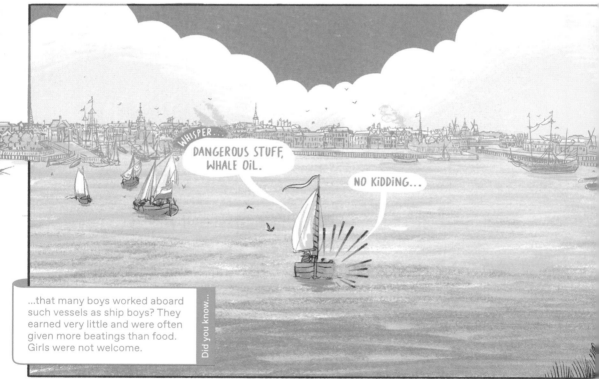

...that many boys worked aboard such vessels as ship boys? They earned very little and were often given more beatings than food. Girls were not welcome.

Did you know...

Franny and Joey are sailing to the eastern part of town. On the left, we see the Oude Haven with the Ooster Oude Hoofdpoort, the 1598 city gate. Above the roofs to the right of the tower of City Hall you can see the turret of the Prinsen Chapel. Only its tower cross and a tombstone have survived.

The Prinsen Chapel was demolished in 1912 and replaced by the Koninginne Church on Boezemsingel. For many people visiting the city, the port was the first thing they saw, so the best features were located along the river.

1
6
5
3

Over the centuries, international trade became increasingly important to Rotterdam. The harbours and shipping companies made huge profits. In the first half of the twentieth century, the 'sea castles', giant ships that sailed to the Dutch East Indies and to North and South America, departed here.

Colonialism ended after the Second World War, but many liberated colonies are economically dependent on their former colonizers to this day.

Fast forward?
Go to page 98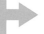

1653
The Silly Ship

In the seventeenth century, Rotterdam was the second largest city in the Republic after Amsterdam. Travellers praised it as an international centre of science and philosophy. In 1653, hundreds of years before the first modern submarine was launched, the Frenchman Jean Duson designed a peculiar vessel called the *Malle Schip*. He built it in a shipyard behind the Boompjes. It was a vessel that Duson claimed could dive underwater and destroy as many as hundreds of enemy ships. He also said his invention was super-fast and could sail back and forth to London in a day.

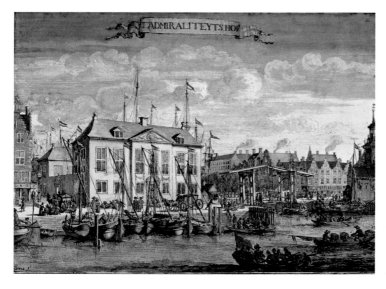

In the seventeenth century, various cities and provinces had their own navies. Rotterdam had the oldest, the Admiraliteit van de Maeze, founded in 1597. The warships were built at its own shipyard, 's Landswerf, located on Buizengat. Part of a coloured map, Johannes de Vou, 1694 (collection MM).

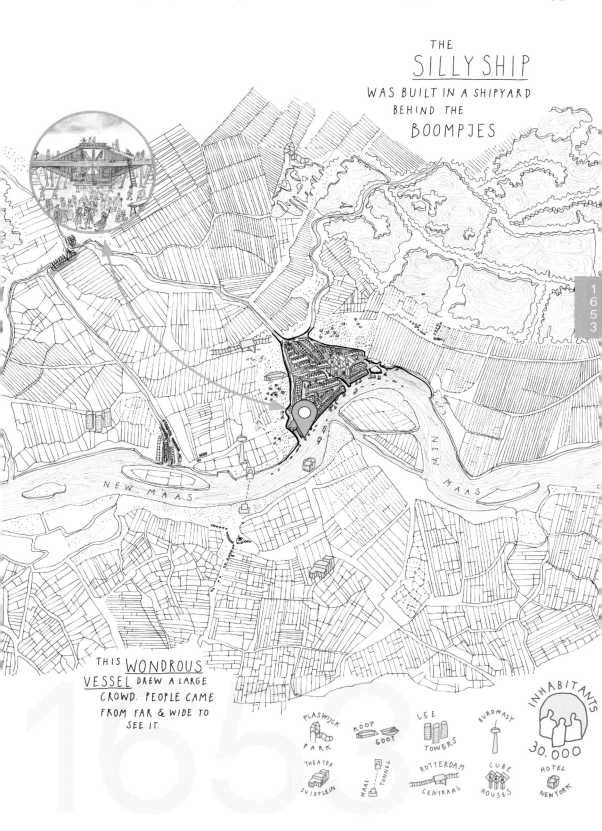

THE
SILLY SHIP
WAS BUILT IN A SHIPYARD
BEHIND THE
BOOMPJES

1
6
5
3

NEW MAAS

NEW MAAS

1653

THIS WONDROUS
VESSEL DREW A LARGE
CROWD. PEOPLE CAME
FROM FAR & WIDE TO
SEE IT.

PLASWIJCK
PARK

KOOP
GOOT

LEE
TOWERS

EUROMAST

INHABITANTS
30.000

THEATER
ZUIDPLEIN

MAAS TUNNEL

ROTTERDAM
CENTRAAL

CUBE
HOUSES

HOTEL
NEW YORK

Jean Duson eagerly capitalized on Rotterdam's reputation as a centre of innovation. His ship became a must-see. People from far and wide came to the yard to take a look. They soon began to call it the *Malle Schip*, the Silly Ship, because the dense, wooden colossus certainly looked silly and peculiar. Normal vessels had sails, but this one had an axis in the middle with a paddle wheel for propulsion. At its front and back, it had thick beams to ram enemy ships, both at sea and in port. The *Malle Schip* seemed to be the invention of the century. But was it?

1
6
5
3

← Portrait of Jean Duson. The lyrics of this mocking song reveal what Rotterdammers thought of him: *'t Was 1653 toen het allemaal begon. Er kwam een Fransman in de stad, zijn naam was Jean Duson. Van alles had hij bij zich, maar vooral zijn grote mond. Vandaar dat hier in Rotterdam geen mens hem aardig vond* ('Twas 1653 when it all went down. A Frenchman by the name of Duson came to town. He was many things, but above all he gave lip. Hence here in Rotterdam we thought him a rip'). Print, Marcus Quern, 1654 (collection RM).

Portrait van Desiderius Erasmus, a famous contemporary of Jean Duson. Painting, Lucas Cranach, 1523 (collection MBVB).

The peculiar vessel *Blixem van de See*, built in Rotterdam. The ship was 72 *voet* long, 14 *voet* high and 8 *voet* wide (a Rotterdam *voet* was 28 centimetres). Print, unknown, 1653 (collection SAR).

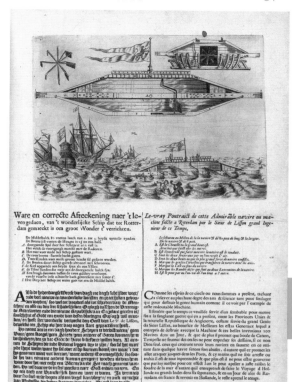

Jean Duson presented his vessel as a secret weapon against the English, with whom the Netherlands fought a naval war between 1653 and 1654. Maarten Harpertszoon Tromp overcame his British opponent Robert Blake Robert Dungeness even without the *Malle Schip*. Drawing, unknown, 1653 (collection RM).

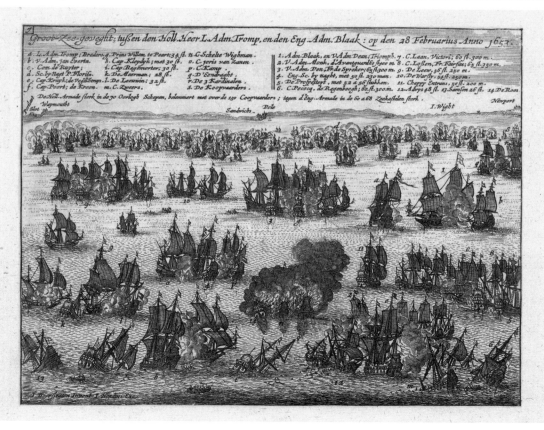

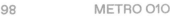

Did you know... ...that Rotterdam got a new City Hall on the Hoogstraat in 1822, with a classicist façade in the Roman style? The current City Hall on the Coolsingel was completed in 1920.

1653

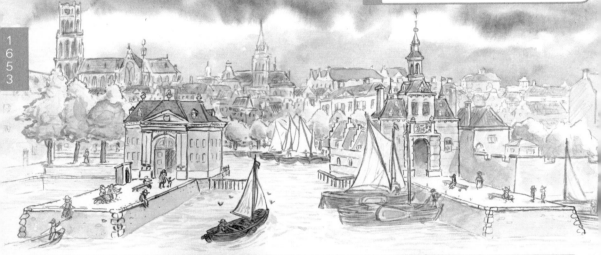

Franny and Joey are sailing into the Oude Haven. On the right is the Ooster Oude Hoofdpoort, the 1598 city gate. Directly behind that was the Blauwe Toren (blue tower), which was a prison first, and the office of the Wisselbank (exchange bank) from 1635. The city council had ordered the shipbuilding yards to move to the Boompjes. The tower to the right of Laurens Church was part of Rotterdam City Hall on the Botersloot. To the left we see proof of artistic licence: the map shows the Wester Oude Hoofdpoort, which would not be completed until 1667.

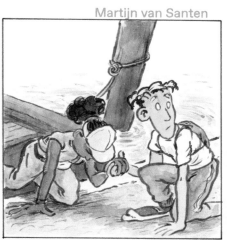

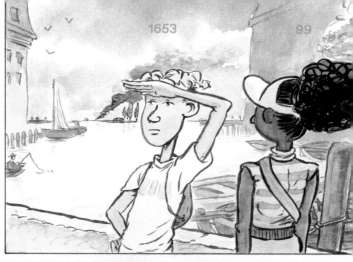

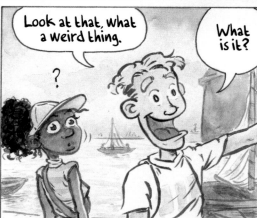

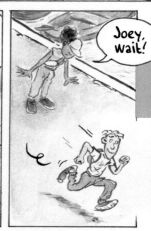

1653

Rotterdam ship carpenters built a lot of herring busses, which were not only used as fishing vessels, but also for trade. The best-known ship type was the fluyt, a three-master with a narrow deck and a bulging belly, which could be sent out to sea even with a small crew of twelve.

The largest type was the East Indiaman of the Dutch East India Company: it was 40 metres long and needed 160 crew members. They often also took along at least a hundred soldiers, plus dozens of passengers, bringing the total of souls on board to 300.

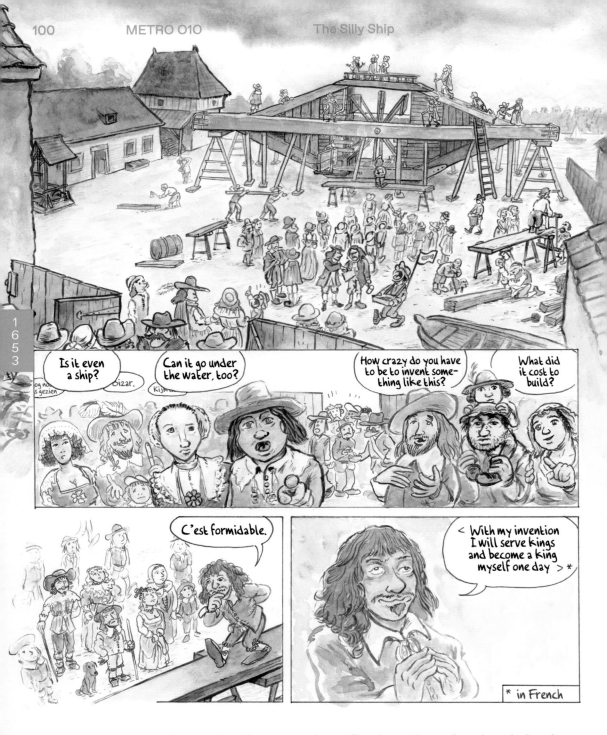

In 1621, Dutch inventor Cornelis Drebbel demonstrated the first submarine to the English King James I; a crew rowed it forward underwater a couple of metres. How Drebbel solved the oxygen problem is not entirely clear. He may have burned saltpetre to release oxygen.

Later, Dutch naval men found a solution that was not only effective, but also obvious: the snorkel, a long tube protruding from the submarine above water. The first snorkels were installed in 1939. Now every submarine uses snorkels.

...that people first used the word 'charlatan' for rip-offs like Jean Duson in his time?

Did you know...

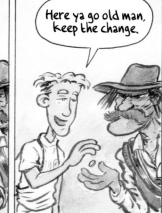
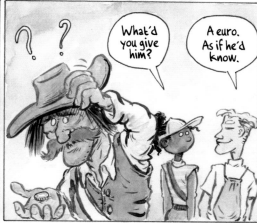

1653

Jean Duson's design, the *Blixem van de See* (The Lightning of the Sea), resembled Drebbel's submarine. The rowing crew had been replaced by paddle wheels driven by a spring. The States of Holland and many private individuals put money into it. But

when the day came for Duson to demonstrate his invention to the public, he disappointed people. Rather than make a poor show, he fled Rotterdam and no one would ever see him again. And his *Malle Schip*? It never sailed and was eventually sold for firewood.

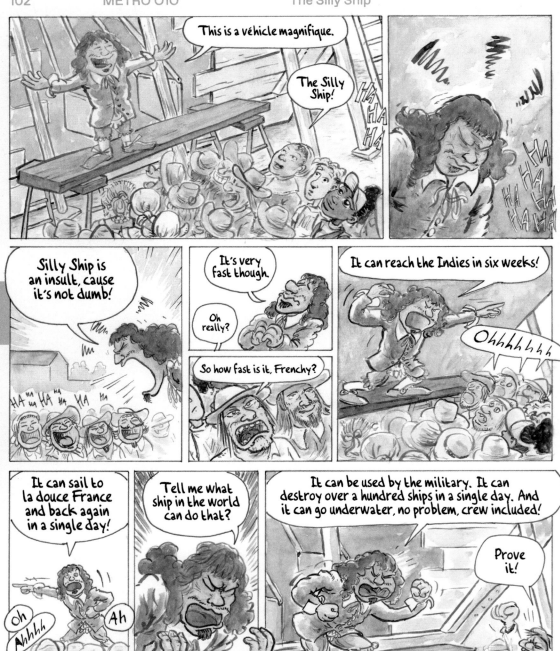

In 1651, England and the Low Countries got into a conflict over trading interests. Thanks in part to their fluyts, the Dutch controlled 80 per cent of Europe's cargo shipping. England's new ruler, Oliver Cromwell, wanted to limit the access of Dutch vessels. He argued that the North Sea and Channel were 'English waters'. On the Dutch side, people followed the view of Hugo de Groot, founder of maritime law, who argued that the sea should be free for all. There is a statue of him in front of the City Hall.

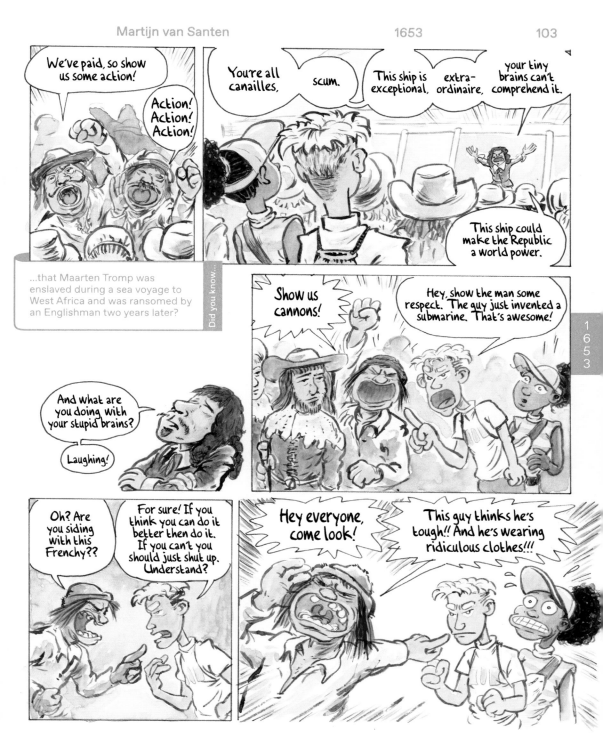

The cause of the so-called First English Sea War was a crazy incident. In May 1652, Fleet Admiral Maarten Harpertszoon Tromp waited too long to lower his flag to salute an English fleet. The English ships immediately opened fire. After a victory at Dungeness, Tromp tied a broom to the main mast to show that he had swept the sea clean. At least, that is what the shocked English told each other. English and Dutch victories alternated. After two years, the war ended in a stalemate, a draw.

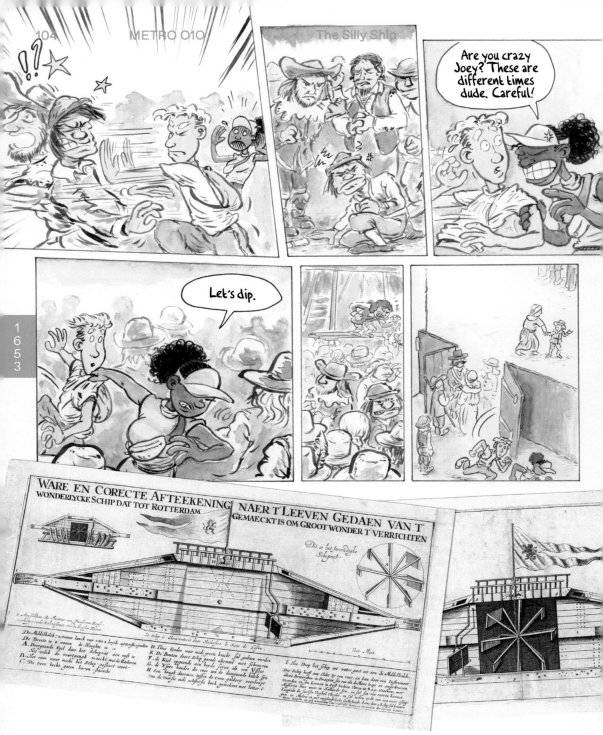

The *Malle Schip* lay decaying on the Boompjes for many years until it was finally sold for firewood. A similar scandal took place in 1879: Rotterdam businessman Lodewijk Pincoffs secretly fled to New York with his wife and children after many Rotterdammers, rich and poor, had invested their money in his harbour enterprise. Operations had to be suspended, but were later resumed. These would become the basis for the port of Rotterdam, which is why Pincoffs got a street named after him and a statue, after all.

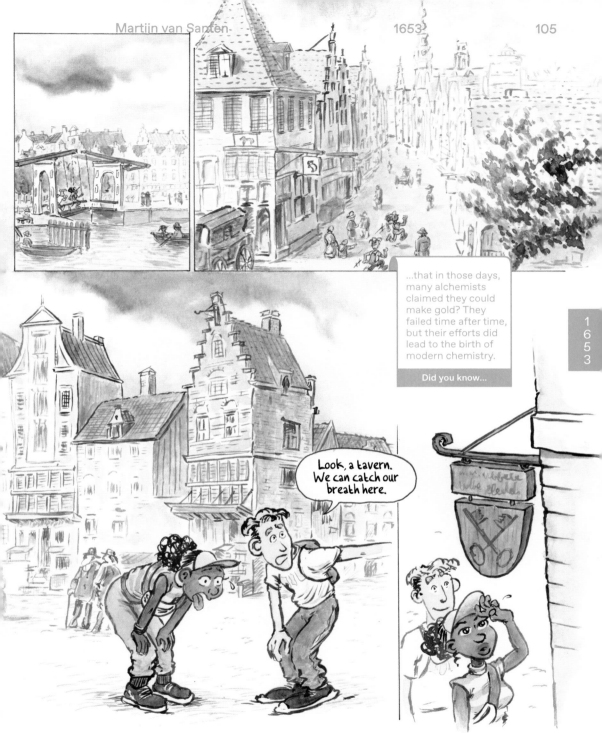

Did you know... ...that in those days, many alchemists claimed they could make gold? They failed time after time, but their efforts did lead to the birth of modern chemistry.

1 6 5 3

Look, a tavern. We can catch our breath here.

Franny and Joey flee Waterstad to the heart of the old city: the Grote Markt. There, they arrive at De Dubbelde Witte Sleutels, a legendary inn that had existed for at least a century by 1653. The famous innkeeper was the explorer Olivier van Noort, who was forced to find a way around South America to India in 1600. He succeeded, and Van Noort was the first Dutchman to make a voyage around the world. Afterwards, he went back to inn-keeping.

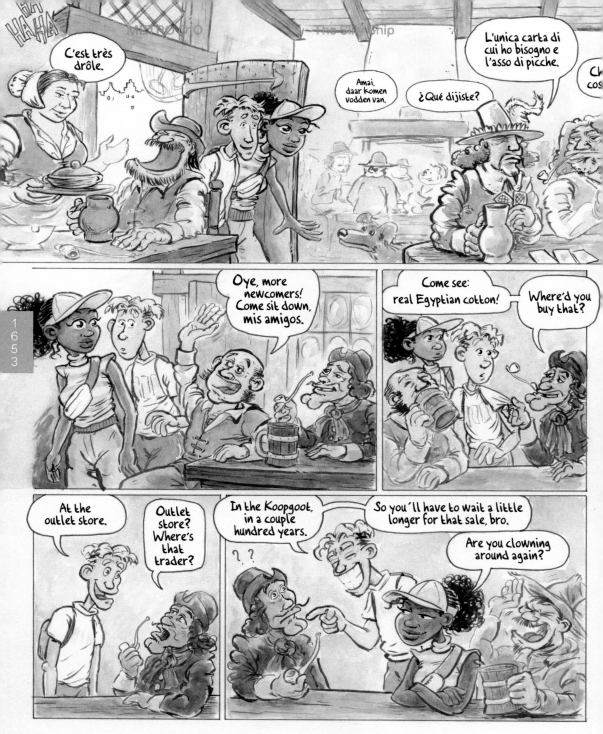

People drank a lot of beer in De Dubbelde Witte Sleutels, even in the middle of the day. The beer came from one of the many breweries in the area, such as De Twee Klimmende Witte Leeuwen and Het Swarte Paard. The ceilings slowly browned with tobacco smoke.

Coffee was becoming popular: by the end of the seventeenth century, there were crowded coffee houses, which were of Ottoman origin, everywhere. The Dutch planted coffee beans in Java and the Dutch East India Company ensured supplies to the homeland. This turned out to be a lucrative business.

It's no wonder that Dirk Versijden misunderstands Franny's criticism of child labour in the try-works. In those days, it was considered normal for children to be put to work at an early age, having to earn their own living and thus not attending school. If they were lucky, they were taken in as apprentices by a guild. Orphans often ended up on a war fleet, with all the dangers that entailed. All the same, in the Low Countries many more ordinary people could read and write than in other countries.

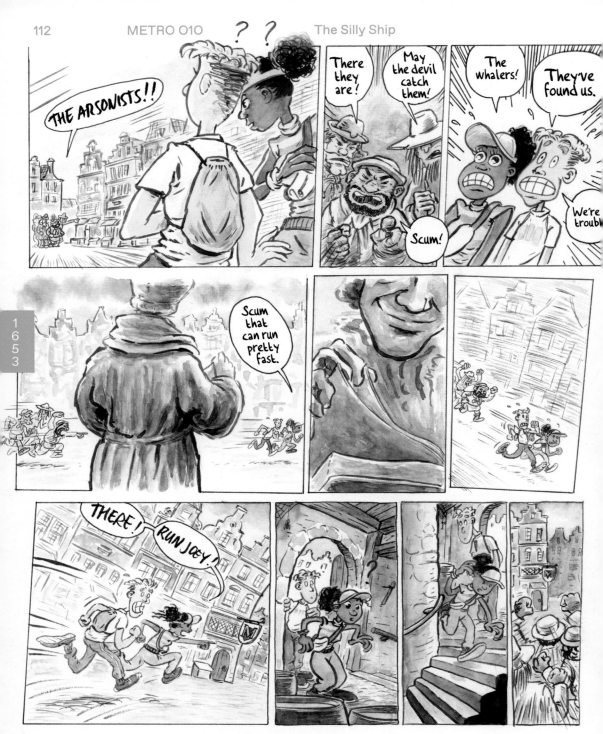

1653

Had Franny and Joey been caught, they would not have survived. Involvement in arson was punishable by death. In Rotterdam, this punishment was carried out in front of the City Hall. Hanging by the town gallows was the most common method. Decapitation was reserved for people of a slightly better background and was considered honourable. If the executioner did not separate the head from the torso with one blow, there was a chance that the public would turn on him. Those condemned to death were not buried, but hung on the outskirts of the city to feed the crows.

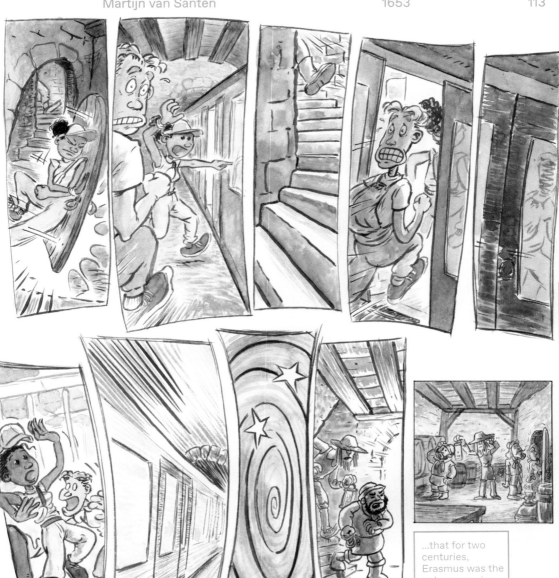

...that for two centuries, Erasmus was the only person in the Netherlands for whom a sculpture had been erected?

Did you know...

For theft, you could be sentenced to years of hard labour in the rasp house (men) or spinning house (women). Men had to grate wood for paint production, women had to spin fibre yarn and sew. One 1630 cell door remains of the Rotterdam rasp house. In the seventeenth century, rasp houses and spinning houses were considered modern institutions: instead of flogging or branding people, they tried to uplift them through labour.

Fast forward? Go to page 120

1760
On the Haringvliet

After the completion of the Zalmhaven in 1693, Rotterdam did not expand any further in the eighteenth century, but the city did change significantly. This was because many wealthy merchants remodelled and embellished their residences, especially in Waterstad, on the Leuvehaven and Haringvliet. Old mansions with stepped gables were remodelled according to the latest fashion and taste. Outside, they were adorned with sculptures and ornaments, inside with mantelpieces, painted ceilings and gold leather wall hangings.

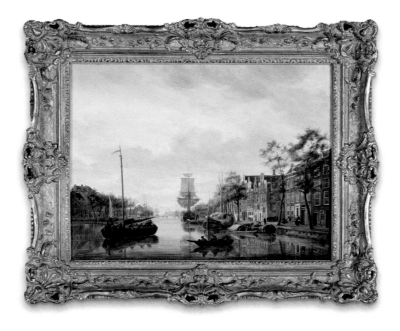

Haringvliet, with the mansions of wealthy merchants on the right. Painting, Gerrit Groenewegen, 1782 (collection MM).

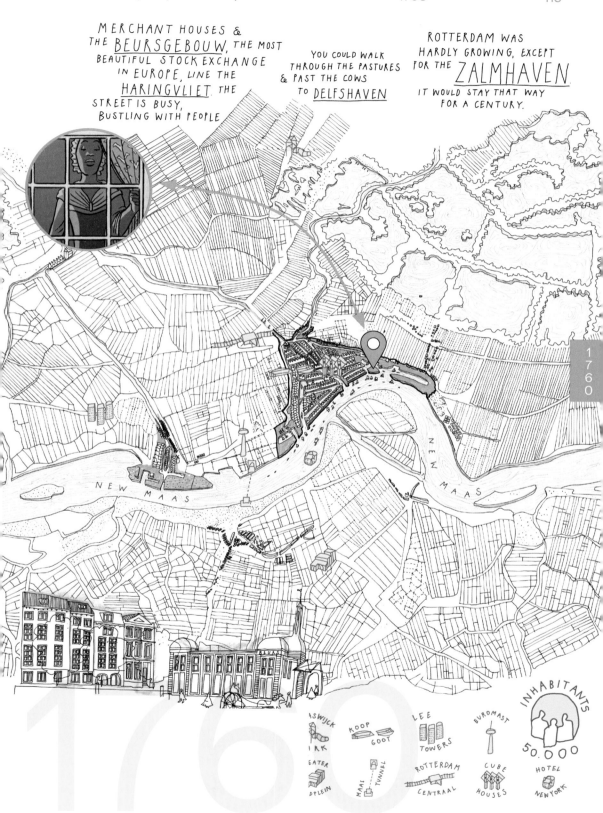

MERCHANT HOUSES &
THE BEURSGEBOUW, THE MOST
BEAUTIFUL STOCK EXCHANGE
IN EUROPE, LINE THE
HARINGVLIET. THE
STREET IS BUSY,
BUSTLING WITH PEOPLE

YOU COULD WALK
THROUGH THE PASTURES
& PAST THE COWS
TO DELFSHAVEN

ROTTERDAM WAS
HARDLY GROWING, EXCEPT
FOR THE ZALMHAVEN.
IT WOULD STAY THAT WAY
FOR A CENTURY.

1760

NEW MAAS

NEW MAAS

ISWIJCK
IRK

KOOP
GOOT

LEE
TOWERS

EUROMAST

INHABITANTS
50.000

EATER
DPLEIN

MAAS TUNNEL

ROTTERDAM
CENTRAAL

CUBE
HOUSES

HOTEL
NEW YORK

How did these merchants get so rich? Many of them were doing business as part of the Dutch West India Company or the Dutch East India Company. They held offices on the Haringvliet and Boompjes. That's where the warehouses for spices from the East Indies and sugar from Surinam and Brazil, and the shipyards at which new merchant ships were built, were located.

They not only traded goods, but also people. Slave trade was unfortunately a common commercial activity at the time. VOC director and later mayor Joshua van Belle was able to build a fine mansion on Leuvehaven thanks to the slave trade.

1760

Family portrait of the Rotterdam sugar refiner and collector Jan **Snellen.** He lived on the Haringvliet; this **is** what his living room looked like. **The** sugar plantations at which ensl**aved** people were put to work made **him** rich. Painting, Art Schouman, 1746 (collection MBVB).

Model of the ship *Padmos/Blijdorp*, built at the VOC shipyard in Rotterdam, 1722 (collection MM).

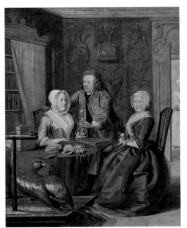

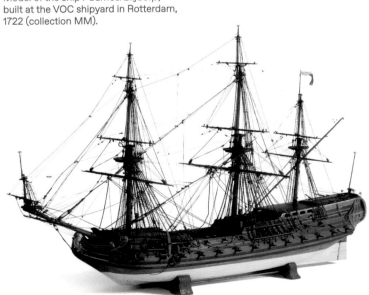

Many people got a piece of the pie, not only the traders themselves, but also the suppliers and owners of businesses that processed the products grown by enslaved people.

The Dutch West India Company had a monopoly on the slave trade until 1730, at which time this privilege expired. Individual traders were now also allowed to get involved in the transporting and selling of enslaved people. In Rotterdam, Herman van Coopstad and Jacobus Rochussen started a new shipping company with this gruesome objective.

Wine glass with an engraving of the Surinamese sugar plantation Siparipabo. Glasses like this would also be in the cabinets of houses on the Haringvliet. Circa 1750-1775 (collection MBVB).

Sugar mill on a Caribbean plantation. The owner of the plantation was a Dutchman. Processing sugar cane was dangerous work. Many enslaved people suffered severe burns. Seventeenth century (collection Granger).

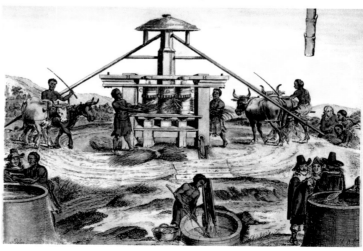

Their company shipped an estimated 23,000 enslaved people to Surinam and Curaçao between 1747 and 1779.

The ships first sailed to Ghana, where European products were exchanged for enslaved people. The crossing to America took two months if all went well, but usually longer. Along the way, 12 per cent of the 300 enslaved people died on average. The survivors were sold to plantation owners. Next, the ships returned to Rotterdam loaded with tropical products.

1
7
6
0

This type of sugar caster could be found on the tables in the merchant mansions on the Haringvliet. At that time, sugar was still a real luxury due to the high taxes on this product. 1707 (collection MBVB).

The first Dutch book to include images of African enslaved people. J.D. Herlein, *Beschryvinge van de volks-plantinge Zuriname*, 1718.

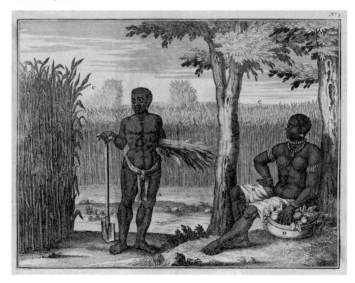

Advertisement for the sale of snow ship *Hermina Elisabeth*. That this was a slave ship is evident from the items described, such as various slave collars and shackles. 1777 (collection MM).

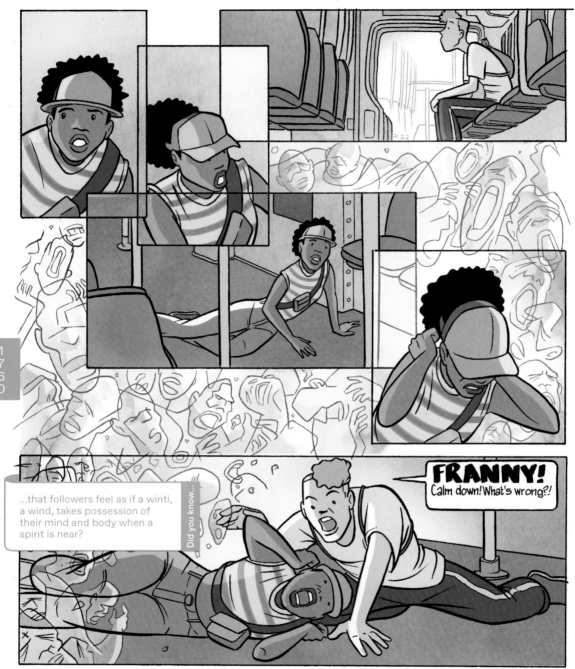

Followers of the winti faith can contact the gods and spirits of their ancestors. It is therefore not strange that Franny hears the spirits of her enslaved ancestors in the metro. There are rituals that allow the ancestors to literally speak through the mouths of those present.

On the Surinamese plantations, the winti faith was a great support for the people from Africa who had to perform slave labour there – also to hold on to their own African culture. No wonder winti has many followers to this day. In 1747, slave trader Isaac Jacobus Rochussen married Esther Hudig in Rotterdam's City Hall.

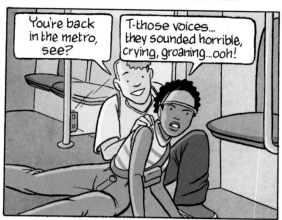

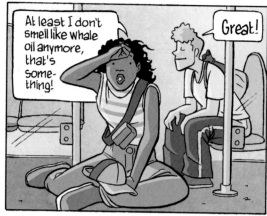

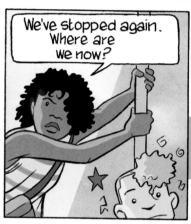

It was a grand celebration. The wedding guests sang to the happy couple: *Rochussen, wiens koopvlyt vroeg en spae, met noest beleid en onbesproken wandel, het wilde Afryke en woest Amerika doet krioelen van zijn drukken slavenhandel* ('Rochussen, whose trading at all times, his diligent conduct and best behaviour, will fill wild Africa and savage America through his busy slave trade'). The Rotterdammers knew. Everyone knew. Incidentally, Rochussenstraat is not named after this slave trader, but after the nineteenth-century painter Charles Rochussen. They were related.

1760

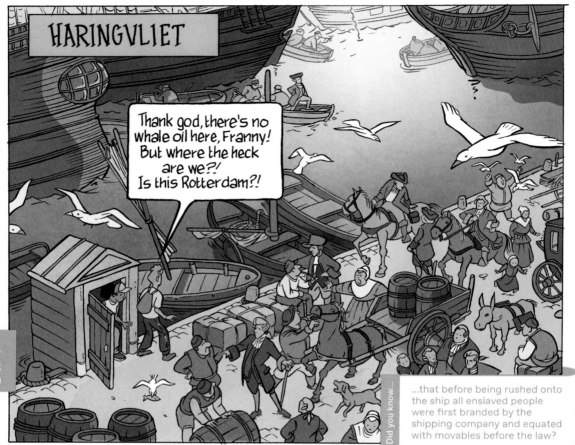

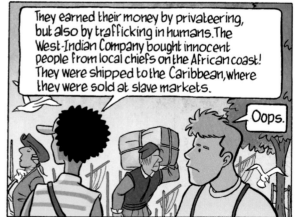

The Netherlands abolished slavery on 1 July 1863. Every year on that day, we celebrate Keti Koti, the Surinamese holiday, to commemorate this. *Keti Koti* means 'broken chains'. In 1863, 47,000 enslaved people were freed, but they had to continue working for meagre wages for another ten years. Understandably, they left the plantations as soon as they were allowed. From 1873, they were replaced by contract workers. Poor people from India and Java were lured to the West under false pretences and contractually bound to poorly paid jobs.

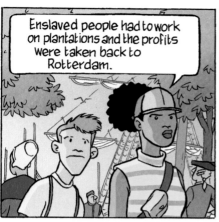

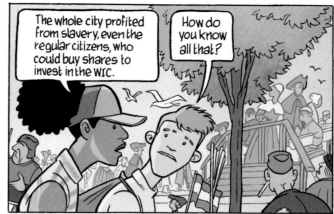

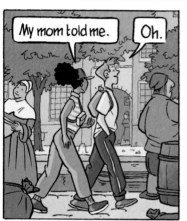

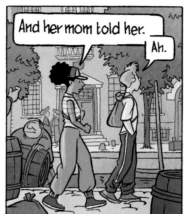

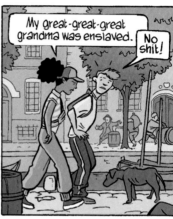

1760

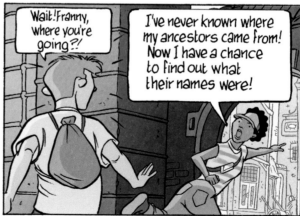

Franny is talking about shares in plantations. You could indeed buy those if you had any money. More importantly, entire industries could only exist thanks to products grown by enslaved people: sugar, tobacco, cotton, coffee and so on. Around 1770, 19 per cent of Dutch trade consisted of such products and 40 per cent of economic growth was directly or indirectly related to slavery. Many Rotterdammers owed their incomes – from very plain to lavish – to it.

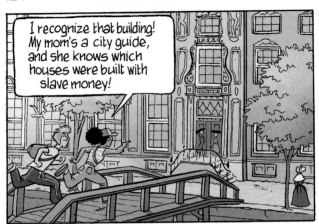

From the *Surinaamsche Nieuwsverteller* of 26 June 1788: 'Some time ago, two male negroes, named TITOS and PRIMEYRO, belonging to Miss GRATIA DE BRITTO, have taken to their heels. You are all kindly requested not to keep or conceal these slaves, but to deliver them to their owner, in exchange for a proper bounty.' It is to be hoped that Titos and Primeyro were not caught, but found freedom among the Maroons (communities of fugitive enslaved people) in the jungle.

Did you know... ...that Joshua van Belle had one of Johannes Vermeer's most famous paintings, namely *Lady Writing a Letter with her Maid*, hanging in his mansion on Hoogstraat?

Domestically, other than in the colonies, the Dutch only knew short-term slavery. If owners brought their enslaved people with them, after six months they automatically became free people who could go wherever they wanted. Owners could have a judge extend the term to one year, but no more.

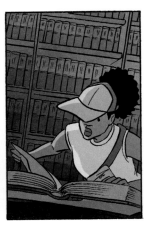

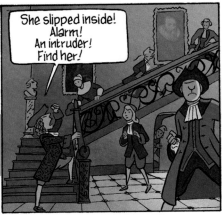

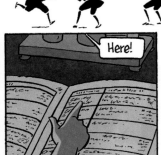

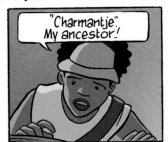

1760

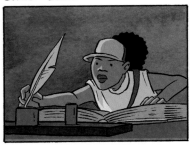

Plantation owners would rename the enslaved people brought from Africa to work in Suriname or the Caribbean. If an owner wanted to appear educated, he chose a name from Roman or Greek times: Caesar, Venus, Jupiter. Sometimes he chose a name based on attributed traits. *Charmantje* – Charming – is a striking example.

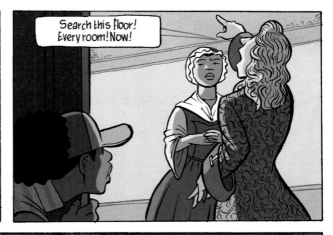

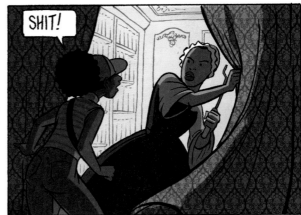

By adding the word 'freed', Franny manages to free her great-great-great-grandmother. Only freed slaves were given a surname, so Franny also adds her own surname: 'Wijngaard.' Slaves were property and therefore worth money. That's why the owners in Rotterdam kept precise records and insured their overseas enslaved people against death or illness. In Rotterdam, for instance, they could take out insurance with cashier Mees. *Manumissies* (releases) were rare. The government was against it. They believed it would only cause discontent and riots.

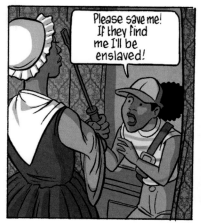

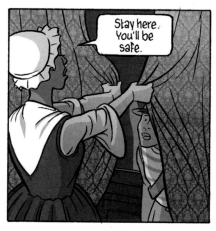

1760

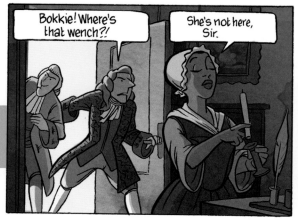

Wealthy people thought it quite stylish to have a foreign, coloured manservant or maid. One of these was Bokkie. Stadholder William V was gifted a seven-year-old boy from West Africa in 1766, whom he named Willem Frederik Cupido.

This boy became a page at court and later married a maid from Germany. In 2018, The Hague Historical Museum organized a meeting of Cupido's descendants.

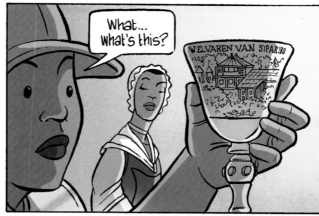

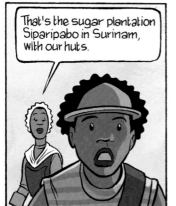

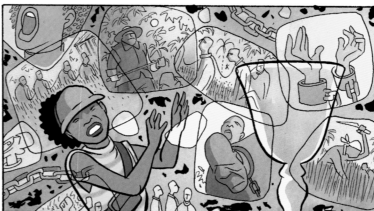

1
7
6
0

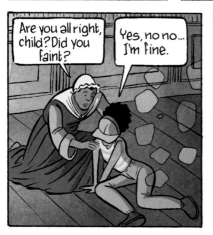

This is the type of glass used by plantation owners in Suriname or Europe to toast the wellbeing of their property, in this case sugar plantation Siparipabo on the Commewijne River in Suriname. The contrast between the richly decorated glass and the harsh conditions on the plantation is wry. The glass was probably commissioned by the owner of the plantation.

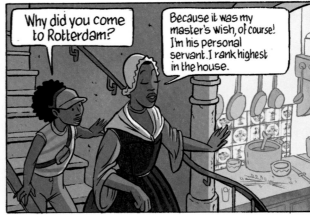

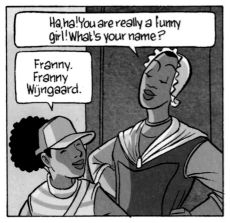

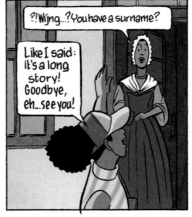

1760

The Dutch West India Company, founded in 1621 with government support and dissolved in 1792, had eight *Kamers*, or Chambers (branches). *De Kamer van de Maze*, in which Delft and Dordrecht also participated, was based in Rotterdam. From 1635, the slave trade really expanded. The Dutch West India Company had the monopoly until 1730. The transatlantic slave trade was the domain of Spaniards, Portuguese, French, Dutch, British and Danes. Brandenburg (later Prussia) also participated for a while, as did Sweden. Altogether, 12 to 14 million Africans were shipped to both Americas.

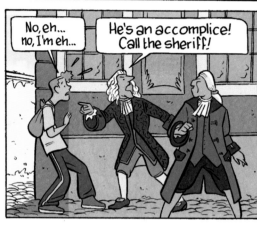

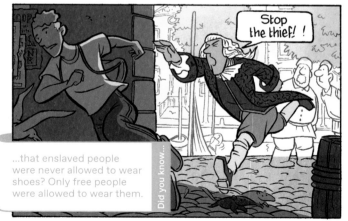

This rich gentleman is wearing a colourful coat and trunk hose or culotte, showing that he is a distinguished person. Lower-class men wore plain long trousers. In the eighteenth century, rich gentlemen and their ladies would shave their heads and wear white-powdered wigs. This fashion had been introduced by the French king Louis XIV, who had little hair of his own. After the French Revolution of 1789, it suddenly became conservative – in contemporary terms 'right-wing' – to wear a wig.

1760

...that the Rotterdam slave ship *Willem en Carolina* purchased enslaved people in West Africa for 115 guilders per person? And that these fetched an average of 274 guilders in Paramaribo?

Did you know...

In the Low Countries, the history of slavery began in the seventeenth century and lasted until 1863, when the system was abolished. All in all, circa 600,000 enslaved people were carried off on Dutch ships during those centuries. Most Rotterdammers with a Surinamese or Antillean background are descended from these people. Today, descendants are demanding recognition for the suffering inflicted on their ancestors for profit, en masse. This painful past should be part of our national history, we should not be furtively silent about it or condone it.

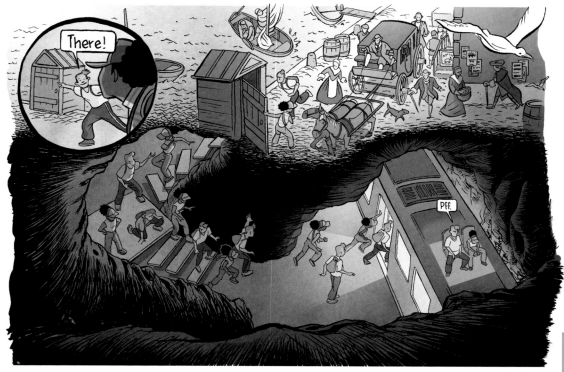

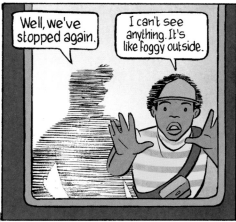

White Dutch people could also be enslaved, for example by pirates from Morocco and Algeria who had captured a Dutch ship. In most cases, their relatives were able to ransom them, using their joint savings to pay. Enslaved people who converted to Islam were often allowed to join the pirates.

One of these, De Veenboer, even became admiral of the Algerian fleet under his new name, Soliman Reys.

Fast forward?
Go to page 142

1872
The New Waterway

In 1866, under the direction of engineer Pieter Caland, work began on the New Waterway (*Nieuwe Waterweg*): a 4.5-kilometre channel, deep enough for the largest vessels of the time, right through what was then called 'De Hoek van Holland' (Hook of Holland). A huge project. It gained our country so much knowledge that we are the biggest player in the world in terms of water management to this day.

In 1872, the New Waterway was completed. Rotterdam's location was very advantageous for international trade. This allowed its port to grow

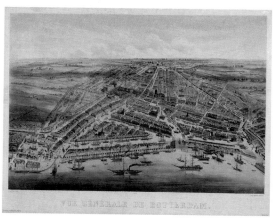

Bird's-eye view of the city of Rotterdam from the south. Vessels are moored at the quay along the Boompjes. On the Nieuwe Maas there are many paddle steamboats alongside a number of sailing vessels. Map from 1855 (collection MM).

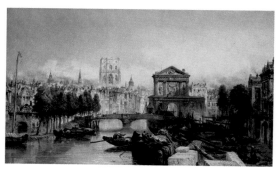

Rotterdam cityscape with Delftsche Poort and Saint Laurens Church. This is what the city looked like in the first half of the twentieth century, before the Second World War. Painting James Webb, 1895.

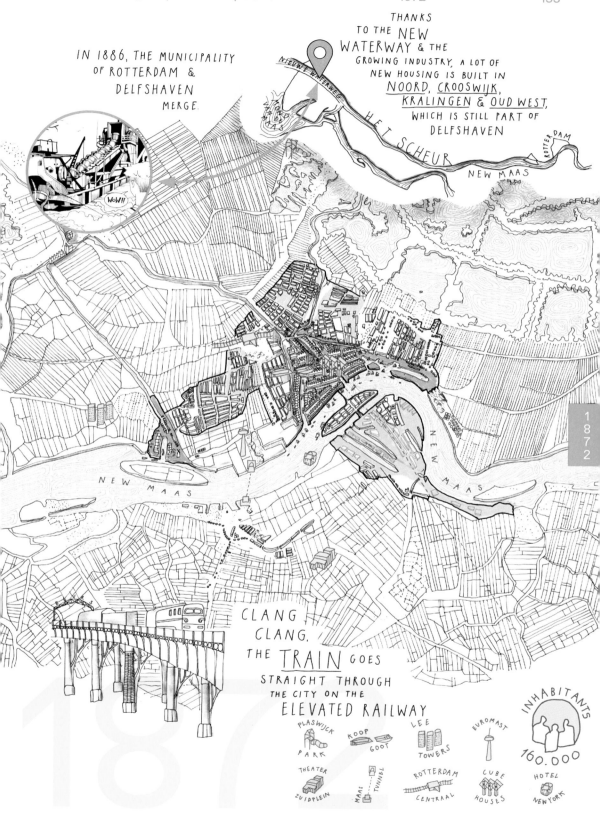

THANKS TO THE NEW WATERWAY & THE GROWING INDUSTRY, A LOT OF NEW HOUSING IS BUILT IN NOORD, CROOSWIJK, KRALINGEN & OUD WEST, WHICH IS STILL PART OF DELFSHAVEN

IN 1886, THE MUNICIPALITY OF ROTTERDAM & DELFSHAVEN MERGE.

NIEUWE WATERWEG

MAAS

HET SCHEUR

ROTTERDAM

NEW MAAS

WOW!!

1872

NEW MAAS

NEW MAAS

CLANG CLANG. THE TRAIN GOES STRAIGHT THROUGH THE CITY ON THE ELEVATED RAILWAY

PLASWIJCK PARK

KOOP GOOT

LEE TOWERS

EUROMAST

INHABITANTS 160.000

THEATER ZUIDPLEIN

MAAS TUNNEL

ROTTERDAM CENTRAAL

CUBE HOUSES

HOTEL NEW YORK

rapidly: Rijnhaven opened in 1895, Maashaven
in 1905 and Waalhaven – the largest dug-out
harbour in the world – in 1910. The city needed
a lot of people to work in and around the harbours.
Rotterdam grew from 160,000 residents in 1872
to 315,000 in 1900. Many workers came from
Noord-Brabant and moved to Rotterdam to live
in districts built from scratch by contractors who
wanted to earn a quick buck. The workers lived in
small dark dwellings on narrow streets, in districts
without parks, and they were poor even though
their children worked hard as well.

1
8
7
2

The last stretch of the New Waterway, the Maas estuary
flowing into the North Sea between Den Briel and Hook of
Holland. Painting, Adam Willaerts, 1633 (collection MBVB).

Wooden model of the Zuidelijke Dam near Hook of Holland. 1874 (collection MM).

Pieter Caland's briefcase. Circa 1860-1870 (collection MM).

Hydraulic engineer Pieter Caland designed the plan for the New Waterway and also directed its digging. Drawing, unknown, 1866-1872 (collection SAR).

On 31 October 1866, William III put the first spade into the ground to celebrate the 'transection of the Hook of Holland', the official starting signal for digging the New Waterway. Drawing, unknown, 1866 (SAR collection).

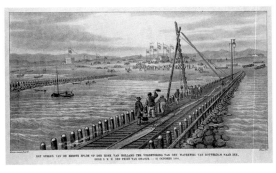

It was minister Johan Rudolf Thorbecke who decided to dig the New Waterway. This is why he is depicted here as a lighthouse illuminating the whole country. Drawing, unknown, 1871 (collection SAR).

Thorbecke made every effort to improve Dutch infrastructure. He was responsible for the New Waterway and for the construction of the railways. Painting, unknown, circa 1789-1872.

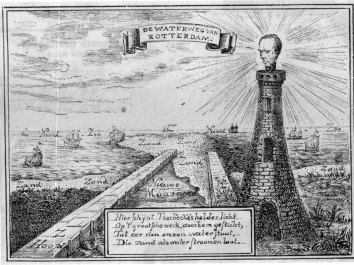

The working-class districts built at the time were the Oude Noorden, the Oude Westen and, a little later, the Nieuwe Westen, Kralingen, Crooswijk, Katendrecht and the Afrikaanderwijk. The city centre also changed: in 1870 the Binnenrotte, around which the city had once been founded, was filled in to build a railway viaduct that allowed the steam trains with their black smoke plumes to run right through the city.

It took years to dig the New Waterway. Work on the removal of the excavated soil continued long after the canal came into use. Photo, J. Perger, 1878 (collection KV).

1
8
7
2

WATERWEG van ROTTERDAM naar ZEE.

Opruimen van gronden uit den Nieuwen Maasmond door den Excavator.

1878.

The old city canals were filled in to make room for the many rattling carts and horse-drawn carriages. The city was noisy and crowded; the quays were full of merchandise, bags and crates.

← Holland Amerika Line.
Design Willem F. ten Broek, 1936.

↓ The Holland Amerika Line (NASM) via Boulogne sur Mer. Jan van Beers, 1898.

↓↓ Map of the Nieuwe Maas and the Scheur showing the work that was done to improve the useability of the waterway between Rotterdam and the North Sea. 1875 (collection MM).

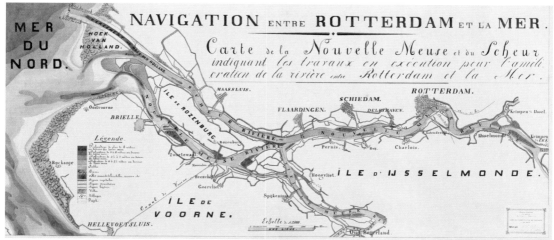

In the city centre, shopping palaces sprang up like those in Paris or London: large shops with shop windows for the city's residents to feast their eyes on the latest fashions. A particularly modern building was the 1897 *Witte Huis* (White House), at 45 metres the tallest building in the Netherlands at the time. It had two lifts, electric light, telephone lines and central heating. Journalists compared it to the skyscrapers in New York.

1
8
7
2

The elevated railway, officially named the Binnenrotte viaduct, was a 2.2-kilometre-long railway flyover. The elevated railway was opened on 28 April 1877 and connected Amsterdam to Belgium. It was the only railway line in the Netherlands that actually ran right through a city centre. Photo, unknown, 1895 (collection SAR).

The Maashaven in Rotterdam; here the largest vessels of the time, with their huge plumes of smoke, gained access to the city. Photo, unknown, 1906 (ANP Photo Archive collection).

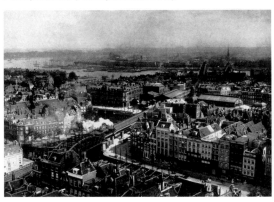

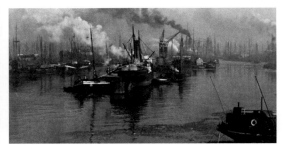

Child labour used to be very common. It was only in 1874 that work by children up to the age of twelve was banned. From 1901, all children aged six to twelve had to go to school. Photo, unknown (collection NA).

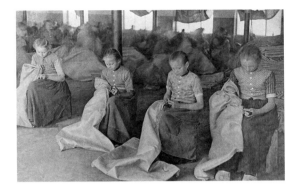

The Hennepgang, one of Rotterdam's many narrow streets, featuring tall houses set close together. Often, whole families would live in a single room. Photo, B.H.W. Berssenbrugge, 1908 (collection SAR).

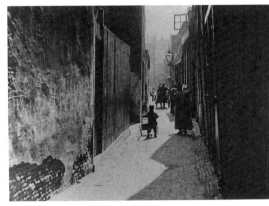

Rotterdam, late nineteenth century. The entire city was built on the water, with the port as its centre. Very different from today: the port has almost disappeared from the city. Photo, unknown.

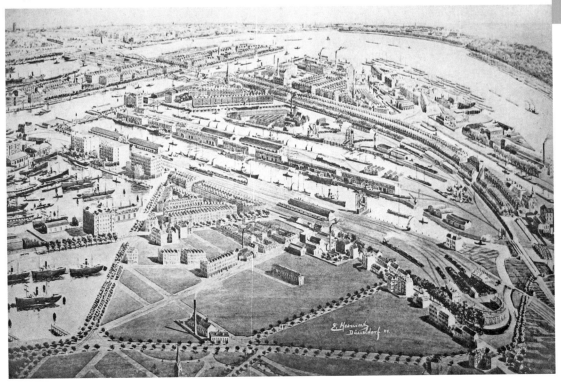

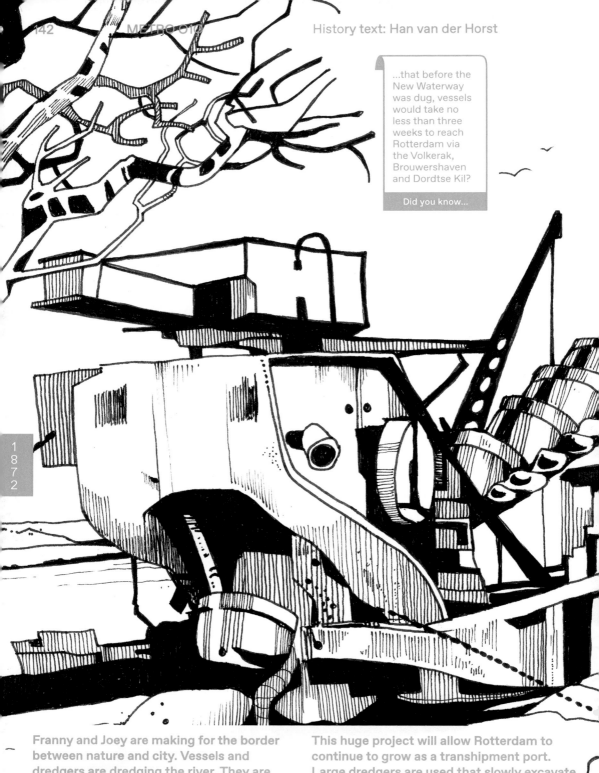

...that before the
New Waterway
was dug, vessels
would take no
less than three
weeks to reach
Rotterdam via
the Volkerak,
Brouwershaven
and Dordtse Kil?

Did you know...

Franny and Joey are making for the border
between nature and city. Vessels and
dredgers are dredging the river. They are
constructing the New Waterway, which
will allow larger vessels to travel between
Rotterdam and the North Sea.

This huge project will allow Rotterdam to
continue to grow as a transhipment port.
Large dredgers are used that slowly excavate
the bottom of the river. The buckets of
sludge are brought to the surface.

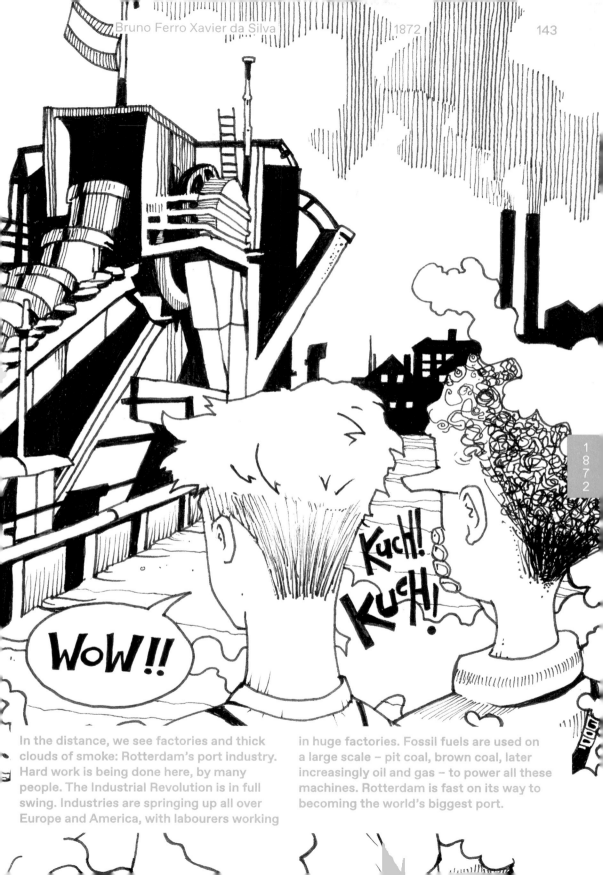

In the distance, we see factories and thick clouds of smoke: Rotterdam's port industry. Hard work is being done here, by many people. The Industrial Revolution is in full swing. Industries are springing up all over Europe and America, with labourers working in huge factories. Fossil fuels are used on a large scale – pit coal, brown coal, later increasingly oil and gas – to power all these machines. Rotterdam is fast on its way to becoming the world's biggest port.

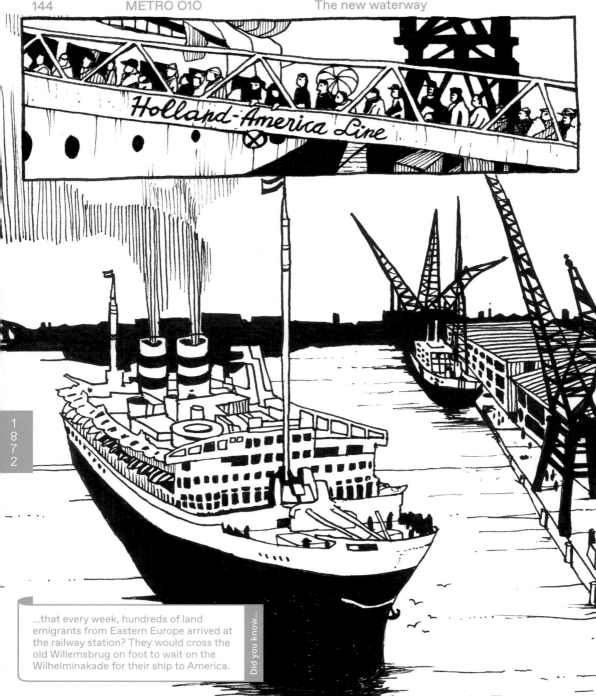

1
8
7
2

> ...that every week, hundreds of land emigrants from Eastern Europe arrived at the railway station? They would cross the old Willemsbrug on foot to wait on the Wilhelminakade for their ship to America.

Did you know...

In 1901, the Holland-America Line advertises 'new twin-screw steamers of 12,500 tonnes'. Here, one is leaving for New York. Is it the *Rotterdam*, the *Amsterdam*, the *Statendam*, the *Potsdam*, the *Maasdam*, the *Rijndam*? Wealthy passengers arrive at the Wilhelmina Pier in carriages; poor emigrants from Eastern Europe haul their meagre possessions onto the steamer themselves. Three million people set off for America from the Wilhelminakade. You can find the names of all passengers between 1900 and 1940 at the Rotterdam City Archives.

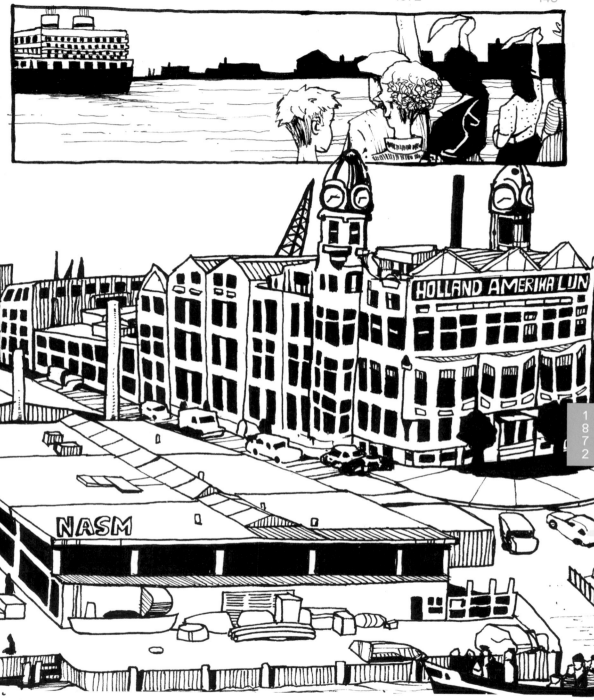

1872

Imagine taking a one-way trip to New York by steamer! It's how Hotel New York came by its name. The office was built in 1901 in the Art Nouveau style as the headquarters of the Holland America Line. Around this time, this legendary shipping company sent steamers carrying emigrants to America once a week.

In 1971, this service stopped. The shipping company could no longer compete with air traffic. Since 1993, Hotel New York has been a hotel and restaurant. In 2024, the Landverhuizersmuseum FENIX (Emigrant Museum) will open in Katendrecht.

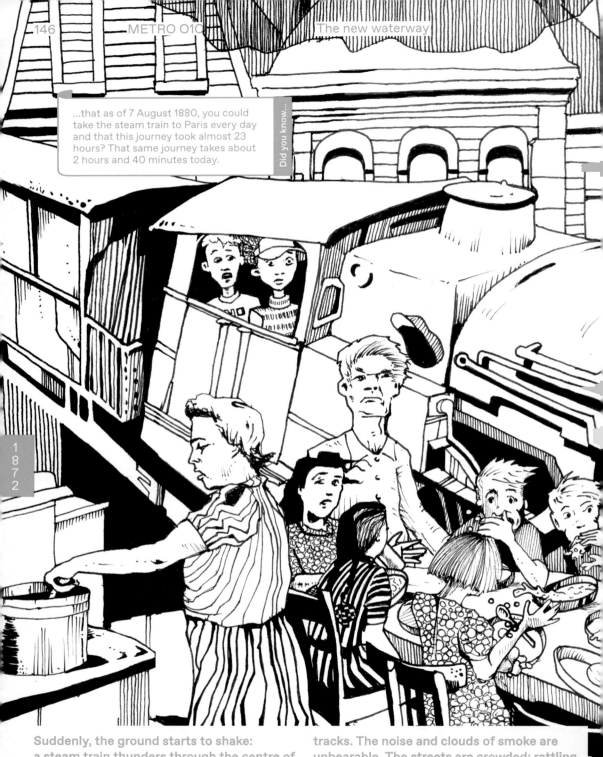

...that as of 7 August 1880, you could take the steam train to Paris every day and that this journey took almost 23 hours? That same journey takes about 2 hours and 40 minutes today.

Did you know...

1872

Suddenly, the ground starts to shake: a steam train thunders through the centre of Rotterdam. A railway line has been built right through the residential area, carrying the train from Amsterdam directly to Dordrecht, Antwerp, Brussels and Paris. Working-class families live in shabby hovels close to the tracks. The noise and clouds of smoke are unbearable. The streets are crowded: rattling handcarts, horse-drawn carriages, the sound of market vendors. There is a market for everything in town: for grain and beer, oil and coal.

Pieter Oud, Mayor of Rotterdam. Photo, J. van Bilsen, 1940 (collection NA).

Harvesting rye on the Vroesenlaan: an urban farm as a solution to the food shortage during the war. Photo, E.A. Hof, 1942 (collection SAR).

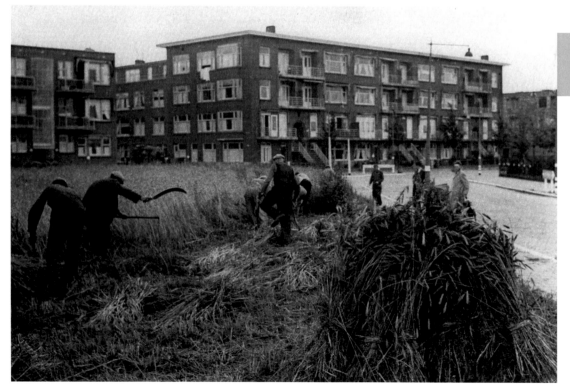

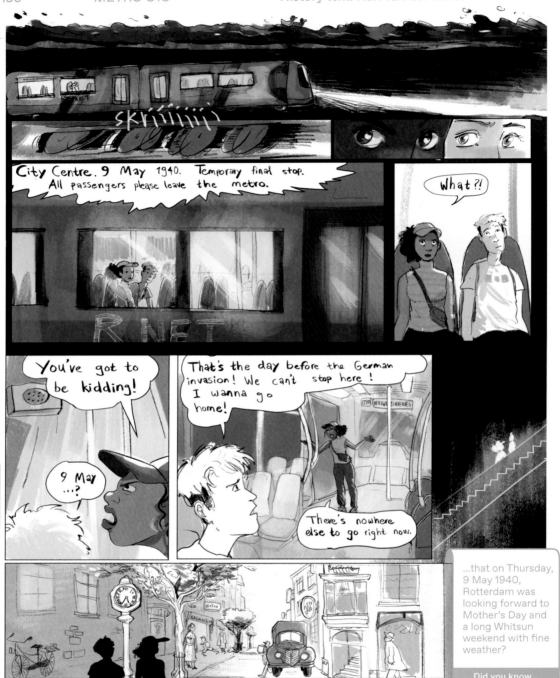

Abraham Tuschinski, a Pole of Jewish descent, actually wanted to travel on to New York with the Holland America Line to pursue a career there. But he stayed in Rotterdam and, through his great zeal and entrepreneurship, became the owner of several magnificent cinemas: Thalia, Cinema Royal, Scala, Olympia and the 1,500-seat Grand Theatre. Audiences empathized deeply with the films. When the in-house orchestra played at intermission, everyone sang along at the top of their voices.

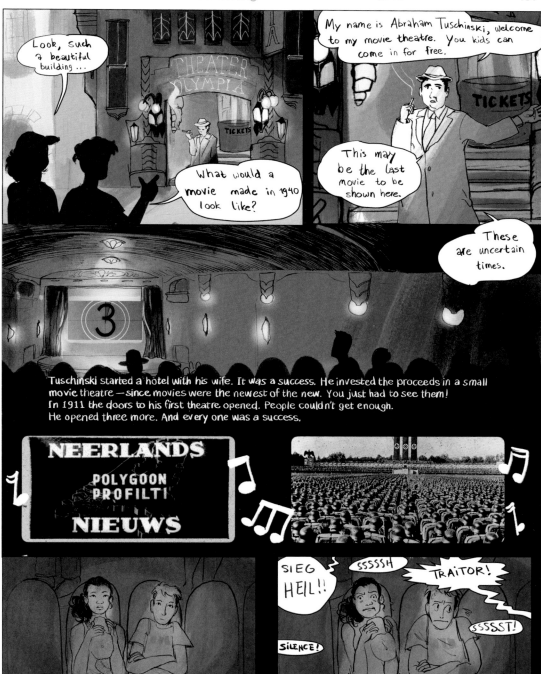

Tuschinski also built cinemas outside Rotterdam. The Theater Tuschinski in Amsterdam, named after him, is perhaps the most beautiful cinema in the world. His Rotterdam cinemas also looked like palaces. Cinema was immensely popular in those years. There was no television, yet; this would only become available around 1960. In 1939, 40.4 million cinema tickets were sold in the Netherlands, which then had a population of 9 million. Proportionally, twice as many people went to the cinema as do today.

The Great Dictator (1940) is a movie written and directed by Charlie Chaplin. It's a sarcastic take on dictator Adolf Hitler, who is called Adenoid Hynkel in the film. Chaplin plays two roles: that of a Jewish barber and that of a dictator.

1940

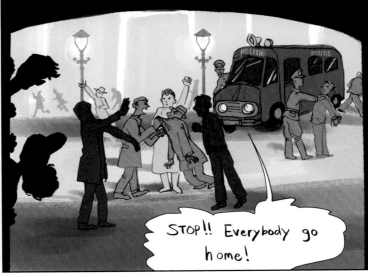

The Great Dictator did not actually run at the Olympia on that night. Its American premiere was not until 15 October 1940. On the programme were De Wrekende Rancher and Verdacht van Moord, both rated 18 and over. Enamoured couples often went dancing after the film, for instance at Dancing Pschorr with its glass, luminous dance floor. Or at Mephisto, where great jazz musicians such as Coleman Hawkins or the Rotterdam-Surinamese hero Kid Dynamite performed.

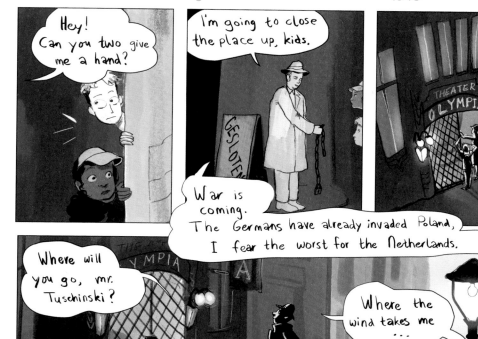

...that Dirk Reese was the king of Rotterdam nightlife alongside cinema owner Tuschinski? Reese owned Dancing Pschorr.

Did you know...

Even before the war, fights between NSB members and dissenters occurred. Leader of the NSB Anton Mussert had told an American journalist that he and his National Socialists would await a German attack 'with arms crossed' – that is, without resisting. Many Dutch people thought this was treason.

It became a scandal. The NSB (National Socialist Movement) existed from 1931 to 1945 and collaborated with the German occupier. NSB members held administrative positions and contributed greatly to the deportation of Jews.

1
9
4
0

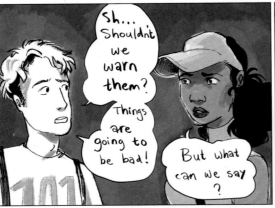

Anyone with half a brain knew that a German invasion was inevitable. Tuschinski's cinemas were destroyed during the bombing, but his prediction that all conviviality would disappear did not come true. During the occupation, there was a run on the remaining cinemas and entertainment venues.

People tried to forget their misery for a couple of hours. Illegal resistance newspapers complained that it was no time for even small pleasures, as the country was being oppressed and countless Jews were being deported.

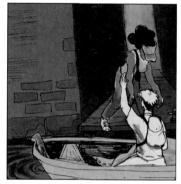

The Netherlands was neutral in the First World War (1914-1918). This is why in 1940, many people thought our country would once again be able to stay out of harm's way. A German officer who hated Hitler informed the Dutch embassy that an attack was imminent, but the government did not heed this warning. On 10 May, shortly after midnight, Dutch airspace was violated by German transport planes full of tanks, paratroopers and soldiers. Goal: capture the whole of the Netherlands. In Rotterdam, the Germans targeted the Waalhaven airfield first.

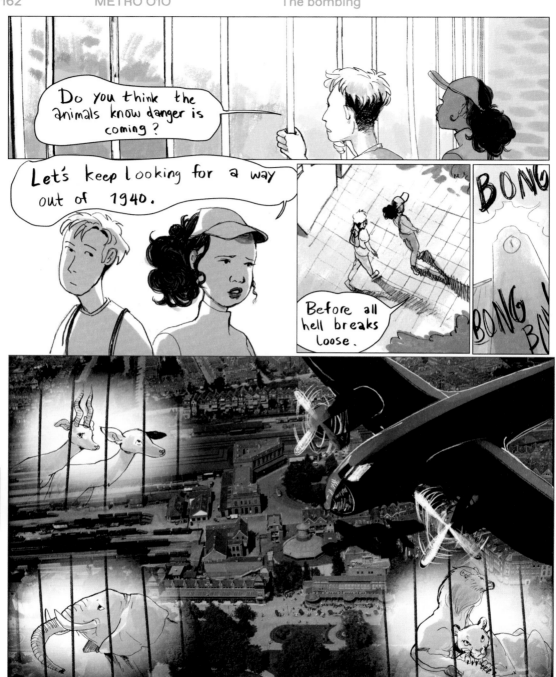

Franny and Joey are arriving at the old zoo in the centre of Rotterdam, roughly where De Doelen is located today. On 12 May, this zoo was badly damaged by bombs, killing many animals, while others escaped. One zebra was spotted running through a shopping street and several sea lions went swimming in the city canals. The zoo's new location was almost ready: the current Blijdorp Zoo, designed by Sybold van Ravesteyn. The move to Blijdorp took place earlier than anticipated.

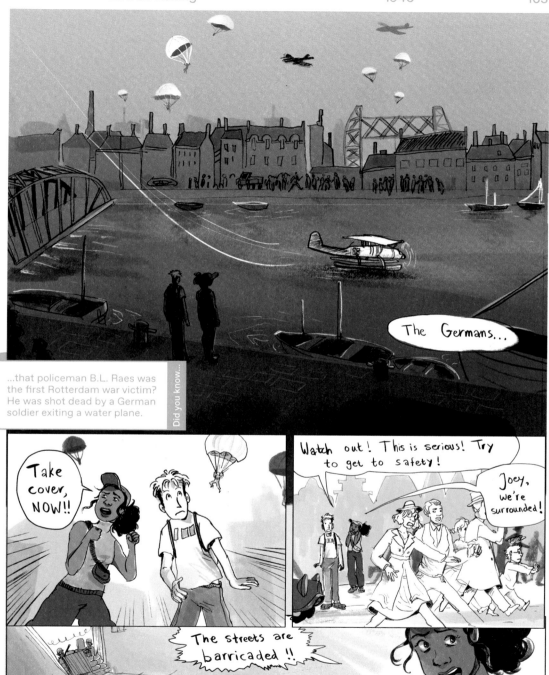

On 10 May 1940, the Germans landed water planes on the Maas River, near the Noordereiland, and tried to capture the bridges over the Maas. Dutch resistance was much fiercer than expected, leading to a battle of Rotterdam. The Germans took over Waalhaven airfield with paratroopers.

They managed to occupy Rotterdam-Zuid and the Noordereiland from there. Meanwhile, the Rotterdammers tried to get to work as usual. At the time, no one knew what this war was going to bring.

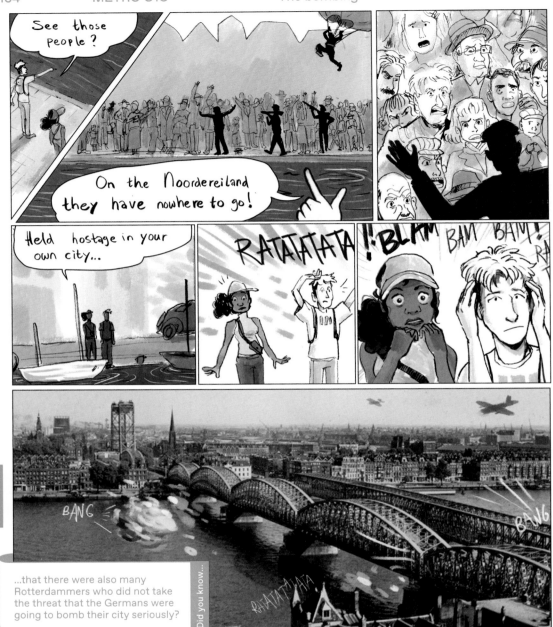

The battle for the bridges over the Maas in Rotterdam began in the early hours of 10 May and ended on 14 May with the surrender of the Dutch after the big bombing. The possession of these bridges was of crucial importance to the Germans. Except for the Marines, most Dutch soldiers did not normally have combat duties – they would bake bread for the troops, for example – yet they resisted fiercely for four days. The German paratroopers landing between the cities of The Hague and Rotterdam were taken out.

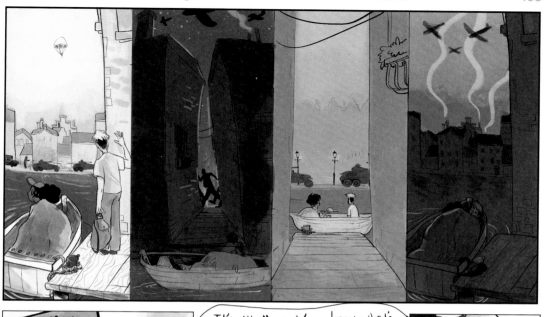

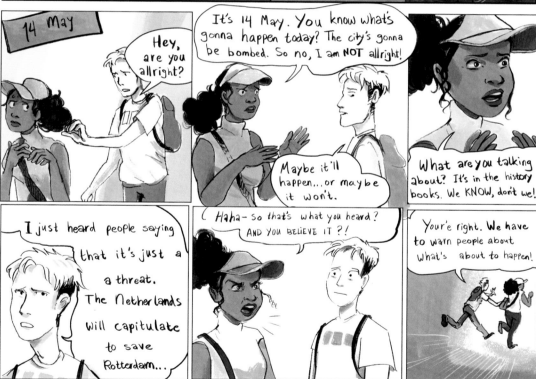

While the Dutch army held firm in Rotterdam, the Germans advanced from the east and south. Dutch Commander-in-Chief Henri Winkelman was given supreme government power in the Netherlands on 13 May, after the Queen and the government had fled to London. He was ordered to keep fighting until it was nothing more than senseless bloodshed. The bombing of Rotterdam on 14 May, followed by the threat of a bombing of Utrecht, made Winkelman decide that resistance had become futile.

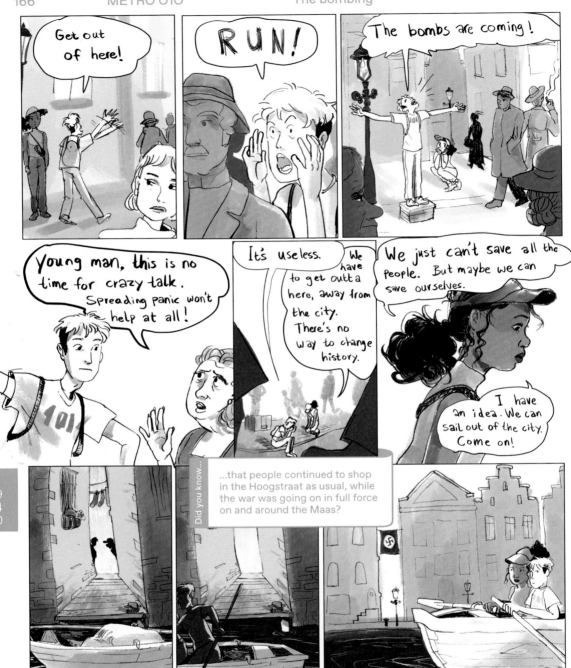

As early as 10 May, many believed in a 'fifth column' of German soldiers who had supposedly been dropped behind the front line in disguise – as nuns, as priests, as Dutch soldiers – to commit acts of sabotage together with Germans living in the Netherlands. Supposedly they collected intelligence, spread false rumours, spoiled Dutch morale, gave instructions to enemy troops, yes, even handed out poisoned sweets to Dutch children. One and all hunted down members of this fifth column. Later, the stories almost always turned out to be alarmist.

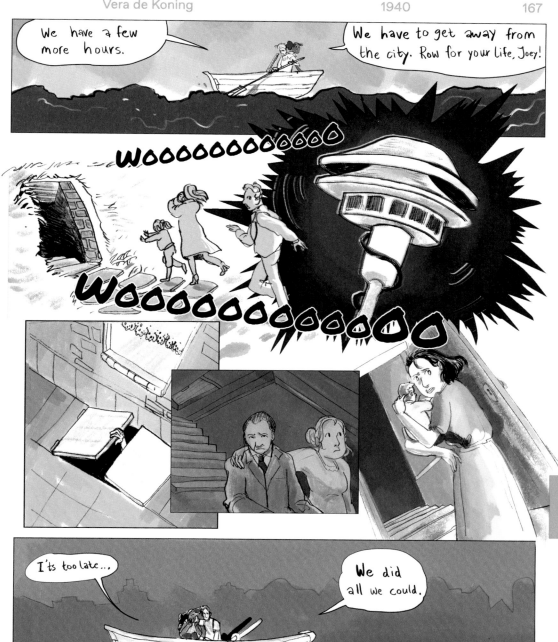

On the morning of 14 May, German negotiators visited the Dutch commander in Rotterdam, Colonel Pieter Scharroo, to demand Dutch surrender. Otherwise, a bombing would follow. Scharroo first wanted to see a letter signed by the German commander. Only then did he ask Winkelman's permission to surrender. But by then the bombers were already in the air. Most pilots did not see the flares that the Germans fired from the ground as a warning. It was too late for mayor Oud to organize an evacuation.

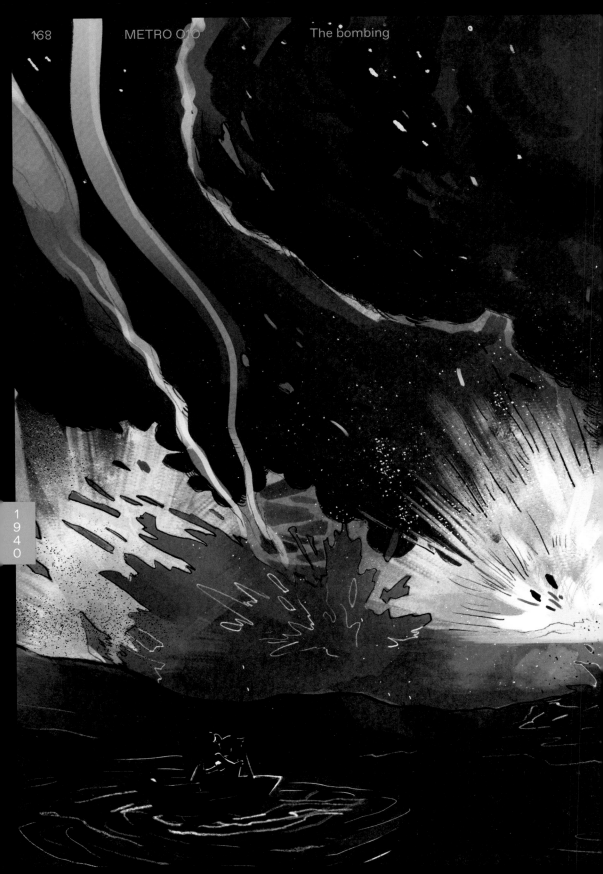

1
9
4
0

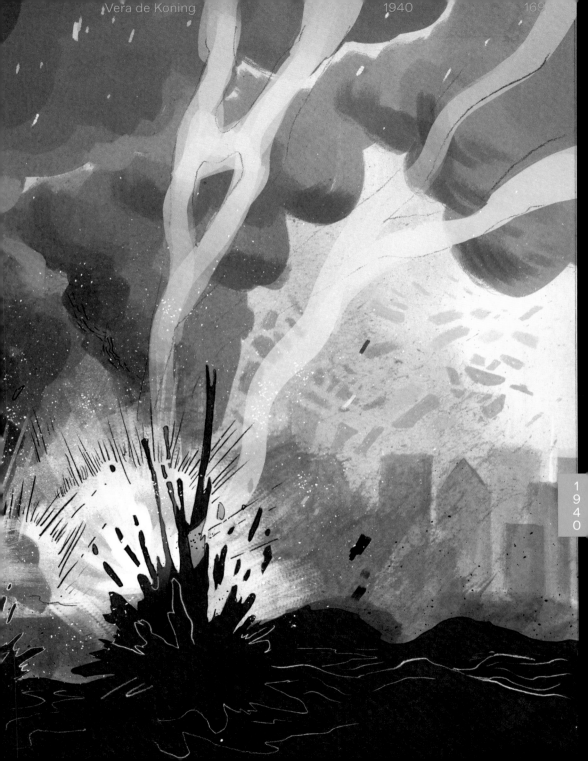

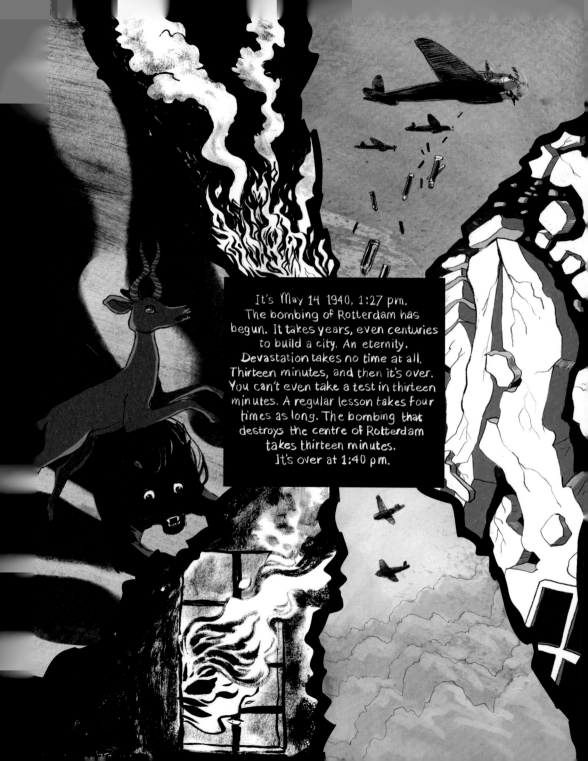

It's May 14 1940, 1:27 pm. The bombing of Rotterdam has begun. It takes years, even centuries to build a city. An eternity. Devastation takes no time at all. Thirteen minutes, and then it's over. You can't even take a test in thirteen minutes. A regular lesson takes four times as long. The bombing that destroys the centre of Rotterdam takes thirteen minutes. It's over at 1:40 pm.

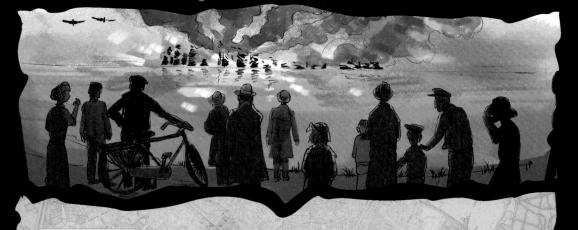

...that the German bombing on 14 May destroyed 250 hectares of city? You can get an idea of the scale by taking the 'Fire Boundary'-walk along the markings of this area.

Did you know...

Fatality estimates range from 800 to 1,400. Some 30,000 buildings were badly damaged and more than 80,000 Rotterdammers lost their homes.

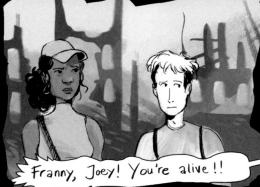

Franny, Joey! You're alive!!

They fled in all directions by the thousands, mainly towards the Kralingse Bos and the Land van Hoboken.

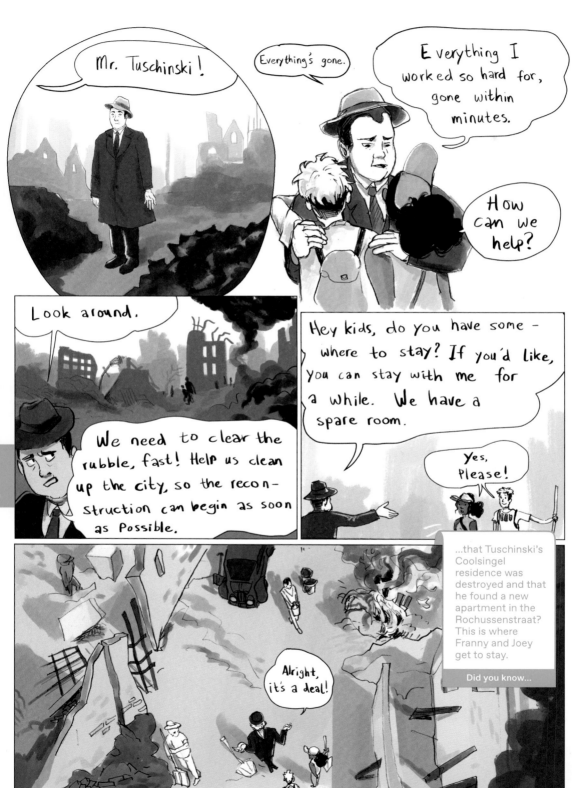

The biggest human disaster to hit Rotterdam in the Second World War was the Holocaust. It started with discrimination against Jews: their telephones and radios were taken away, they were no longer allowed to sit on park benches, they had to wear the Star of David. Everywhere were signs saying 'Jews Not Wanted'. Of 13,000 Jewish Rotterdammers, less than 1,400 survived. 6,790 people were called to report to Loods 24, between the Binnenhaven and Spoorweghaven on Zuid, and were put on transport to Auschwitz and Sobibor. Of these people, 6,302 died.

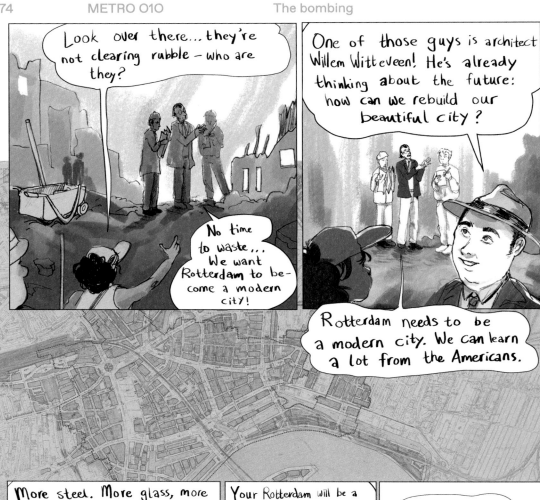

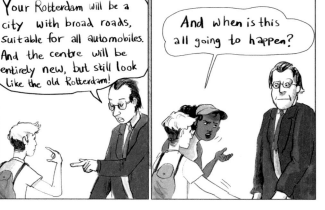

Engineer Willem Gerrit Witteveen, director of the Municipal Technical Department, had to design a reconstruction plan immediately after the bombing. He set up camp beds for his staff to stay at work overnight. After just ten days, they completed a first sketch of Rotterdam's new city centre. There was to be plenty of space for cars, replacing the hovels. If you want to see what Witteveen liked, why not visit the Blijdorp district, or the former bank building on Coolsingel that now houses a bookshop.

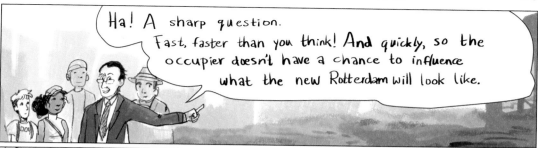

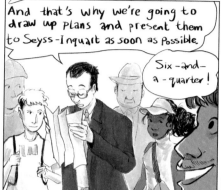

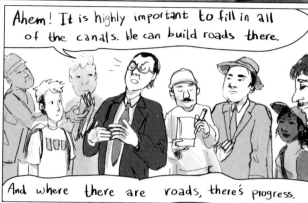

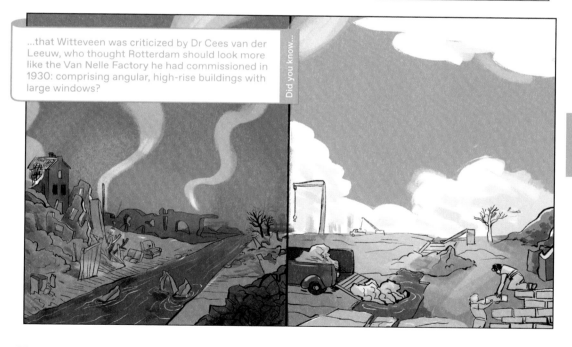

...that Witteveen was criticized by Dr Cees van der Leeuw, who thought Rotterdam should look more like the Van Nelle Factory he had commissioned in 1930: comprising angular, high-rise buildings with large windows?

Did you know...

1940

The Rotterdam Schie was filled in with debris from the destroyed city centre to make room for a wide traffic road connecting Rotterdam to The Hague and Amsterdam. The bricks from the destroyed buildings were chipped off and reused as much as possible, for example to build emergency housing and emergency shops. Entire districts were built using these bricks at the time. All in all, workers extracted circa 50 million bricks from the rubble: plenty of building material. By necessity, people were already doing a lot of recycling back then.

1
9
4
0

Immediately after the capitulation of the
Netherlands, Rotterdam began to fanatically
clear the rubble. Even buildings that were
only partially damaged and could have been
restored were demolished. In Middelburg,
by contrast, the city centre had also
been destroyed, but there they opted for
restoration. In Rotterdam, 17,000 men and
women came to help clear what was called
de puin – 'the rubble' – in Rotterdam-speak.
They earned 1.5 guilders a day. Curious
onlookers were given a flyer stating: 'Viewers
and talkers are of no use to us! Go home or
sign up as a volunteer.'

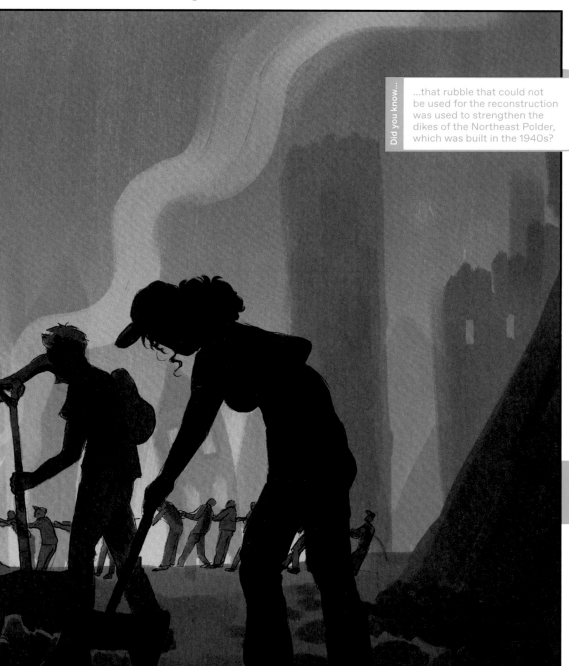

...that rubble that could not be used for the reconstruction was used to strengthen the dikes of the Northeast Polder, which was built in the 1940s?

1 9 4 0

Dirk Hannema, the then-director of Museum Boijmans, did his best to protect the museum's art treasures. He had the sculpture of Erasmus buried in the museum garden, for example. To improve the museum's chances, Hannema started collaborating with the Nazis. This allowed him to organize wartime exhibitions. This was of course frowned upon after the liberation and so he was dismissed.

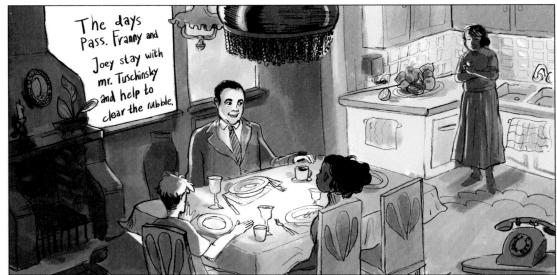

Seyss-Inquart was Reich Commissioner of the occupied Netherlands – the highest representative of German authority, feared by all. Hitler was the great leader in his life. Arthur Seyss-Inquart, born Artur Zajtich, first belonged to the 'moderate' wing of the Austrian Nazis, but later turned extremist.

In the year of 1946, he was found guilty of war crimes and crimes against humanity at the Nuremberg war crimes trials and subsequently hanged.

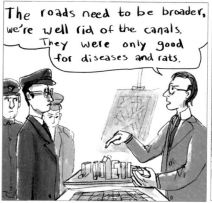

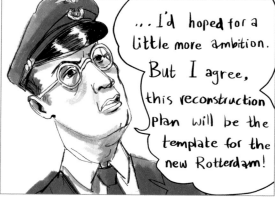

Arthur Seyss-Inquart, who was also mockingly called 'six-and-a-quarter', believed that Rotterdam should become one of the main ports in the Great German Empire. He therefore supported the reconstruction in the first years after the bombing. In 1942, the Maas Tunnel

was completed. In 1943, however, he had the construction projects stopped because all available building materials had to be used for bunkers and fortifications. The new priority was the Atlantic Wall, a German defence line of more than 5,000 kilometres.

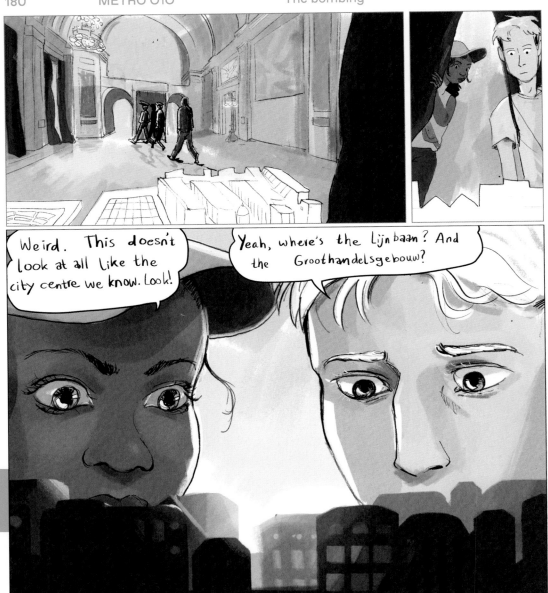

1940

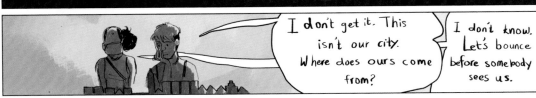

Franny and Joey are looking at a never-realized model by Witteveen. Witteveen was not modern enough in the eyes of prominent Rotterdammers. He had to make way for his successor, engineer Cornelis van Traa, who wanted a radically new Rotterdam. He designed the city with the clean lines and blocks we know from the Wederopbouwcentrum (center for post-war reconstruction). There was no more room for Witteveen's vision. Is that a pity, or is it just as well? Take a look at the reconstruction architecture in the next chapter and decide for yourself!

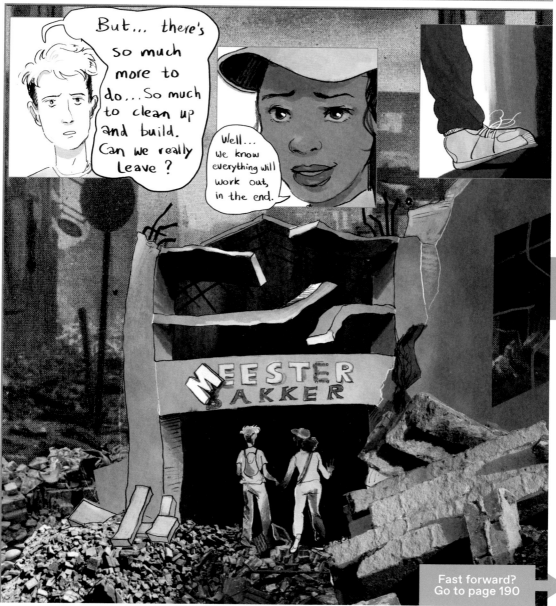

Fast forward?
Go to page 190

CHANGE

Earlier we learned forbearance
And the harbours with their water
Talked about later
And about how we together

Must learn to build
For a future
And how this is our due
Slowly growing with us
Until everything blossoms anew
And until we again whole

1945
Post-war reconstruction

Perhaps cynically, the 1940 bombing made room for renewal, which is why the post-war reconstruction was dubbed 'the German city renovation'. Rotterdam humour.
Cornelis van Traa was chief assistant to city architect Witteveen during the war years. When Witteveen became overworked and went on sick leave in 1944, Van Traa took over his duties.
In 1946, Van Traa's *Basisplan voor de Wederopbouw* (Basic Reconstruction Plan)

As early as 18 May 1940, four days after the bombing, city architect Willem Witteveen was commissioned by the city council to design a reconstruction plan. Photo, Spaarnestad Fotoarchief, 1940 (collection SAR).

In 1944, Cornelis van Traa succeeded architect Witteveen. His renewed *Basisplan* not only provided for the reconstruction, but also for the demolition of several buildings that had survived the bombing but had to make room for the new layout. Photo, unknown, 1962 (collection SAR).

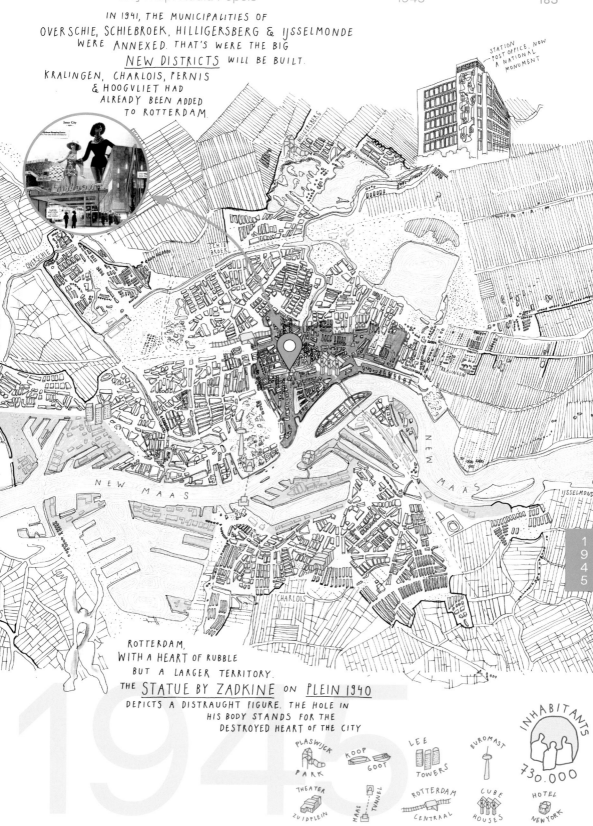

IN 1941, THE MUNICIPALITIES OF
OVERSCHIE, SCHIEBROEK, HILLIGERSBERG & IJSSELMONDE
WERE ANNEXED. THAT'S WERE THE BIG
__NEW DISTRICTS__ WILL BE BUILT.
KRALINGEN, CHARLOIS, PERNIS
& HOOGVLIET HAD
ALREADY BEEN ADDED
TO ROTTERDAM.

STATION
POST OFFICE, NOW
A NATIONAL
MONUMENT

Inner City

HILLEGERSBERG

SCHIE
BROEK

OVERSCHIE

KRALINGEN

N E W M A A S

IJSSELMONDE

N E W M A A S

CHARLOIS

1945

ROTTERDAM,
WITH A HEART OF RUBBLE
BUT A LARGER TERRITORY.
THE __STATUE BY ZADKINE__ ON __PLEIN 1940__
DEPICTS A DISTRAUGHT FIGURE. THE HOLE IN
HIS BODY STANDS FOR THE
DESTROYED HEART OF THE CITY

1945

PLASWIJCK
PARK

KOOP
GOOT

LEE
TOWERS

EUROMAST

INHABITANTS
730.000

THEATER
ZUIDPLEIN

MAAS
TUNNEL

ROTTERDAM
CENTRAAL

CUBE
HOUSES

HOTEL
NEW YORK

was adopted by the city council. Architects and businessmen wanted Rotterdam to be more modern, with more room for traffic. The port needed to be bigger for the economy to be able to grow.

The priority was to restore the Rijnhaven, Maashaven and Waalhaven, which had been blown up by the Germans. At the same time, Van Traa started thinking about new harbour basins, factories and refineries. This led to the construction of the Botlek and Europoort. The city centre was radically modernized: the narrow streets and picturesque canals of yesteryear did not return.

1945

Map from Witteveen's *Wederopbouwplan*.
December 1941 (collection SAR).

Newbuild on Coolsingel.
Photo, W. van Rossem, 1956 (collection NA).

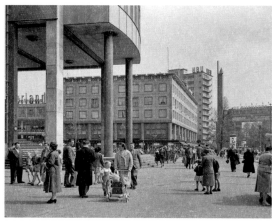

A couple of buildings were more or less spared, including the Saint Laurens Church, the City Hall, the Post Office, the Erasmushuis, Hotel Atlanta, Beurs and the Schielandhuis. But hardly any other building was left intact.

All the remains of damaged buildings were demolished. Nothing was allowed to stand in the way of the *Basisplan*. The new centre was to be an efficient hub of spacious traffic routes and concrete architecture. People from abroad came to watch Rotterdam reinvent itself.

The Groothandelsgebouw, designed by architects Van Tijen and Maaskant, is the key symbol of Rotterdam's reconstruction. When it was completed in 1953, it was the largest building in the Netherlands. Photo, unknown, 1953 (SAR).

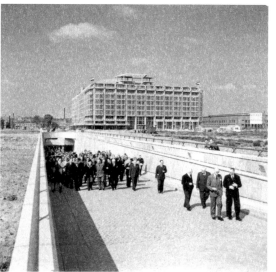

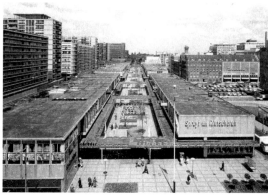

A pedestrians-only street like Lijnbaan, a new shopping concept, was an international novelty. Photo, unknown, 1956 (collection SAR).

Around the city, many new residential areas with
industrially produced residential blocks rose up in
the countryside: Pendrecht, Zuidwijk, Hoogvliet,
Het Lage Land and Lombardijen. The dwellings
had large windows at the front and back, separate
bedrooms for parents and children, a kitchen with
a geyser and a private bathroom.

The reconstruction period was a time of optimistic
belief in progress: city dwellers would have more
free time, earn a little more each year and be
able to save up for a television, washing machine,
refrigerator and car.

Hofplein, the roundabout as the centre
from which new roads departed. Photo,
unknown, 1954 (collection SAR).

1
9
4
5

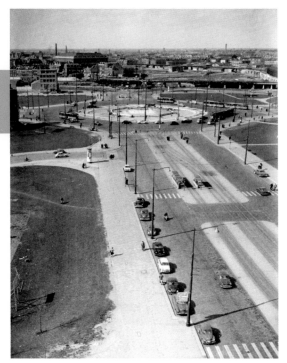

For the 80,000 residents made
homeless by the bombing, whole
districts of emergency housing were
built, like this Utrecht Village. Photo A.
de Herder, 1940 (collection SAR).

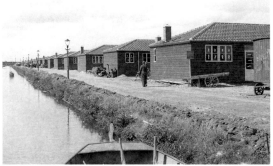

→ Map of the Port of Rotterdam, from the centre to the Botlek, commissioned by the Stichting Havenbelangen. This map hangs in Rotterdam's City Hall. 1958 (collection MM).

↘ Ossip Zadkine's famous sculpture *De Verwoeste Stad (The Destroyed City)* represents the dramatic destruction of the centre of Rotterdam; it's a man without a heart, holding up his arms in despair. Unveiled in 1953. Photo, A. de Herder, 1988 (collection SAR).

↓ Map of Rotterdam showing the 1940 street pattern and over it, darker in colour, the new post-war construction plans. 1955 (collection MM).

↓↓This neighbourhood of emergency dwellings, known as the Brabantse Dorp, was built near Zuidplein in 1941. The complex was demolished in 1965-1966. Photo, J. van Rhijn, 1941 (collection SAR).

↘↘ Temporary shopping streets were made of bricks taken from the rubble, neatly chipped off and painted white. This prevented people from noticing how blackened the bricks actually were. Photo, unknown, 1941 (collection SAR).

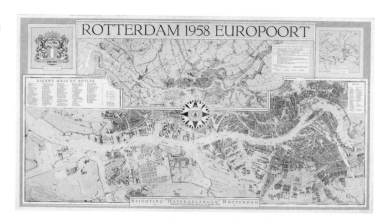

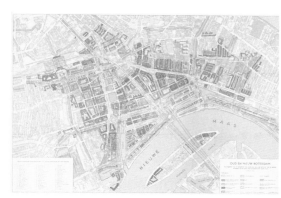

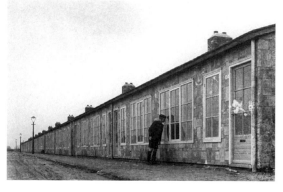

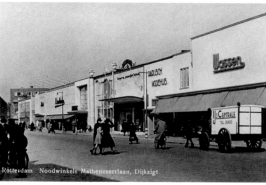

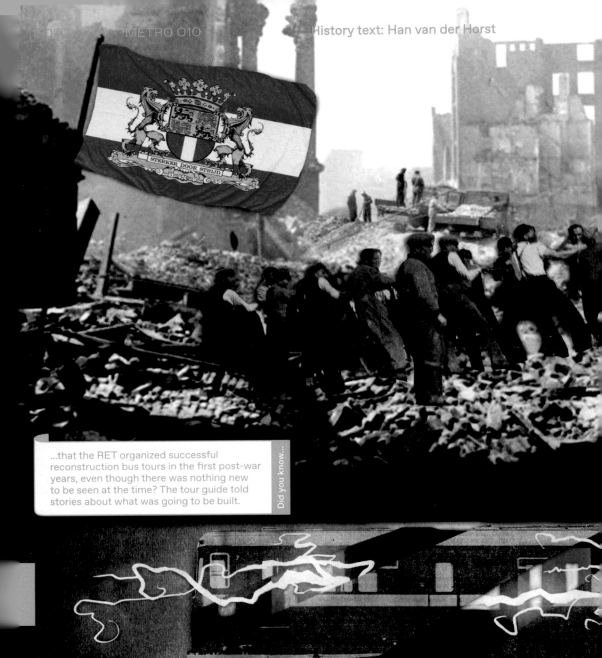

STERKER DOOR STRIJD

...that the RET organized successful reconstruction bus tours in the first post-war years, even though there was nothing new to be seen at the time? The tour guide told stories about what was going to be built.

After the liberation on 5 May 1945, there was a huge housing shortage in Rotterdam, but the recovery of industry and the port was given priority. The Germans had looted many factories and destroyed much of the port, including 40 per cent of the quays.

Until 1950, valuable machinery was recovered from Germany, as well as some trams. The devastated city centre was next, but not until the 1950s. Of the temporary shops and places of entertainment, only restaurant Old Dutch on Rochussenstraat survives.

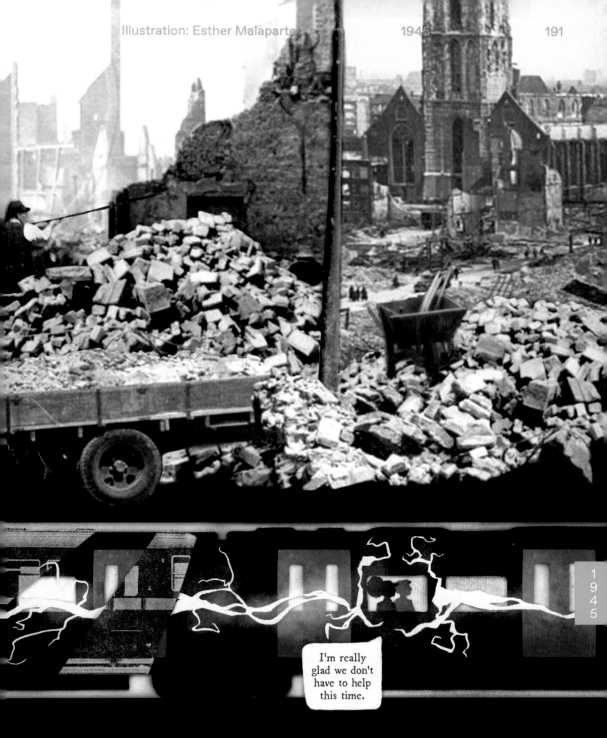

After the war, many Rotterdammers were filled with nostalgia for the vanished inner city. Books with photos and old memories were in great demand. People missed the cosiness of the old days. But even without the bombing, much would certainly have been demolished. Thousands of hovels

had been scheduled for demolition. And even before the bombing, many urban beauties had disappeared, such as the Zakkendragershuis, the Ooster Church and the windmills around the old town. Only Korenmolen De Noord had survived, but it burned down in 1954.

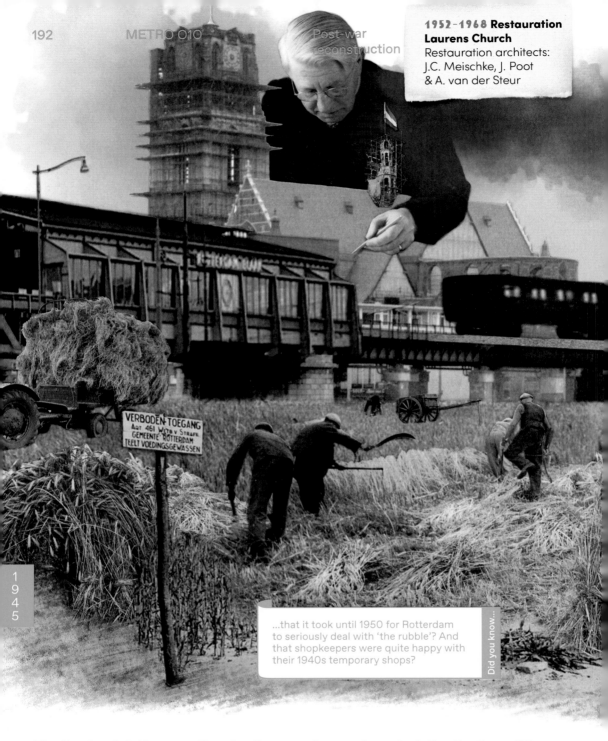

Post-war reconstruction

1952-1968 Restauration Laurens Church
Restauration architects:
J.C. Meischke, J. Poot
& A. van der Steur

VERBODEN TOEGANG
Art 461 Wtbk v Strafr.
GEMEENTE ROTTERDAM
TEELT VOEDINGSGEWASSEN

1945

...that it took until 1950 for Rotterdam to seriously deal with 'the rubble'? And that shopkeepers were quite happy with their 1940s temporary shops?

Did you know...

The Great or Saint Laurens Church, often referred to simply as Laurens Church, is the only remaining medieval building in Rotterdam. In 1952, Queen Juliana laid the foundation stone for its restoration, which was not completed until 1968. The church contains several attractions, including the bronze doors depicting the theme 'War and Peace' – a design by renowned Italian sculptor Giacomo Manzú. The 23-metre-high church organ has 7,600 pipes. It's the largest organ in the Netherlands and the largest mechanically driven organ in Europe.

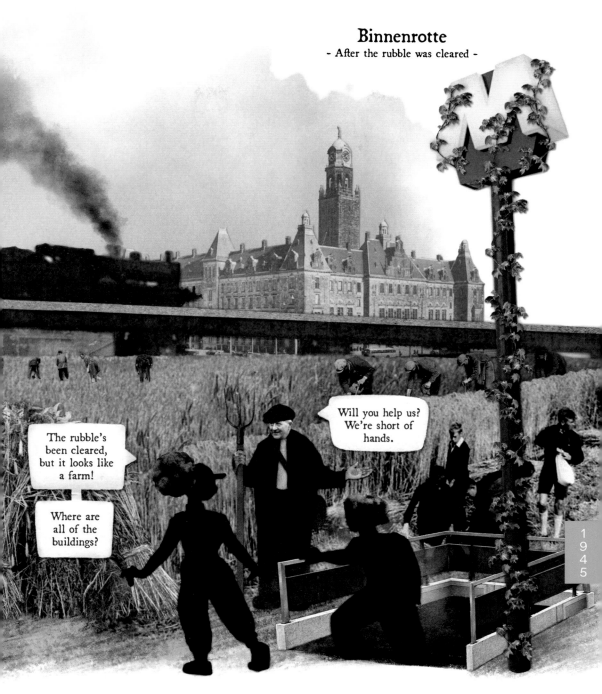

Binnenrotte
- After the rubble was cleared -

From 1941, vegetables and grain were grown on 'the rubble' in Rotterdam. During the occupation, the available food had to be distributed as fairly as possible among the population. People were given coupons with which they could buy a measured amount of food and fuel.

This prevented famine – until the start of the Hunger Winter at the end of 1944. Today's urban agriculture focuses on promoting organic farming and environmentally conscious living, for example through food forests and rooftop vegetable gardens.

Weena
- 1950s -

1953 Groothandelsgebouw
Architects: H.A. Maaskant
& W. van Tijen

Wow! They've built a lot here!

The fountain is even on, ready for Feyenoord's championship!

1945

1955 Hofplein Fountain
Architect: J.R.A. Koops
Artist of the water animals:
C. van Kralingen

'The rubble' was still bare in the first years after the war, but then things started to move forward. The Groothandelsgebouw of 1953, which later became a multifunctional business building (*Groot Handelsgebouw* literally means Large Wholesale Building), was the key symbol of the reconstruction:

220 metres long, 85 metres wide and 43 metres high, a whopping 445,000 square metres in nine storeys. The Hofplein fountain was completed in 1955. In 1990, someone put orange paint in the water because of the World Cup. Since then, the fountain water has been coloured often on special occasions.

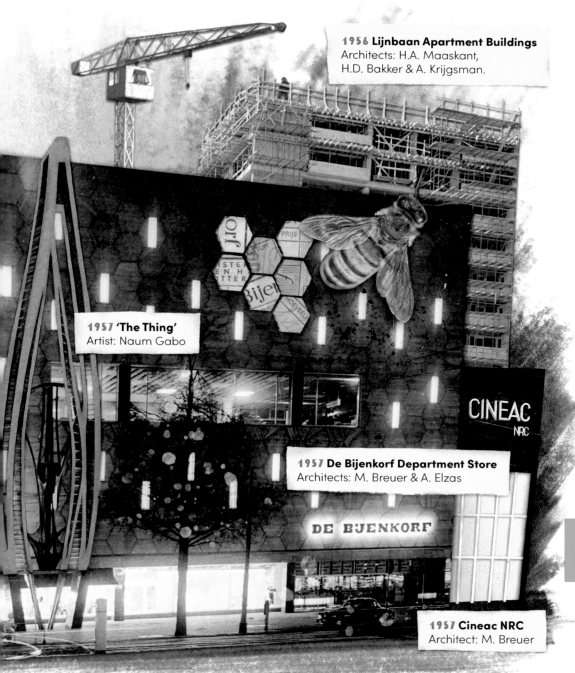

1956 Lijnbaan Apartment Buildings
Architects: H.A. Maaskant,
H.D. Bakker & A. Krijgsman.

1957 'The Thing'
Artist: Naum Gabo

CINEAC
NRC

1957 De Bijenkorf Department Store
Architects: M. Breuer & A. Elzas

DE BIJENKORF

1957 Cineac NRC
Architect: M. Breuer

1945

Part of the centre that arose during the reconstruction period has since been replaced in turn: the C&A on the Coolsingel, the V&D on the Rodezand and a shopping arcade on the Hoogstraat, where the Markthal now sits. In recent years, there's been a renewed appreciation of reconstruction architecture.

...that architects from all over Europe came to look at the Lijnbaan in 1953? A pedestrian-only shopping area was an entirely new phenomenon!

Did you know...

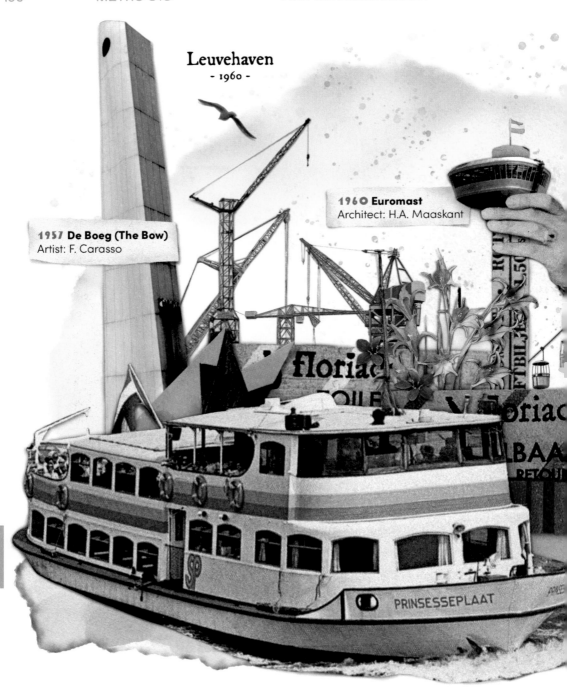

Leuvehaven
- 1960 -

1960 O Euromast
Architect: H.A. Maaskant

1957 De Boeg (The Bow)
Artist: F. Carasso

flor\[a...

...OILE...

V...loria...

...LBAA

RETOU...

PRINSESSEPLAAT

1945

Artist Fred Carasso's monument *De Boeg* (The Bow) in Rotterdam commemorates fallen sailors: the 3,500 sailors from Dutch merchant ships who lost their lives in the Second World War. Ossip Zadkine's *De Verwoeste Stad* is also one of the 51 war memorials. The Euromast was built as the centrepiece of the Floriade in 1960, an international horticultural exhibition that took place on both sides of the Westzeedijk. Visitors travelled from one side to the other by cable car. Four million people visited from all over the world.

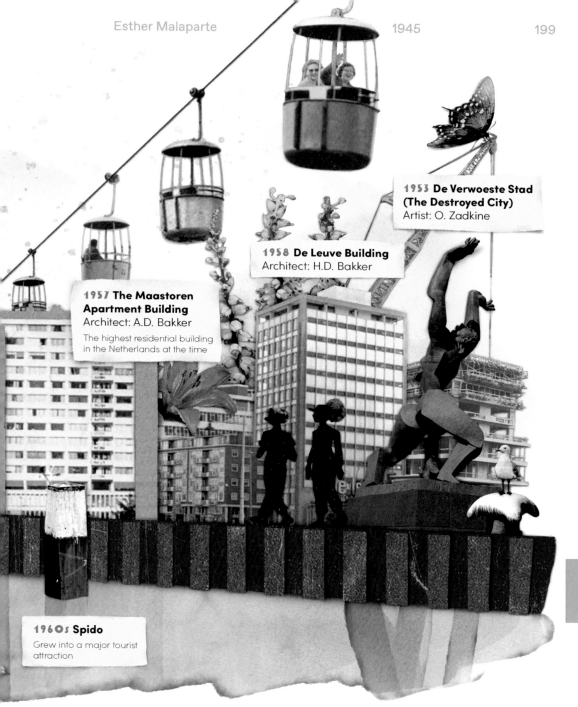

1953 De Verwoeste Stad (The Destroyed City)
Artist: O. Zadkine

1958 De Leuve Building
Architect: H.D. Bakker

1957 The Maastoren Apartment Building
Architect: A.D. Bakker

The highest residential building in the Netherlands at the time

1960s Spido
Grew into a major tourist attraction

Since 1947, many Rotterdammers have taken their out-of-town guests on a tour of the port on a Spido vessel. Waterborne transport had existed for much longer. In 1919, George van Beuningen came up with the idea of using small craft to transport goods and people to and from vessels. They followed fixed routes. Special ambulance boats were also introduced to cater to the sick.

...that the port moved in the direction of the Botlek and the Maasvlakte, where there was room for the new super tankers, while work on the city centre and the new residential areas continued unabatedly?

Did you know...

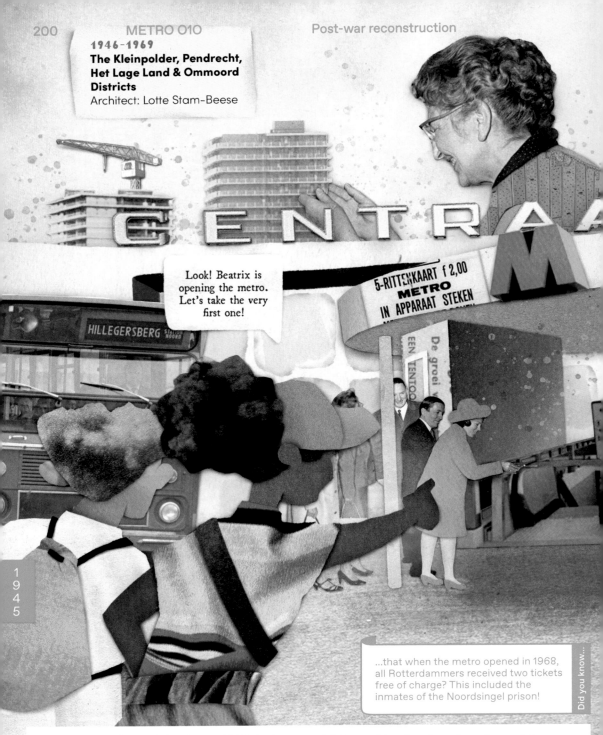

1946-1969
The Kleinpolder, Pendrecht, Het Lage Land & Ommoord Districts
Architect: Lotte Stam-Beese

Look! Beatrix is opening the metro. Let's take the very first one!

5-RITTENKAART f 2,00
METRO
IN APPARAAT STEKEN

De groei

EEN TENTOO

HILLEGERSBERG

1945

When the old Central Station, a 1957 design by Sybold van Ravesteyn, was demolished, many Rotterdammers were sad at the loss of the building. Pieces of the old station building have been incorporated in the current Central Station, which dates from 2014. For instance, two statues (also known as *speculaasjes*), which used to stand on the wings of the stations, have been placed above the tunnel from the city centre to the Provenierswijk. In addition, the original station clock and the letters CENTRAAL STATION adorn its façade.

Central Station
- February 9ᵗʰ, 1968 -

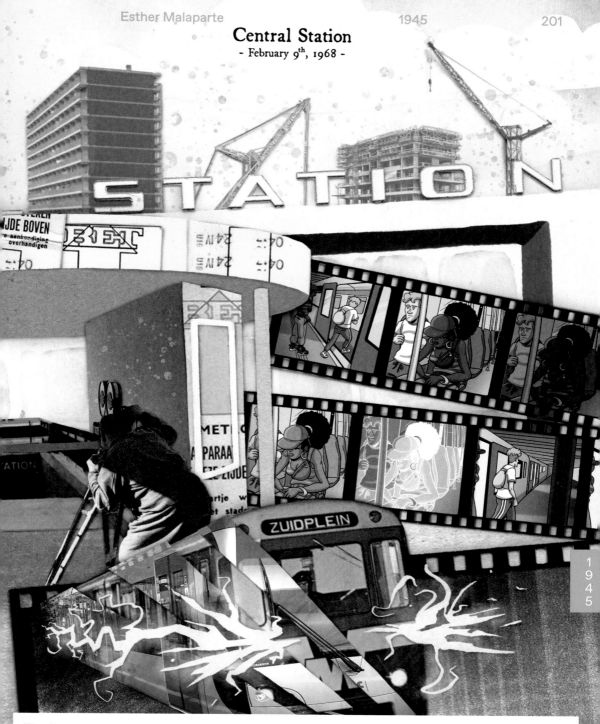

The Rotterdam metro was officially opened by Princess Beatrix and Prince Claus on 9 February 1968. Public interest was enormous: 200,000 people took a ride in the first two days. Rotterdam Alexander railway station opened in 1968. The residents of Ommoord and Het Lage Land, post-war newbuild housing estates which where designed by Lotte Stam-Beese, had to wait until 1983 for a first metro line. The Alexandrium shopping centre – bigger than Zuidplein – was completed in 1984.

Fast forward?
Go to page 212

1970
Urban renewal

During the post-war reconstruction, the city council was mainly concerned with expanding the port and making money: the economic growth of the city was paramount.

But what about ordinary Rotterdammers?
They had to live in an unhealthy city with polluted air and dirty drinking water. They lived in hovels in the old districts, such as the Oude Noorden, the Oude Westen and Feijenoord. Their dwellings, built in the late nineteenth century for dock workers, were dilapidated, small and had no bathrooms. The streets were packed with cars and these districts had no open spaces or parks.

The impoverishment of old buildings: Batavierenstraat in the Oude Westen. Photo, unknown (collection NA).

In procession, locals from the Oude Westen marched on the City Hall to strengthen their demands. Photo, A. Groeneveld, 1968-1973 (collection SAR).

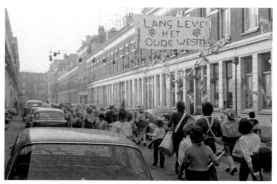

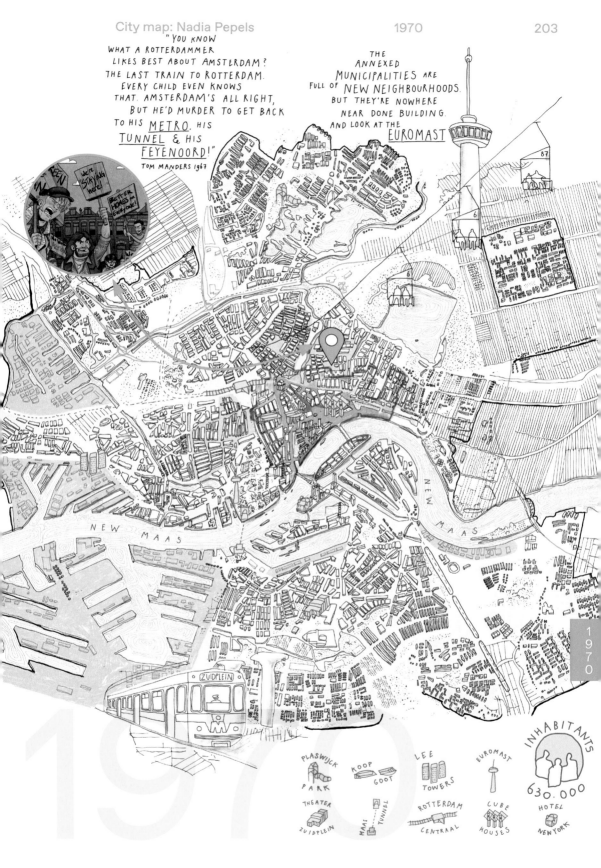

"YOU KNOW
WHAT A ROTTERDAMMER
LIKES BEST ABOUT AMSTERDAM?
THE LAST TRAIN TO ROTTERDAM.
EVERY CHILD EVEN KNOWS
THAT. AMSTERDAM'S ALL RIGHT,
BUT HE'D MURDER TO GET BACK
TO HIS METRO, HIS
TUNNEL & HIS
FEYENOORD!"
TOM MANDERS 1967

THE
ANNEXED
MUNICIPALITIES ARE
FULL OF NEW NEIGHBOURHOODS.
BUT THEY'RE NOWHERE
NEAR DONE BUILDING.
AND LOOK AT THE
EUROMAST

NEW MAAS

NEW MAAS

ZUIDPLEIN

PLASWIJCK PARK KOOP GOOT LEE TOWERS EUROMAST INHABITANTS 630.000

THEATER ZUIDPLEIN MAAS TUNNEL ROTTERDAM CENTRAAL CUBE HOUSES HOTEL NEW YORK

The city council wanted to demolish the old districts to build new offices and motorways. But the Rotterdammers who lived there rebelled and demanded improvement of their living conditions. They successfully resisted the demolition of their dwellings and made their demands clear: 'Build for the neighbourhood!'

The city council put aside its megalomaniac plans and started paying attention to the liveability of Rotterdam. For the first time, residents were allowed a say in the future of their districts. Old districts were not simply demolished, but improved as part of 'urban renewal'.

In the 1970s, large parts of the Crooswijk district were demolished to make way for new housing. Many people who had lived in the area for generations were forced to leave. Photo, unknown (collection SAR).

Local residents occupy the dome of the Koninginne Church in Crooswijk to stop the impending demolition. Photo, R. Mieremet, 1972 (collection NA).

1970

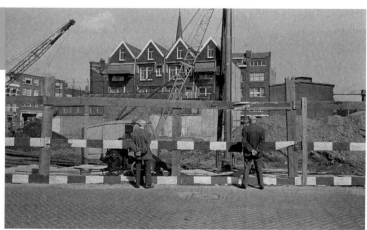

Dwellings were refurbished, expanded with bathrooms and sometimes merged, creating larger homes. In each district, urban blocks were demolished to make room for parks or squares. Residents could continue to live in their own districts, with their friends and neighbours. This way, social structures remained intact.

Nowadays, gentrification (renovation and upgrading) makes it increasingly difficult for ordinary Rotterdammers to continue to live in their own neighbourhood. Who exactly are these ordinary Rotterdammers? They are increasingly newcomers, migrants who were born in another country, but had a better chance of finding work or an education here.

Police stop Crooswijk residents as the demolition of the Koninginne Church begins. Photo, R. Mieremet, 1972 (collection NA).

Urban renewal in Rotterdam-Noord on the Pijnackerplein takes place in agreement with local residents. Photo, A. de Herder, 1972 (collection SAR).

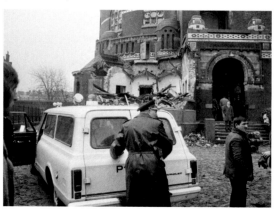

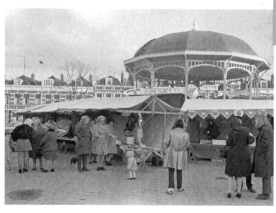

The booming economy in the Netherlands created a lot of work, so much so that there was a labour shortage. Companies therefore went to countries like Spain and Italy, and later to Morocco and Turkey, to recruit people to work in the port or in factories. In the 1960s, many Cape Verdeans came to the city as well.

These *gastarbeiders*, 'guest workers', who did not have much money at first, usually went to live in the old districts, in which affordable rooms or houses were still available to rent at the time. As a result, the composition of these

Pamphlet by Aktiegroep Het Oude Westen against the decay of the district, 1970.

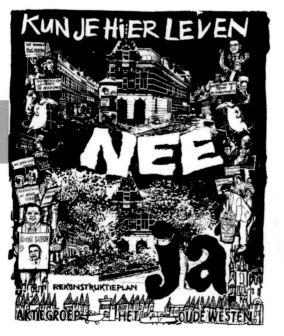

1970

Coolsingel demonstration for affordable new housing, 1975. Photo, A. de Herder (collection SAR).

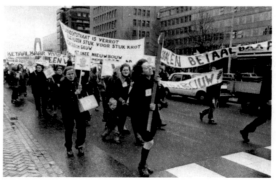

The initiative for *Monument voor de gastarbeider* (2013) by artist Hans van Bentem was taken by various Rotterdam parties, including children of the first generation of guest workers and the Centrum Beeldende Kunst.

The monument on the Afrikaanderplein is a combination of many symbols: an obelisk as a victory column, eight colours of stone for the eight countries of origin of immigrants (Greece, Italy, Spain, Portugal, Yugoslavia, Turkey, Tunisia and Morocco), terrazzo as a North African material, an Eiffel Tower as a reference to the great buildings to which immigrants contributed, ship steel for the port, a sun as a Mediterranean symbol and nod to the Turkish moon. Photo, Max Dereta, 2013.

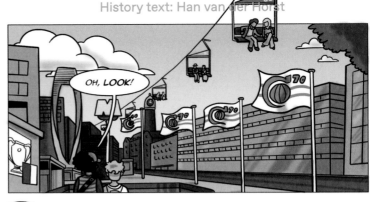

1970

In 1970, Rotterdam celebrated '25 jaar Wederopbouw' (25 years of post-war reconstruction) with the event C'70; the 'C' stood for 'Communication'. Mayor Wim Thomassen stated that the city wanted to communicate with its residents, not only by providing citizens with information, but also by hearing their opinions. At the city's New Year reception, students presented a model of a Saturn rocket, designed by artist Toni Burgering, which the mayor fired off amid general laughter. The rocket, which was supposed to be 112 metres high, was never built.

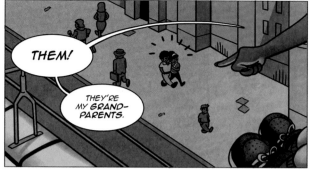

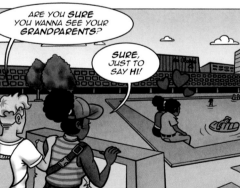

The numerous kiosks erected on and around Coolsingel were meant to bring a little cosiness among the tall buildings. For a fee, people could have their picture taken with the European Cup I that Feyenoord had won that year: 'Met de Cup op de kiek.' The proceeds went to children living in the old districts. The biggest attraction was a 2-kilometre-long cable car that ran across the city centre. As many as 6,000 people boarded it every day. Hook of Holland wanted to buy the cable car after the festival, but couldn't get the money together. It was subsequently demolished.

ROTTERDAM CHOOSES THE THEME 'COMMUNICA-TIONS' TO CELEBRATE ITS SILVER LIBERATION AND RECONSTRUCTION ANNIVERSARY.

Did you know... ...that you can never be born if you prevent your grandfather's marriage? In science fiction, this is called 'the grandfather paradox'.

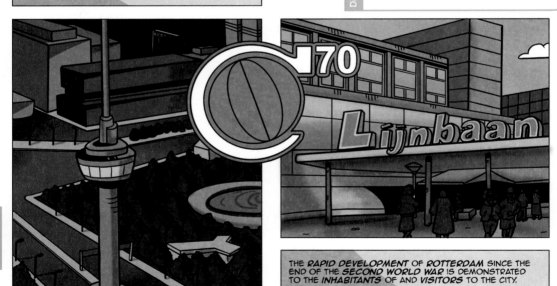

THE RAPID DEVELOPMENT OF ROTTERDAM SINCE THE END OF THE SECOND WORLD WAR IS DEMONSTRATED TO THE INHABITANTS OF AND VISITORS TO THE CITY.

The main organizer and life and soul of C'70 was Anton Fibbe, who worked at the Chamber of Commerce on Blaak, the place where entrepreneurs have to register. His C'70 made it clear that Rotterdam was a modern, vibrant and entrepreneurial city that wanted to communicate with its citizens.

After C'70 he became intensively involved in urban renewal. Major building projects such as the cube houses and the buildings around the Oude Haven, designed by famous architect Piet Blom, were realized partly thanks to Fibbe.

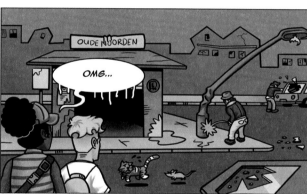

...that the Oude Noorden is now known as a nightlife area with trendy bistros, brewery cafés, galleries, jazz clubs and the Hofplein theatre?

Did you know...

Rotterdam was proud of its Lijnbaan, the first pedestrian-only shopping area in the Netherlands and Europe, designed by Van den Broek & Bakema. It was full of luxurious and expensive shops, which the public could admire without being hindered by car traffic. But Rotterdam had another face as well: the run-down neighbourhoods around the city centre that had sprung up between 1870 and 1910. Four to five families lived there in cramped little apartments that shared a single flight of stairs. They had only a sink with a tap, no shower. Rats overran the streets.

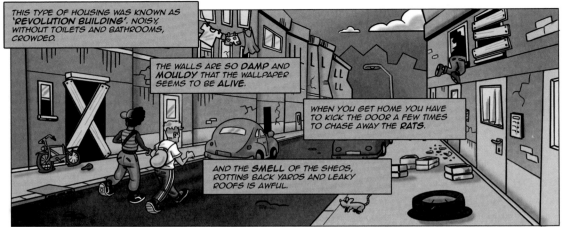

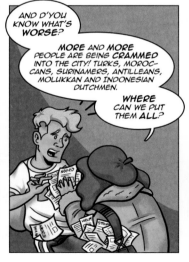

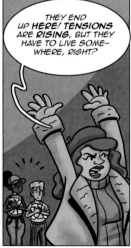

Mayor Wim Thomassen and his aldermen wanted to replace the old neighbourhoods with new buildings, but despite the poor conditions, residents still loved their districts. They wanted renewal and improvement, not demolition. And they did not want to be sent to new apartment blocks on the outskirts of the city, either.

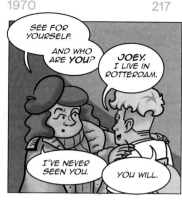

...that the so-called *Lelijke Eend*, 'Ugly Duckling', was a popular car at the time, as hip as miniskirts and jeans? The car was actually called a Deux-Chevaux (two horses) and had an output of 2HP (horsepower).

Did you know...

1970

From 1960 onwards, employers found it more difficult to find workers. So they brought in immigrants from abroad: first from Spain, Italy and Portugal, then from Turkey and Morocco, and then from Surinam, the Antilles and Cape Verde. These so-called 'guest workers' often just wanted to earn money and then return home. But things turned out differently: they stayed in Rotterdam, where they ended up in the old districts, bringing their families to join them. 'Guest workers' were regularly exploited by 'landlords'.

...that Pim Fortuyn started his political career as the leader of Leefbaar Rotterdam and was assassinated by an environmental activist in 2002?

Did you know...

1970

On Saturday 20 June 1970, activists led by Miss Pekel took 30 children swimming in the Hofpleinfontein. Demand: a new swimming pool for the Oude Noorden. This District Committee prevented the Noordplein from becoming a busy traffic junction. Members of Aktiegroep Het Oude Westen occupied the council chamber in the City Hall, because they were not allowed to participate in a meeting about the old districts. That is how it was in the 1970s. People demanded to have their say and they were right: making city is something we should all do together!

In 1972, there were violent riots on the Afrikaanderplein, in which native locals attacked Turkish newcomers. The trigger was the fact that a Turkish landlord had evicted a Dutch woman. Several right-wing populist politicians have emerged since –

Pim Fortuyn, Geert Wilders, Thierry Baudet – criticizing the current multicultural society.

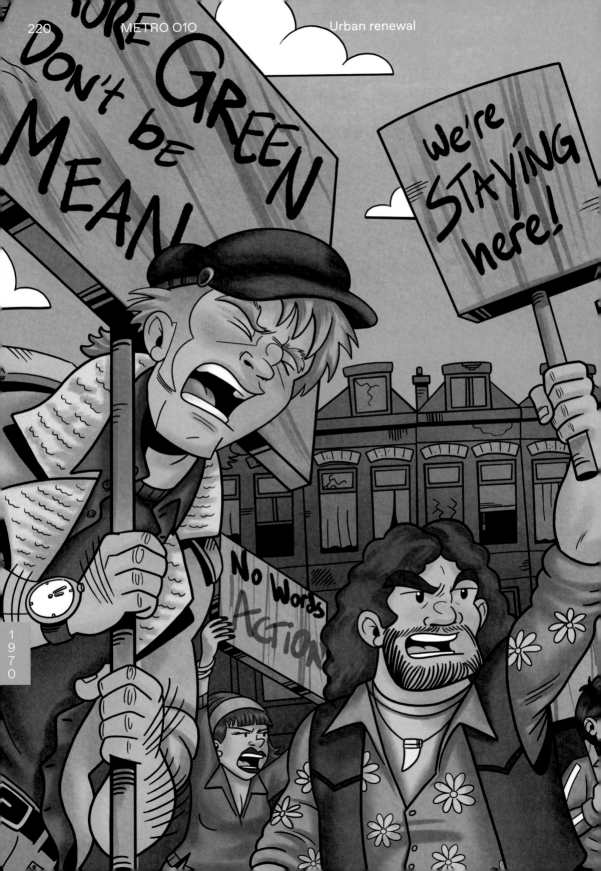

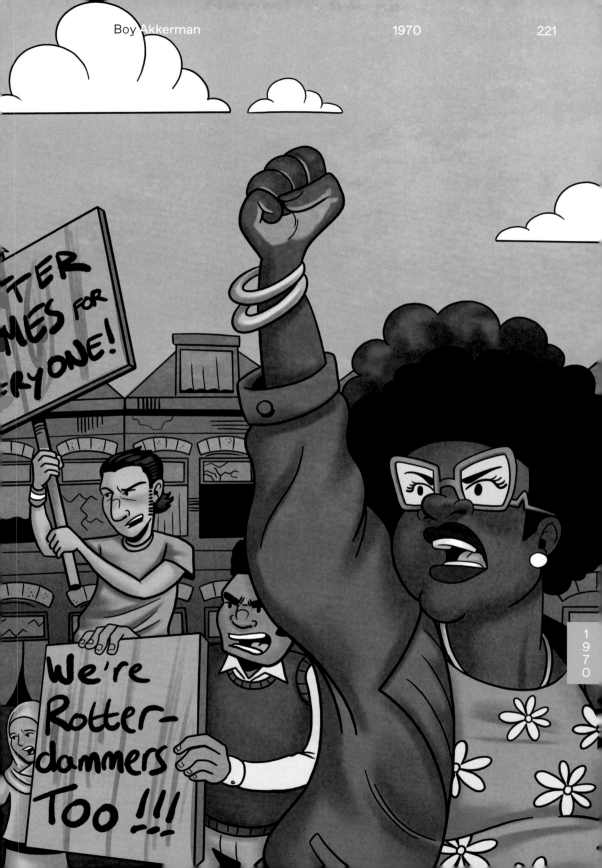

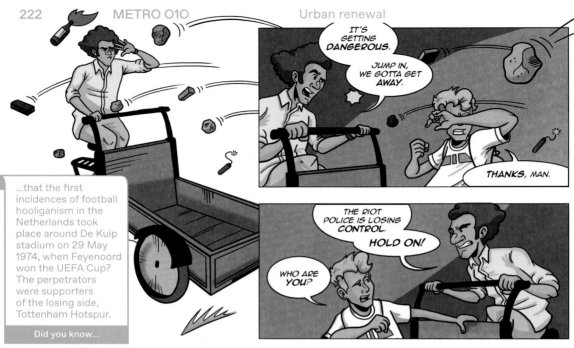

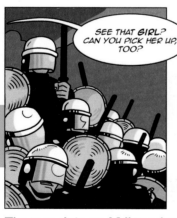

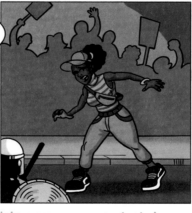

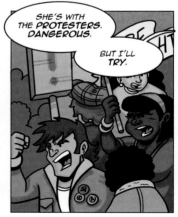

The race riots on Afrikaanderplein were exceptional for that time. If ordinary Rotterdammers took to the streets, it was usually to demand good and affordable housing. Residents of all colours and nationalities had to live bunched together in dilapidated dwellings. They made protest signs and marched for a better neighbourhood. Sometimes things got out of hand and then the *Mobiele Eenheid*, the riot police, had to restore order. A well-known activist of the time was Gerrit Sterkman, a poet and metal worker who had a square in the Oude Westen named after him.

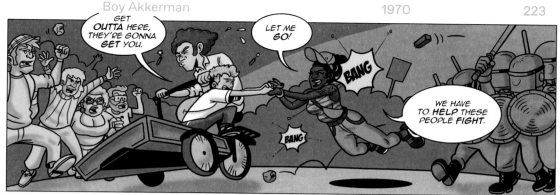

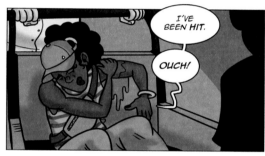

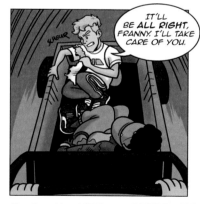

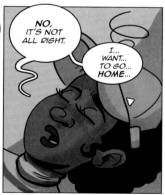

During the 1970s and 1980s, 70,000 dwellings were renovated for original residents and newcomers – a multicultural mix. That was then. Today, districts like the Oude Noorden and Crooswijk are increasingly becoming the domain of middle-class double-income residents.

The lower income groups are losing out. They are finding it increasingly difficult to secure affordable housing in Rotterdam. This process, whereby more and more hip, trendy people come to live and work in old districts, is known as 'gentrification'.

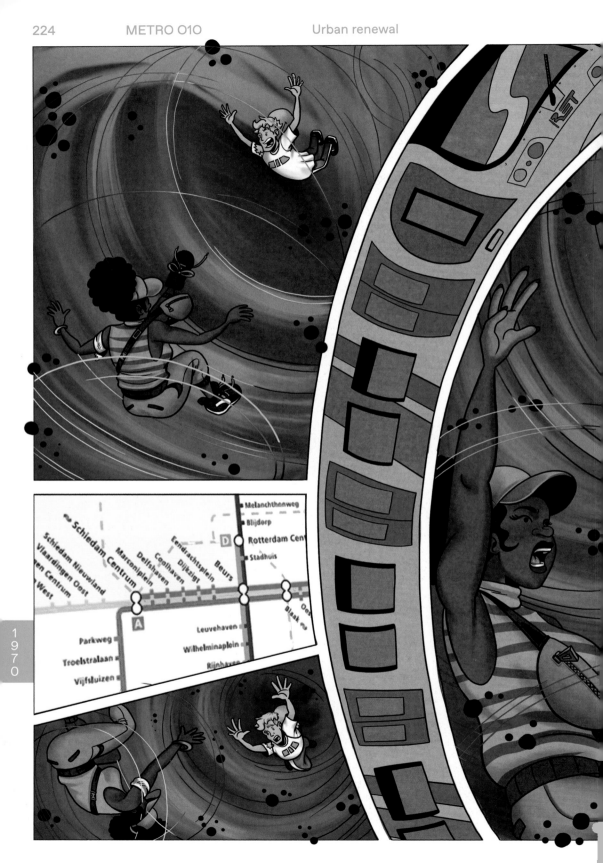

Fast forward?
Go to page 232

ROAMING

There is not always a destination.
But there is a journey.

There is often a departure.
Not always a way back.

When I hit the track,
air touches my toe to skull,
my shoulders drop.

Road swaps places with home.

If I have to roam,
then I prefer to do it here.
In your alleys,
on your paths.

Among all your faces there are routes.
We find.
You the city, we your children.

The fosterer of unheeded,
overlooked.

Take me by the hand, show how we in and out,
heartbeat together.

In difference lies the bridge,
its sparkle.

Rotterdam.

2050
City of the future

Today, Rotterdam is a superdiverse city.
There is no longer a single majority among the
different groups living in the city. Most residents
have an immigrant background, 170 nationalities
are represented in the city, which today is again
growing and has a population of more than
650,000 people.

The port has long since ceased to be where most
Rotterdammers work. Today, large containers are
used and there's no longer any need to haul bags,
crates or boxes. The containers are automatically
hoisted from ships and stacked up high using
robotic trolleys operated by a couple of people
at computers.

With the construction of the First and Second
Maasvlakte, the port has withdrawn from the city.
Ever-larger harbour basins and industrial estates
are being constructed to accommodate ever-
larger ships.

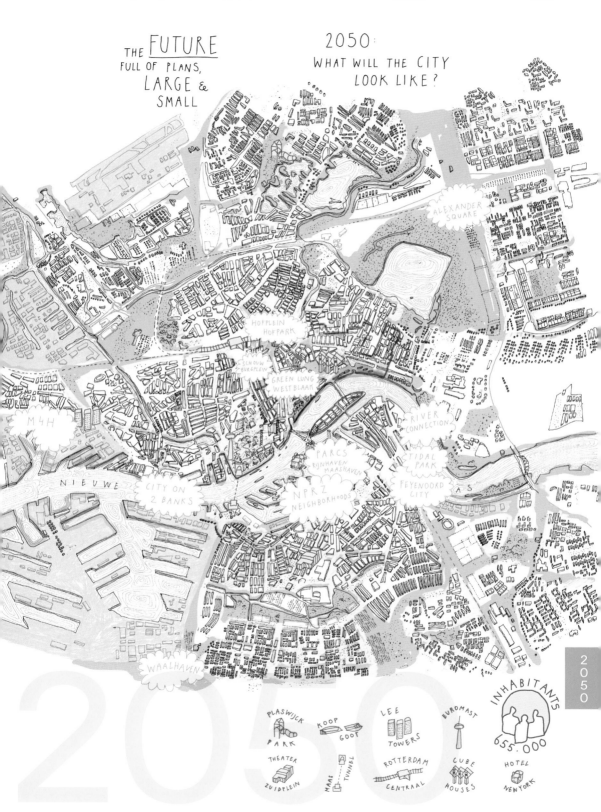

The Port of Rotterdam is no longer the largest in the world, but it is still the largest in Europe. Petroleum is the main product transported, but for how long will it stay that way?

Since 1996, the Erasmus Bridge connects the city centre with the Kop van Zuid. Without Mayor Bram Peper and director of Urban Development Riek Bakker, that bridge would never have been built.

Former city harbour areas are being built-up with housing and offices. On the Wilhelminapier, for instance, which extends the city centre to Zuid. The same is happening in Katendrecht and at former wharfs like the RDM, where educational institutions have now settled. The face of the formerly business-like and efficient city centre has also become more friendly: there are many more shops, terraces and dwellings, it's busier and there's more going on.

Students of urban design and architecture like to spend their traineeships in Rotterdam, not only to research its public housing, but also to see the work of well-known architecture offices, such as Broek Bakema, Maaskant, Carel Weeber, OMA, Team CS, Mecanoo, De Zwarte Hond and MVRDV. Large buildings are still being designed here today, ones that people from all over the world come to see, such as Rotterdam Central Station, the Markthal, the Depot, Theater Zuid-plein or the colossal office building De Rotterdam. This is why Rotterdam is sometimes jokingly called 'the only metropolis in the Netherlands'.

How will the city develop in the future? Rotterdam faces major challenges, including climate adaptation, energy transition, housing and liveability. High time to take a leap into the future!

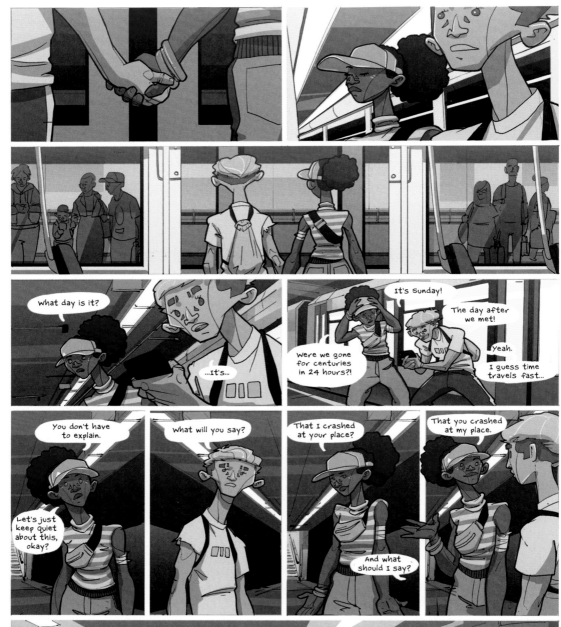

A few weeks later.

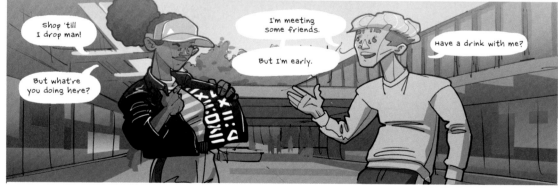

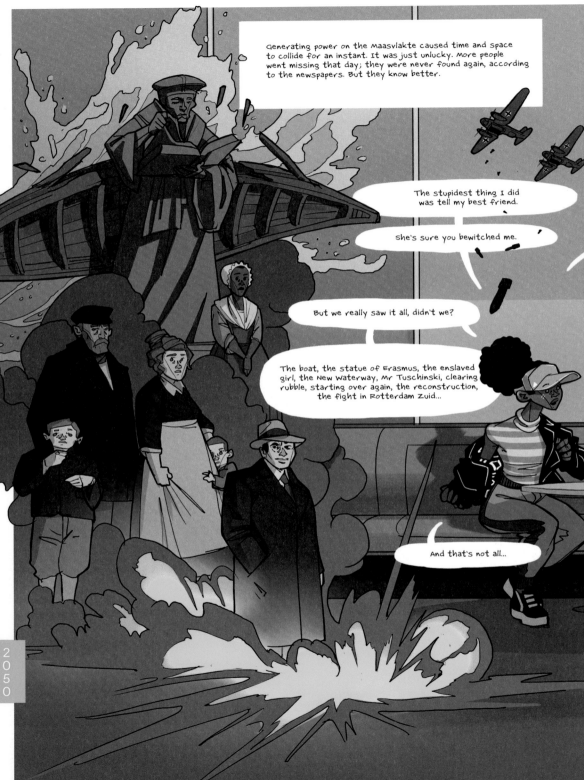

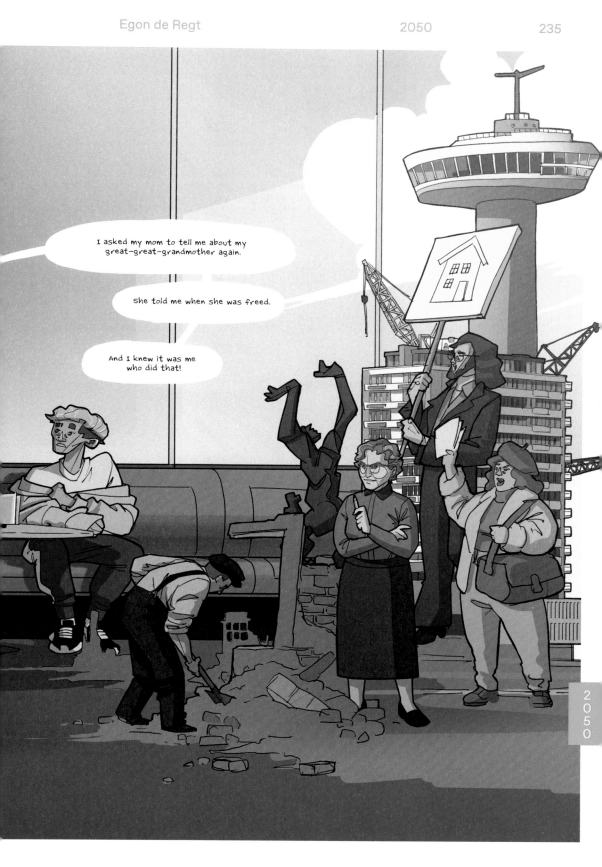

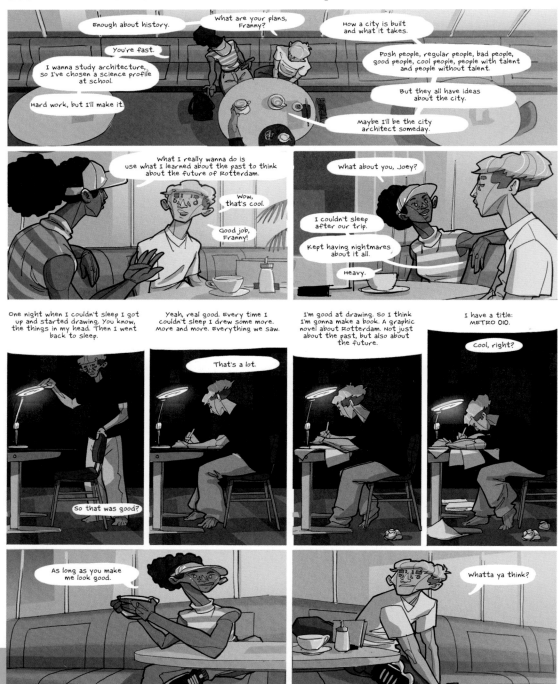

A graphic novel is sometimes also called a literary graphic novel. The difference between a cartoon and a graphic novel is that the latter often has more elaborate and complicated storylines and therefore has a more literary feel. Graphic novels are often used to represent novels, biographies or stories from the past.

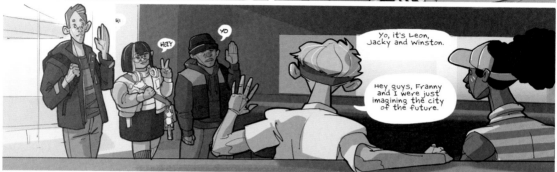
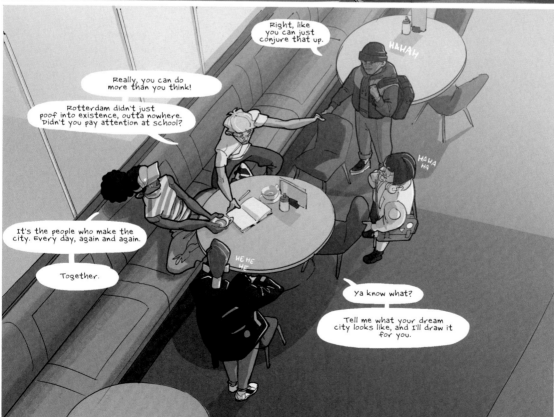

Rotterdam in 2050

Five friends are each dreaming of their own Rotterdam of the future. Their city. How will we live together in 2050? What will the city look like? Will it still be a good place to live in by then? Will living in the city just keep getting better and better?
Of course, we cannot decide everything ourselves, but you often have more influence than you think. Many small steps together make a big step! So what can you, yourself, do to make the city a better place?

City as Playground

Jackie

'I want a city in which you can play sports, games and meet up everywhere. A city that belongs to young people! A pop podium on every corner, a skate park in every street. Safe places to hang out and chill with your friends.
By the river a boulevard with bazaars, beaches and eateries. Sports fields and playgrounds everywhere, every district an outdoor swimming pool. And when a new stadium is built, the old Kuip will become one big ball pit!'

Illustration:
Marvin Bruin

Rotterdoom

Winston

'I'm afraid everything will go down the drain. What will happen if we continue to act like we do and leave things as they are? If we're not careful, Rotterdam will become a totally polluted city in which rising sea levels will cause floods. Nobody will live along the Maas anymore. Harsh storms will make the skyscrapers unliveable: too much nuisance and noise. Summers are so unbearably hot that nobody goes out on the streets anymore. You can hardly walk there anyway, because of all the traffic - the city is one big traffic jam. Things will get harder and more violent, we'll all live in an unhealthy environment and become increasingly unhappy.'

Illustration:
Edwin Hagendoorn

2050

Nature City

Franny

Nature, that's what
my city is all about!
Rotterdam will switch to
hydrogen. The Maasvlakte
will become a wind energy
generation area. No more
cars in the city centre.
We'll travel by public
transport and bikes,
of course. In Rotterdam
Nature City, you can
harvest food straight
from the fields in the
city centre. The wheat
fields that were laid out
in the bombed city centre
during the war are our
inspiration. Apartment
blocks and department
stores will have green
walls. We will construct
vertical greenhouses and
solar panels will provide
the energy to grow the
vegetables. You no longer
need to leave the city
for nature, because the
city itself has become
nature. Maybe we will see
exotic animals on the
streets in the future?
And a green metro will
criss-cross the city.
Whisper-quiet and faster
than ever.'

Illustration:
Gwen Stok

TechCity

Joey

'I'm a Techno-optimist:
technology is going to
save us. You meet through
digital screens mounted
all over the city.
Public transport is by
monorail, the metro
floats above a magnetic
block. Time travel is
so advanced that time
tourism is a reality.
People can take a look
in the past, marvel at
what it was like then.
There's no need to travel
in the future, because
this Rotterdam is the
future. The mayor is
a gender-neutral cyborg,
the ultimate fusion
of human and machine,
made of all the good
characteristics of
previous mayors. From
Mayor Oud to Aboutaleb.'

Illustration:
Stang Gubbels

The Inclusive City

Leon

'No, it is not like that
at all. The city will
not decay, nor will it
be taken over by nature
or technology. Rotterdam
belongs to everybody,
right? So we'll make
it a city for everyone.
Everybody is welcome and
everyone contributes.
Wherever you come
from, whatever you do,
whatever your religion
or gender, whether you
are young or old. The
city is more ground-
floor, accessible to
people with disabilities.
Access to buildings is
very easy. And it does
not matter what you look
like, everyone is okay.
That's my city: a city
for and by everyone!'

2050

Illustration:
Sai Rodrigues

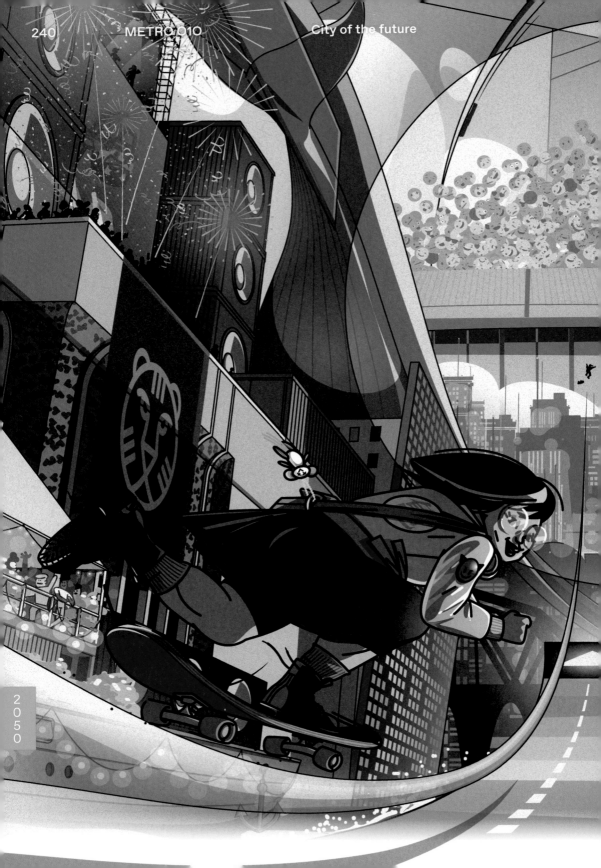

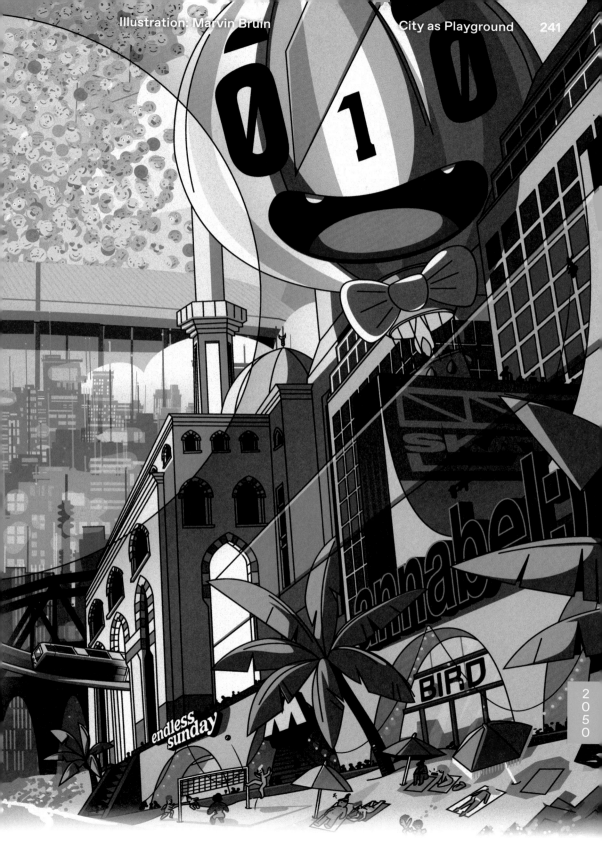

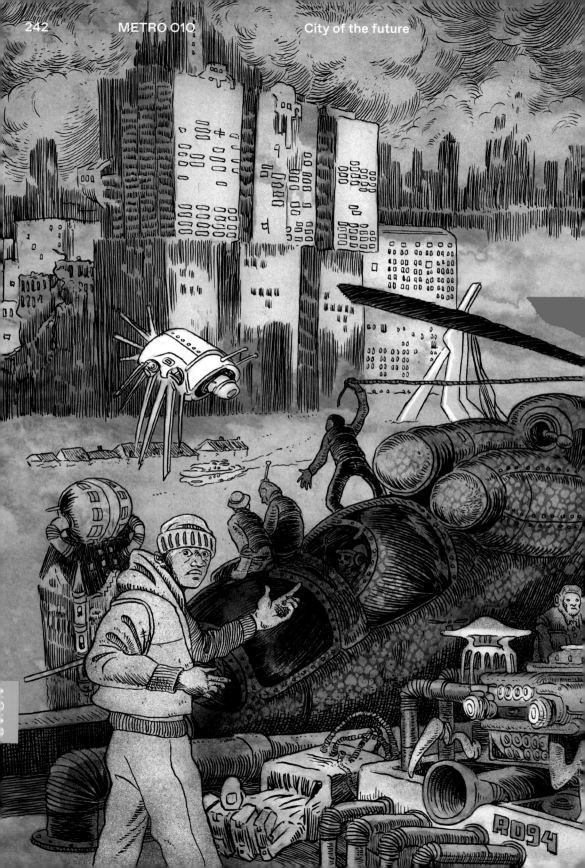

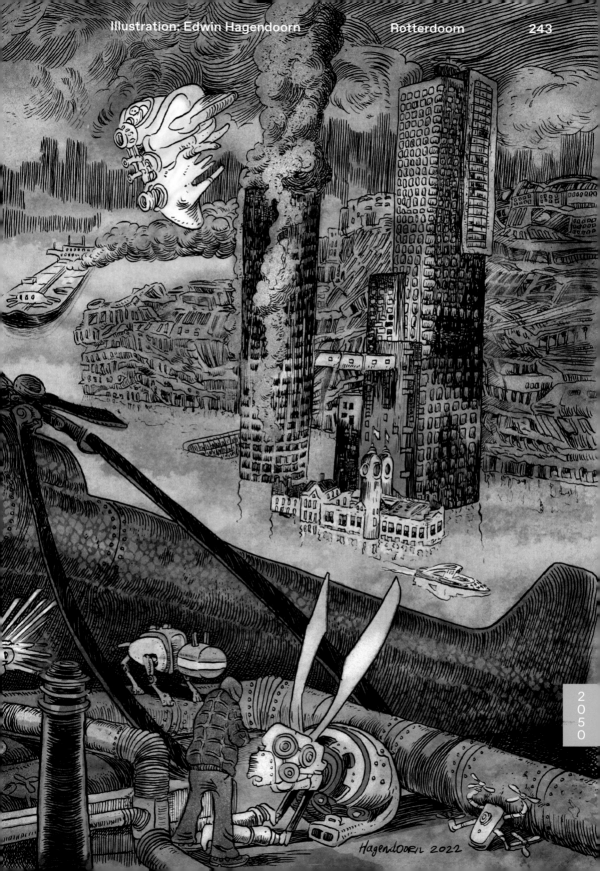

2050

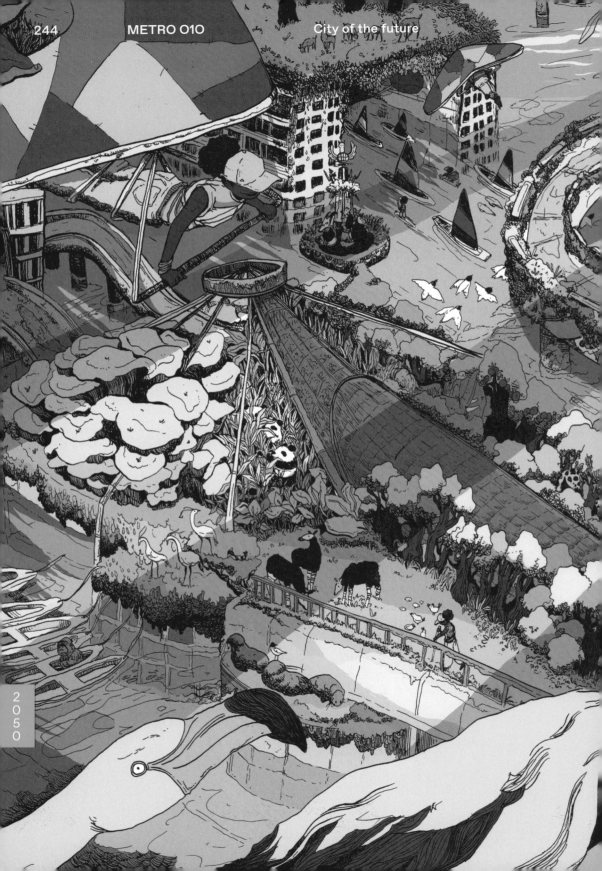

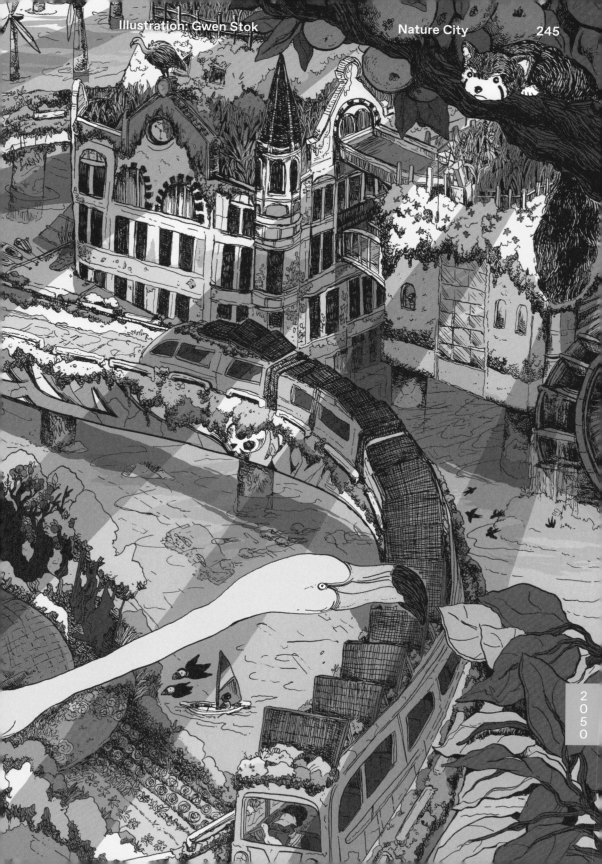

2050

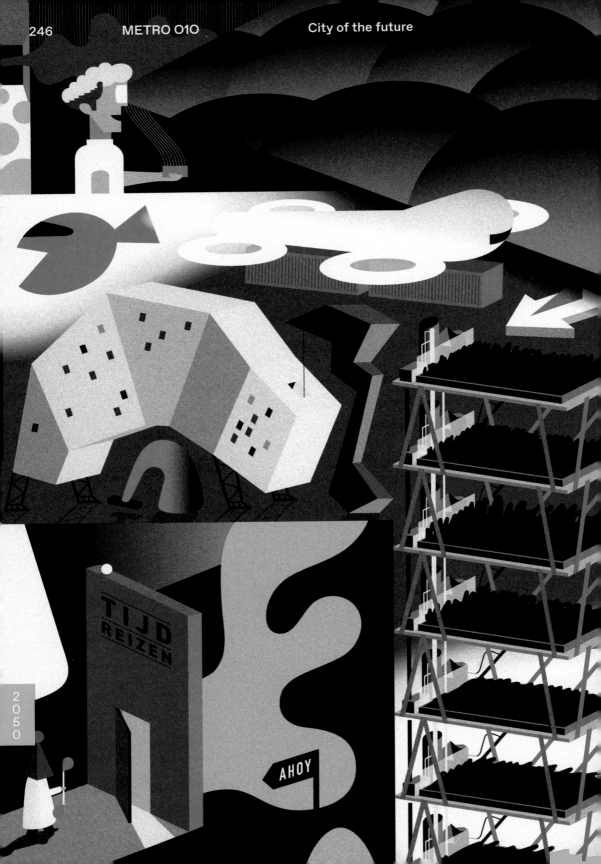

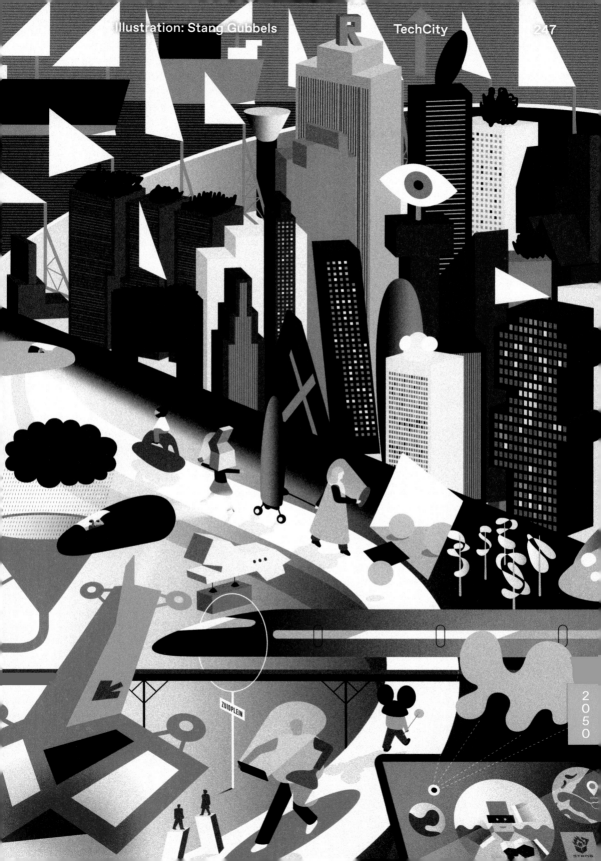

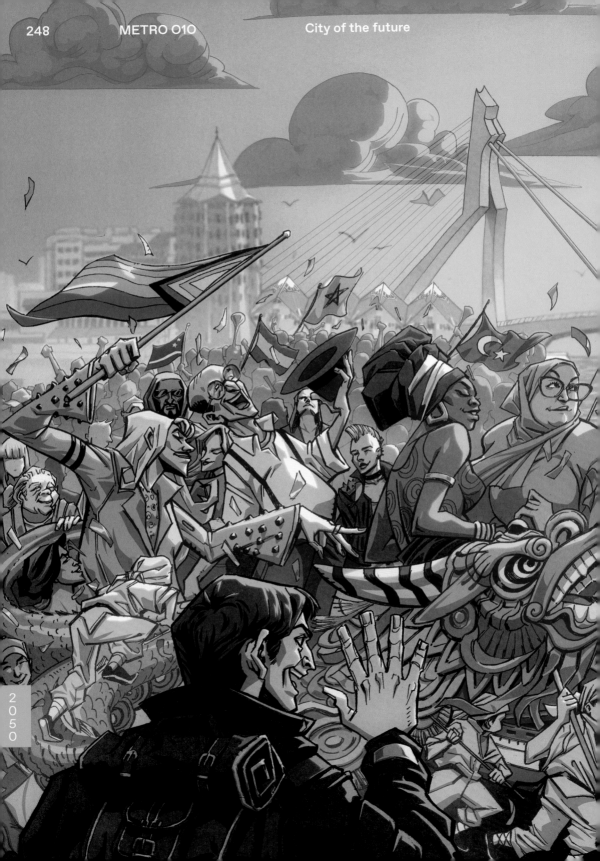

2050

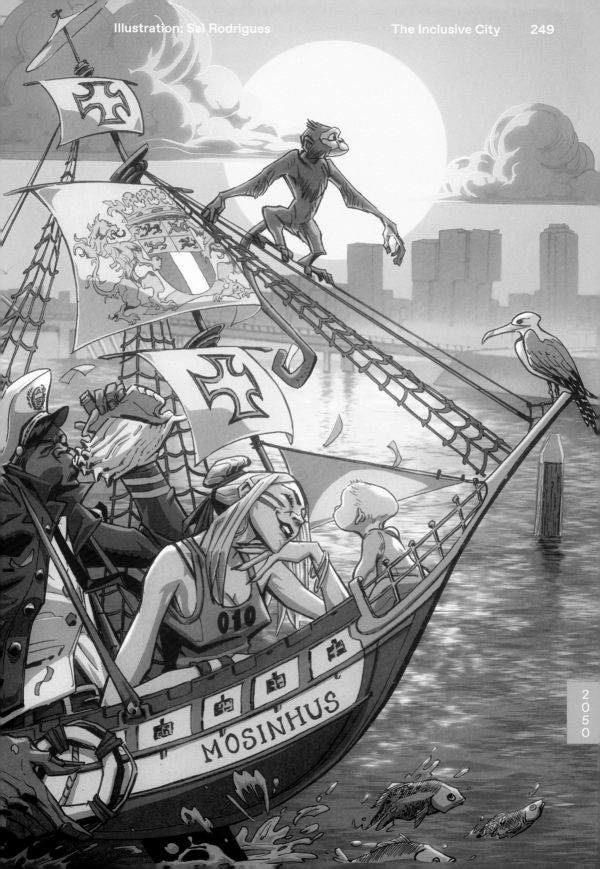

BREATH CITY

Rotterdammers have no fear of heights,
because we see the high-rises as fingers,
Which once took hold of us, and never let go.
Looking upward, to the spot we stand rooted.
See the palm as streets,
on which we leave our footprints.
This city makes you tiptoe.
And sometimes our hearts sink into our shoes.
We walk, our limbs like lead.

But this is a city built on trade.
Here we never stop, we always walk.
We travel, here from Noord through the Poort
van Zuid.
And once you enter this rollercoaster,
You never get off again.

Because here it's all or nothing.
But is it love at first sight?
Get to know her, get out there.
Like it a lot and is it mutual?
Then ask her to go steady.
Does that last long enough to register?
Then ask for her hand,
Take her in your arms and promise her you will
be faithful forever.
And hold her tightly.
Like the stadium tier encircles that
white-green turf.

In our city, things go right, wrong or right wrong.
And if we don't like you here,
We say we don't like the taste of you.
But we welcome everyone to our home port.
From day trippers to tourists.
And I idolize nothing when I say that Rotterdam
does own the most beautiful people.

You are, way ahead of your time.
For history was made.
Through architecture that only today
is praised to the skies.

My city is the truth.
From the Oude Haven to the Nieuwe Binnenweg.
No, from the Nieuwe Haven to the Oude Binnenweg.
White villages, white streets.
Black sailors, black bricks.

OwanO
Our metropolis, oh so small, but oh so big.
Apart from our accent,
everything is for sale here, really.
And if I want to know how you are doing,
I can ask you in 10 different languages,
because this is where five continents meet.

Find my letters on quaysides, my words on lanes,
my sentences on paths.
And when it is time to make love to my notepad
I go to Pendrecht to write.
And my surroundings are so multicultural that I can
take my pick from 176 fonts.
See me enjoy myself, among skyscrapers tickling
the sky.

Every day, I am surrounded by cinematic scenes.
But Rotterdam doesn't act, auditioning
doesn't exist, a script was never written.
Although the shooting continues 24/7. . .
So thick skinned, because hit by bombs and bullets.

010
Only for you would I give myself away.

Because you Rotterdam,
you are a metropolis pure and simple.
And to that, every resident here can attest,
Because this city, sums up the whole world.

KNOW YOUR CITY, MAKE YOUR CITY

'If you get to know the city, you will start to love it and the things you love, you will take care of.'

Jeroen de Willigen

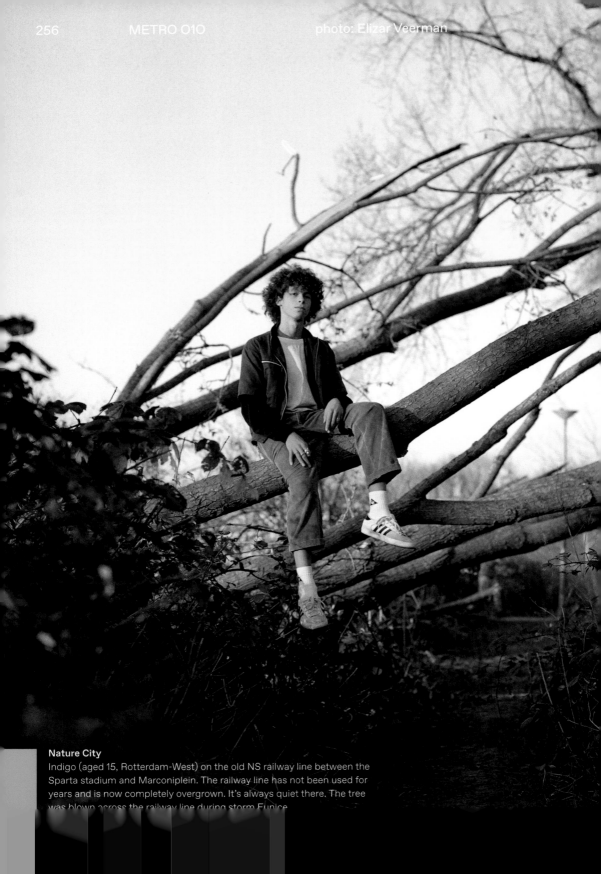

photo: Elizar Veerman

Nature City

Indigo (aged 15, Rotterdam-West) on the old NS railway line between the Sparta stadium and Marconiplein. The railway line has not been used for years and is now completely overgrown. It's always quiet there. The tree was blown across the railway line during storm Eunice.

City Making, what's that?

If you understand your city better, you can also make it better. But what exactly do we mean by 'making city'? Often, the first thing that comes to mind is the literal 'making' of the city: stacking bricks, building roads, designing parks and squares. But with that, of course, you still don't have a city. A city can't exist without people. A city is made by the people who live and work in it. And that, in fact, is the most important thing. All the people in a city are, by definition, city makers. And in a city, people live together.

Making city actually means: constantly looking for new and better ways to live together in a city. Living together can really be anything, as long as it's together. Working and living, of course. But also falling in love or not, making and being friends. Learning by going to school together, but also from each other, or by experiencing things. Caring for people who need it, or being cared for. Going to the movies, or to the theatre, or performing something yourself in front of an audience. Playing sports or coaching, or just going to a club together.

It's not that a city's buildings, streets and squares
don't matter. What a city looks like, how it was built
or created, has quite a lot of influence on how we
can and want to live together there. The space in
a city determines what you can do there.
Every city has its own story, its own history, which
helps determine the atmosphere and character of
the space in the city. If you know and understand
that story, you'll see that you'll love your city more.
And if you love something, you take care of it.

So such a story helps you become a better city
maker, someone who understands how to move
around the city with an eye for its history and
culture. And who understands what you can do
to live well with other city makers. You learn how to
use a city better that way, to find your way in it
and develop yourself and your surroundings.

The stories in this book can help you do this, but
they can't do it for you. You have to do it yourself.
Only then will you contribute to a great city, a city
you want to be in and stay in.

Know your city, make your city!

Jeroen de Willigen
Partner | Creative director De Zwarte Hond

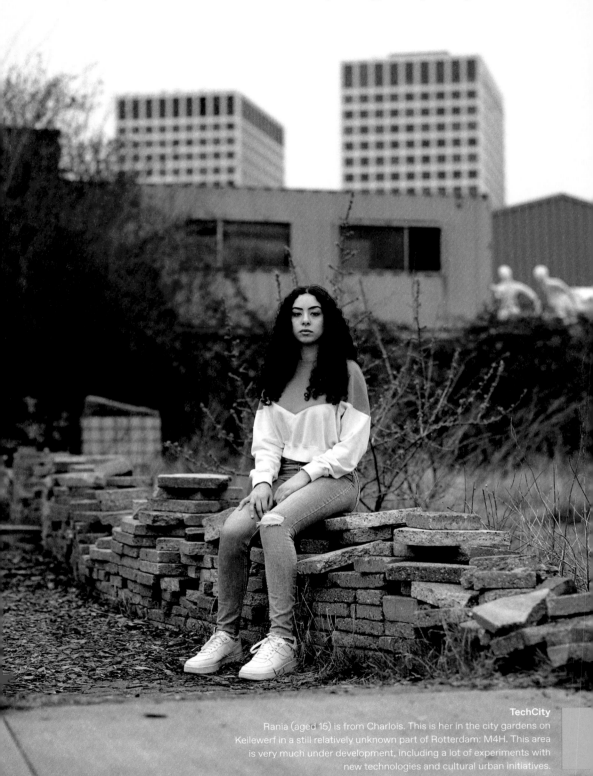

TechCity
Rania (aged 15) is from Charlois. This is her in the city gardens on Keilewerf in a still relatively unknown part of Rotterdam: M4H. This area is very much under development, including a lot of experiments with new technologies and cultural urban initiatives.

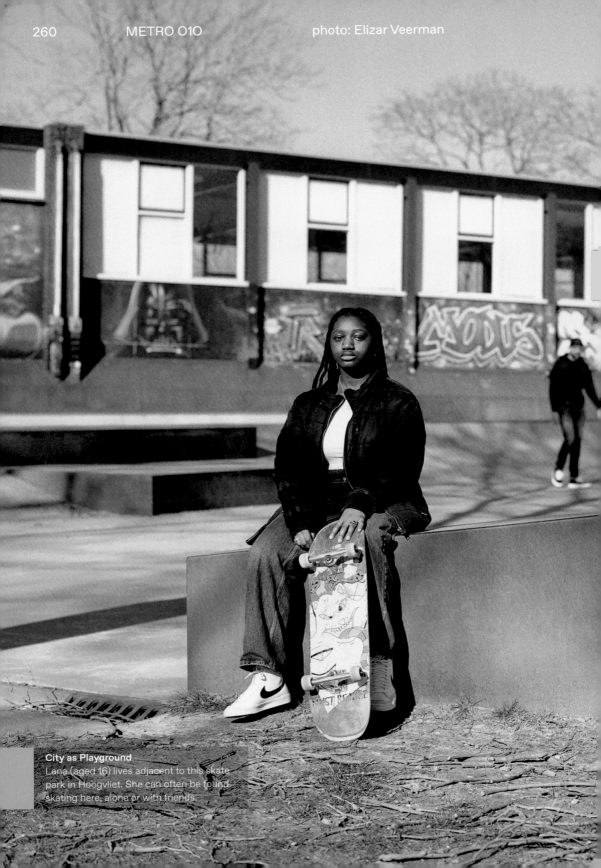

City as Playground
Lana (aged 16) lives adjacent to this skate park in Hoogvliet. She can often be found skating here, alone or with friends.

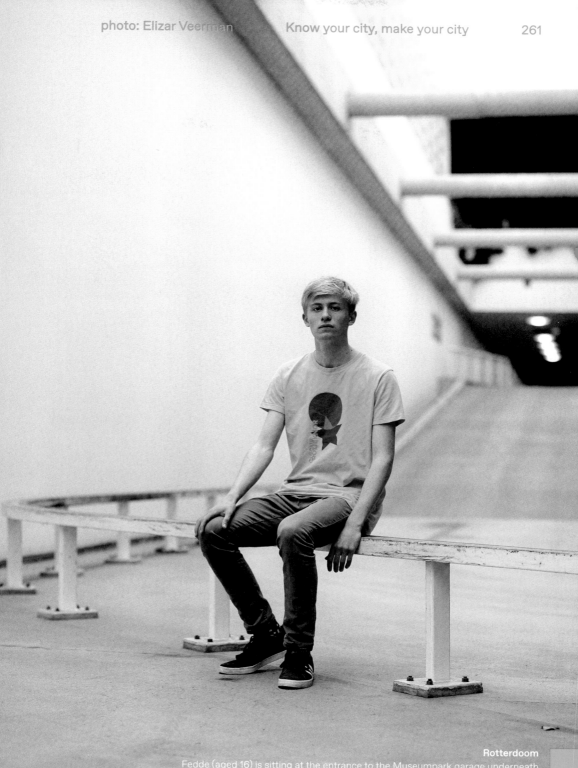

Rotterdoom
Fedde (aged 16) is sitting at the entrance to the Museumpark garage underneath the Depot. This is where the Museumpark underground water storage facility is located: enough space for 10 million litres of water. It's part of Waterplan 2, a project to reduce water issues in the centre of Rotterdam.

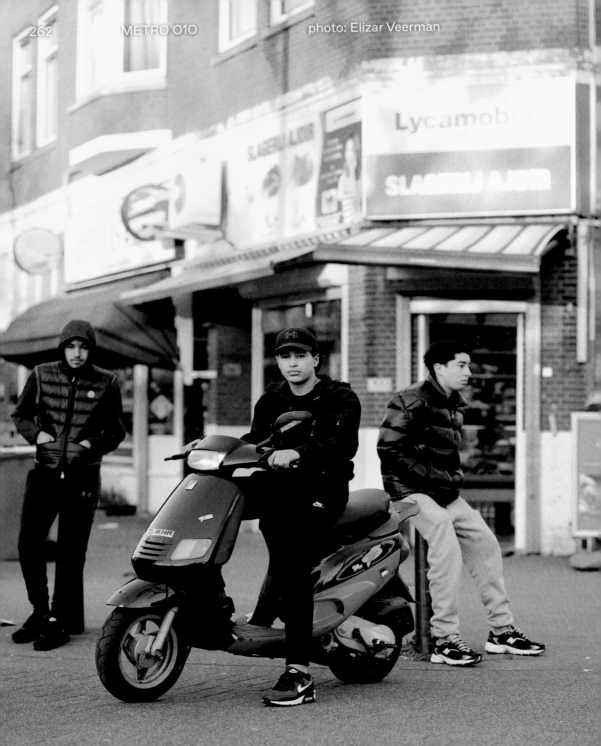

photo: Elizar Veerman

The Inclusive City
Samir (aged 16, Delfshaven) and his friends are standing in front of
the popular local butcher's shop in this district, a place where local
residents gather to get their daily groceries. A meeting place where
everyone is welcome.

Not finished, yet.
A long way to go, still.

It's late. The friends are saying goodbye.
'Great to have met you,' says Franny,
'But I have to go now. My tram is coming soon.'

> 'I'm going to Zuid too,'
> replies Joey, 'but I'm on my bike.
> See you soon'.

Franny is sitting by the window. Where are they all
going, she wonders. Passers-by. Workmen. Shopkeepers.
Children. Office workers.
How do they live, she wonders. Probably very
differently than people did in the old days. She thinks
back to their adventure. The tram is driving through
the busy city traffic. Tall towers to the left and
right. Under construction. Buildings being demolished,
building sites under construction. Activity by the
river. A big ship sails by, heading for the port.
Rotterdam is on the move. People walk the streets
everywhere, in all shapes and sizes.

> All those people have to live somewhere,
> Joey thinks as he cycles through the city.
> In a house, in a street, in a neighbourhood.
> He evades another cyclist.
> What will our city look like tomorrow?
> And the day after tomorrow? Nobody knows.
> Always wait and see.

What we have seen. Heard. Done.
He realizes it tastes like more.
My city, our city. Built up. Demolished.
Destroyed. Rebuilt. Together.
He yanks on his handlebars.

Franny gets an app.
From Joey.

'Miss you.'

'Miss you too.'

Thumbs up from Joey.

The tram stops.
Franny gets out, the sun shining brightly in
her face. Then she sees the silhouette
of someone standing next to his bicycle.
The silhouette detaches itself from the sun
and steps towards her.

Wide smile. Sweaty.
Joey has the folder with drawings in his hand.
'I want more adventures Franny,' he shouts.
'More of what we've seen. Heard. Done.
That city of ours, it's not finished yet.
It's got a long way to go, still.'

You can't make a city by yourself

You can't make a city by yourself. Nor a book. What started as an enthusiastic idea results over a year later in a book that's finding its way in the city of Rotterdam, and beyond. But that didn't happen by itself, either. It's the result of the work of lots of people, who cannot go unmentioned. Because we're proud!

First of all, my thanks go to Johan van Herpen. What a conversation at the kitchen table with a neighbour can lead to! Many thanks to Martijn van der Mark, who turned out to have as much heart for the book as for the city. Thanks to Abdelkader Benali, without whose love of storytelling the book would never have been the book it is. Thanks to Riek Bakker. This book could not have wished for a nicer introduction. Michelle Provoost, Simone Rots and Han van der Horst, whose boundless knowledge of the city and its history laid the framework for the book. Tijn Boon, without whose careful text editing this book would not have seen the light of day. And a big thank you to Léon Kranenburg, El Patron, partner in crime. You gave the project substance and me the courage to keep going.
I thank Eelco van Welie for his confidence in the book.
For the design of the book, I am grateful to Roosje Klap. Roosje gave the book a look like only she can.

This project could never have become what it is today without the generous brainpower and help of so many from the city. Too many to mention here, but I thank you all for the conversations, thinking sessions, visits and litres of coffee we've drunk together over the past year. May it be the start of many joint plans.

Furthermore, I am of course very grateful to the board members of the Ken Je Stad, Maak Je Stad Foundation for their enthusiasm, support and much-needed expertise.

Ruud Visschedijk, Carolien Dieleman, Ronald van Raaij and Karim Amghar, with your help I was able to take seven-mile strides.

To the partners and colleagues at De Zwarte Hond, especially Tijmen Stieber and Jeroen de Willigen, I would like to give special thanks. Your unconditional and almost natural support for this project was heart-warming. That you gave me the time to be able to realize this project is more than special. Only at De Zwarte Hond is something like this possible. Maartje Berendsen and Liesbeth Meijer: without you there'd be no book.

But above all: the desire to make a rich visual story, bringing together many disciplines, would have been impracticable without the extraordinary contributions of all the makers: Boy Akkerman, Benzokarim, Marvin Bruin, Dodici, Loes van Duijvendijk, Bruno Ferro Xavier da Silva, Stang Gubbels, Vienne Lisa Haagoort, Edwin Hagendoorn, Mariana Hirschfeld, Saskia de Klerk, Hanco Kolk, Vera de Koning, Esther Malaparte, Moze Naél, Nadia Pepels, Egon de Regt, Sterre Richard, Sai Rodrigues, Marcel Ruijters, Martijn van Santen, Rachel Sender, Gwen Stok, Elizar Veerman. The professionalism, fun and cooperation with and between everyone exceeded my wildest expectations. The book has become special and that is really thanks to you.

Finally, I would like to thank a number of people close to me who supported me in my belief that I could create something beautiful and who made sure the world kept spinning around me. I'm sure they are very happy that the book is here now. Annemie, Horst, Dirk, Xavier. But above all Roelant, Siebe and Fedde, life can go on, now.

Ellen Schindler
Partner | CEO De Zwarte Hond
Rotterdam, november 2022

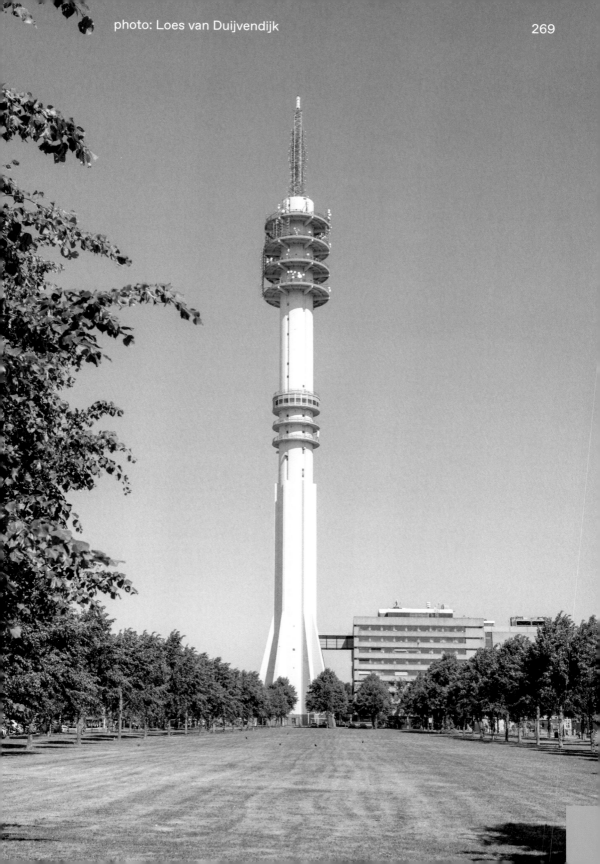

Disclaimer

METRO 010

Stichting Ken Je Stad, Maak Je Stad aims to promote young people's ownership of the metropolitan living environment through layered educational projects by means of a book and/or manifestations.

METRO 010 is powered by De Zwarte Hond
De Zwarte Hond, office for architecture, urban design, and strategy, works on the (European) city on a daily basis. There is an increasing urgency to make cities inclusive and climate adaptive, while the space for this is limited. Solutions in other forms of mobility, living, working and green in the city are therefore becoming increasingly important, but also more complex. These changes demand a lot from the understanding of a city's inhabitants.

De Zwarte Hond is therefore asking itself the question of how to start a conversation about the city in a different way, and how we involve young people, the future city makers, in shaping their city.

METRO 010 makes a valuable contribution to the conversation about the identity of the city and raises topics that everyone can identify with. The book offers a collective narrative, to get to know and understand the city better.

This publication has been made possible with the support of

Colofon

Initiator, concept & art director
Ellen Schindler (De Zwarte Hond)

Story
Abdelkader Benali

Cartoonists and illustrators
Boy Akkerman, Marvin Bruin, Dodici, Bruno Ferro Xavier da Silva, Stang Gubbels, Edwin Hagendoorn, Saskia de Klerk, Hanco Kolk & Marloes Dekkers (colorist), Vera de Koning, Esther Malaparte, Egon de Regt, Sterric, Sai Rodrigues, Marcel Ruijters, Martijn van Santen, Rachel Sender, Gwen Stok.

Drawn maps of the city
Nadia Pepels (De Zwarte Hond)

Historical background
Michelle Provoost
(The future scenarios of Rotterdam 2050 are based on the studio Citizens of the Antropocene by the Independent School for the City.)

History texts and *Did you know...*
Han van der Horst

Urban Poetry
Benzokarim, Vienne Lisa Haagoort, Moze Naél, Mariana Hirschfeld

Translation
D'Laine Camp (InOtherWords)

Photography
Loes van Duijvendijk, Elizar Veerman

Projectlead Ken Je Stad, Maak Je Stad
Maartje Berendsen

Graphic design
ARK (Roosje Klap) with Tijmen Stieber (De Zwarte Hond), thanks to WOAU! (Léon Kranenburg)

Printer
die Keure

Collaboration partners visual material
Alexandra van Dongen (Museum Boijmans Van Beuningen); Hanneke Kempen, Patricia Mensinga (Maritiem Museum); Corinne Lampen, Aura Pattinama (Rotterdam City Archives)

Visual material from collections
Museum Boijmans Van Beuningen (MBVB); Maritiem Museum (MM); Rotterdam City Archives (SAR); National Archives (NA); Museum Rotterdam (MR); Nederlands Fotomuseum (NFM); Rijksmuseum (RM); Koninklijke Verzamelingen, The Hague (KV). Where individual images have been used, we have indicated the origin directly in the caption.

Photography MM Eric van Straaten
Photography MBVB Studio Buitenhof, Tom Haartsen, Jannes Linders

Publisher
nai010 publishers - specialized in books in the fields of architecture, urbanism, art and design:
sales@nai010.com | www.nai010.com

International distribution partners:
North, Central and South America - Artbook | D.A.P., New York, USA:
dap@dapinc.com
Rest of the world - Idea Books, Amsterdam, the Netherlands:
idea@ideabooks.nl

ISBN 978 94 620 8804 7
NUR 693 / 361
BISAC CGN010000
THEMA QXV

First English edition November 2023